The Annual of the Type Directors Club

TYPO
GRA
PH.
Y.

WATSON-GUPTILL PUBLICATIONS/NEW YORK

First published 1988 in New York
by Watson-Guptill Publications,
a division of Billboard Publications, Inc.,
1515 Broadway, New York, N.Y. 10036

The Library of Congress has cataloged this
serial title as follows:
Typography (Type Directors Club (U.S.))
Typography: the annual of the Type Directors Club.—1—
New York: Watson-Guptill Publications, 1980–
v.:ill.; 29 cm.

Annual.
ISSN 0275-6870 = Typography (New York, N.Y.)

1. Printing, Practical—Periodicals. 2. Graphic arts—periodicals.
I. Type Directors Club (U.S.)
Z243. A2T9a 686.2′24 81-640363
AACR 2 MARC-S
Library of Congress [8605]

Distributed outside the U.S.A. and Canada by
Rotovision, S.A.
Route Suisse 9
CH-1295 Mies
Switzerland

Manufactured in Japan
1 2 3 4 5 6 7 8 9 / 93 92 91 90 89 88

Senior Editor: Sue Heinemann
Designer: Alan Peckolick
Letterer: John Jay
Page Makeup: Jay Anning
Photographer: Dennis Williford
Production Manager: Stanley Redfern
Compositor: Trufont Typographers, Inc.
Set in ITC Cheltenham Bold and Light Condensed
ISBN 0-8230-5543-4

ONTENTS

CHAIRPERSON'S

ED BENGUIAT

STATEMENT

This year, as chairman of the Type Directors Club's annual competition, I thought my responsibility would be a lot easier, since I'd done it before—but I was in for a big surprise. The moods of typography were a lot different in the pieces to be judged than they had been in previous years.

Since 1953, the year of the first TDC annual, the typographic profession has become an industry unto itself. Throughout these years, the Type Directors Club has striven to preserve excellence in typographic design and to recognize those who have shown excellence in this area.

For the jury, the selection of the winners in the 34th annual competition of the Type Directors Club was indeed a difficult task. Each judge, in addition to being a fine designer, was also a perfectionist in his or her profession. I certainly did not envy their responsibility in choosing the pieces featured in this annual.

Ed Benguiat began his career as a jazz drummer, playing with the bands of Stan Kenton and Woody Herman and appearing on 52nd Street with such notables as Tiny Grimes and Dexter Gordon. He then turned to the graphic arts.

After studying at Columbia University and the Workshop School of Advertising Art in New York City, he was soon designing letterforms and logotypes. He then worked as a designer and art director at many of the major advertising agencies and publishing houses in New York. Since 1962 Benguiat has worked for Photo-Lettering, Inc., where he is now vice-president and creative director. He also teaches at the School of Visual Arts and lectures throughout the world.

Benguiat has won numerous awards for his graphics and is well known for his many typeface designs. More than 98 of his alphabets are in the ITC collection and more than 500 are available through Photo-Lettering, Inc.

Benguiat is a member of the Type Directors Club, the New York Art Directors Club, and the Alliance Graphique Internationale. With all his activities, he still finds time to fly his own racing plane.

JUDGES

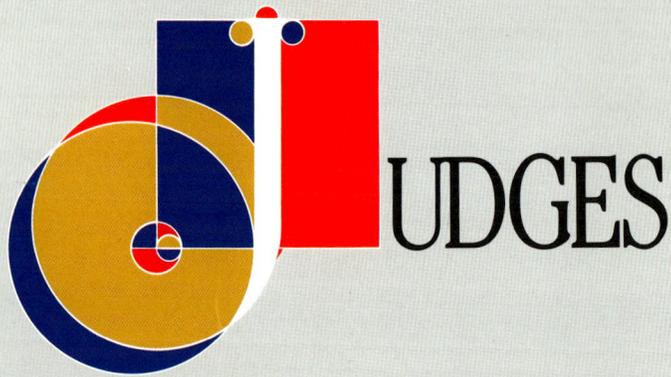

CHARLES SPENCER ANDERSON

Charles Spencer Anderson graduated from the Minneapolis College of Art and Design in 1981 and worked for two Minneapolis design firms before joining the Duffy Design Group in early 1985, shortly after it was founded. He has been instrumental in the studio's rapid ascent to national recognition and was recently made a partner. Indeed, three years after its founding, the Duffy Design Group is ranked as one of the nation's top design studios. Recent annuals from *Communication Arts*, the American Institute of Graphic Arts, *Graphis*, *Print*, and the New York Art Directors Club, among others, show more work from the Duffy Design Group than from any other design firm. At the prestigious New York Art Directors Show in 1987, Anderson himself had more of his pieces selected as finalists than had ever been chosen from a single designer in the history of the show. Two of his pieces were recently chosen by the Library of Congress for inclusion in its Graphic Design Archives.

DAVID BRIER

David Brier is president and creative director of David Brier Design Works, Inc., a three-person design firm. His interest in graphics began eight years ago, in college, when he saw a copy of *U&lc*. Starting out as a handletterer and logo designer, he soon moved into the standard variety of assignments: letterheads, alphabet designs, magazines, and endless promotional projects. Over the years he has done work for such clients as Revlon, Time Inc., Ally/Gargano, *Rolling Stone* magazine, Trump, HBO, ABC TV, NBC TV, Mercedes Benz, and the *New York Times* magazine.

Brier's work has been recognized nationally and internationally by such groups as the Type Directors Club, the Society of Publication Designers, *Graphis*, *Creativity*, and the American Institute of Graphic Arts. Recently the typographic display in his designs was celebrated in *Studio* magazine's annual; he is the youngest designer ever to win such recognition.

JAMES CRAIG

James Craig was born in Montreal, Canada, and studied fine arts in Montreal and Paris before coming to the United States. He received his B.F.A. from the Cooper Union and his M.F.A. from Yale University. A design director for Watson-Guptill Publications and member of the New York Art Directors Club, Craig teaches graphic design at the Cooper Union and lectures widely.

Craig is best known for his books on graphic design, which over the past 20 years have sold almost half a million copies and have been adopted by art schools around the world. The titles are *Designing with Type*, *Production for the Graphic Designer*, *Phototypesetting*, *Graphic Design Career Guide*, and *Thirty Centuries of Graphic Design* (co-authored with Bruce Barton). Craig is presently writing a book intended to help non-designers work more efficiently with graphic designers.

ALAN FLETCHER

Alan Fletcher studied at the Royal College of Art in London and at the Yale School of Architecture and Design in New Haven. After beginning his career in New York, he moved to London, where he co-founded Fletcher/Forbes/Gill in 1959 and worked for such clients as Cunard, Olivetti, and Reuters. Then, in 1972, he became a founding member of Pentagram. His recent clients have included Lloyd's of London, Daimler Benz, IBM Europe, and the Mandarin Oriental Hotel Group.

The recipient of many awards, Fletcher shared, with Colin Forbes, the 1977 Designers and Art Directors Association President's Award for outstanding contributions to design. He was also awarded the 1982 medal for outstanding achievement in industrial design by the Society of Industrial Artists and Designers.

Among the books Fletcher has co-authored are *Identity Kits: A Pictorial Survey of Visual Signs*, *Graphic Design: A Visual Comparison*, and *A Sign Systems Manual*. He is a Royal Designer for Industry, a Fellow of the Society of Industrial Artists and Designers, and past president of the Designers and Art Directors Association and of the Alliance Graphique Internationale.

CARIN GOLDBERG

Carin Goldberg graduated from the Cooper Union and has worked as a staff designer for the CBS Television Network, CBS Records, Atlantic Records, and Condé Nast Publications. She has taught typography, design, and senior portfolio at the School of Visual Arts. For the past five years, Goldberg has been the proprietor of her own graphic design studio. A large part of her work consists of book and record covers. Over the years she has received a number of awards, and her work has been honored by such organizations as the American Institute of Graphic Arts, the Type Directors Club, the Art Directors Club, and *Graphis*.

DIANA GRAHAM

Diana Graham has nearly 20 years of experience in the design and marketing field. Her projects have encompassed identity programs, annual reports, packaging, real estate promotion, architectural and exhibition graphics, marketing programs, and motion picture promotion. Major clients have included ABC, Fischer Brothers, La Salle Partners, MTA, NFL, Macmillan, Drexel Burnham Lambert, Prudential Insurance, General Electric, HBO, Warner Communications, Gulf + Western, Orion, and Universal Pictures.

Honored by numerous awards from leading design publications and organizations, Graham received the first annual Women in Design International Award in 1980. She has also been featured by such publications as *Communication Arts*, *Graphics: New York*, *Real Estate Forum*, *Adweek*, *Novum*, and *Lineagrafica*. Recently she was elected chairman of the Communications Graphics Show for the American Institute of Graphic Arts and served as a board member. She lectures throughout the U.S. and currently teaches senior design portfolio at the School of Visual Arts.

JUDGES

NANCY RICE

Nancy Rice received her B.F.A. in graphic design from the Minneapolis College of Art and Design in 1970. She then joined Knox Reeves Advertising, which later merged with Bozell & Jacobs, Inc., and eventually became a vice-president and senior art director, working on such accounts as General Mills, Bordens, United Way of America, Bristol-Meyers, and Northwestern Bell.

In 1981, with Pat Fallon and Tom McElligott, Rice formed Fallon McElligott Rice, where she continued to handle a variety of major accounts, including the 1984 U.S. Olympic Hockey Team, 3M Company, Mr. Coffee, and *Rolling Stone* magazine. Then, in 1985, she joined Nick Rice to establish Rice & Rice Advertising, Inc., where she continues to handle prestigious clients.

Throughout her career Rice has won top awards for her designs. In October 1986 she was honored as Art Director of the Year by the New York Art Directors Club and the Hall of Fame. Then, in December 1986, she was featured in *Esquire* magazine as one of the people under 40 who is changing the nation. Most recently, in January 1988, Rice & Rice was named the "hottest creative agency in the nation" by *Adweek*.

DENNIS WILLIFORD/PHOTOGRAPHER

Dennis Williford, of Williford Studios, works out of the photo district in downtown Manhattan. He has more than thirteen years of experience in the photographic industry. After receiving his education at the School of Visual Arts in New York City, he joined the Ronald DeMilt Studios, where he eventually attained the position of studio manager. Williford has done photographic work for such large advertising agencies as Young & Rubicam, Mingo-Jones, and McCann-Erickson. His images have been used by such diverse clients as Kentucky Fried Chicken, Eastern Airlines, Miller Brewing Company, Metropolitan Life, Nabisco, BMW, the United Negro College Fund, Barclays Bank, and the Plaza Hotel. He has also taught classes in photo illustration at the School of Visual Arts.

Williford has been of great assistance to the Type Directors Club in shooting all the award-winning pieces shown on these pages. This was no easy task, considering that each item was not only a different size, but also had to be photographed in scale with the existing page format.

CALL FOR ENTRIES

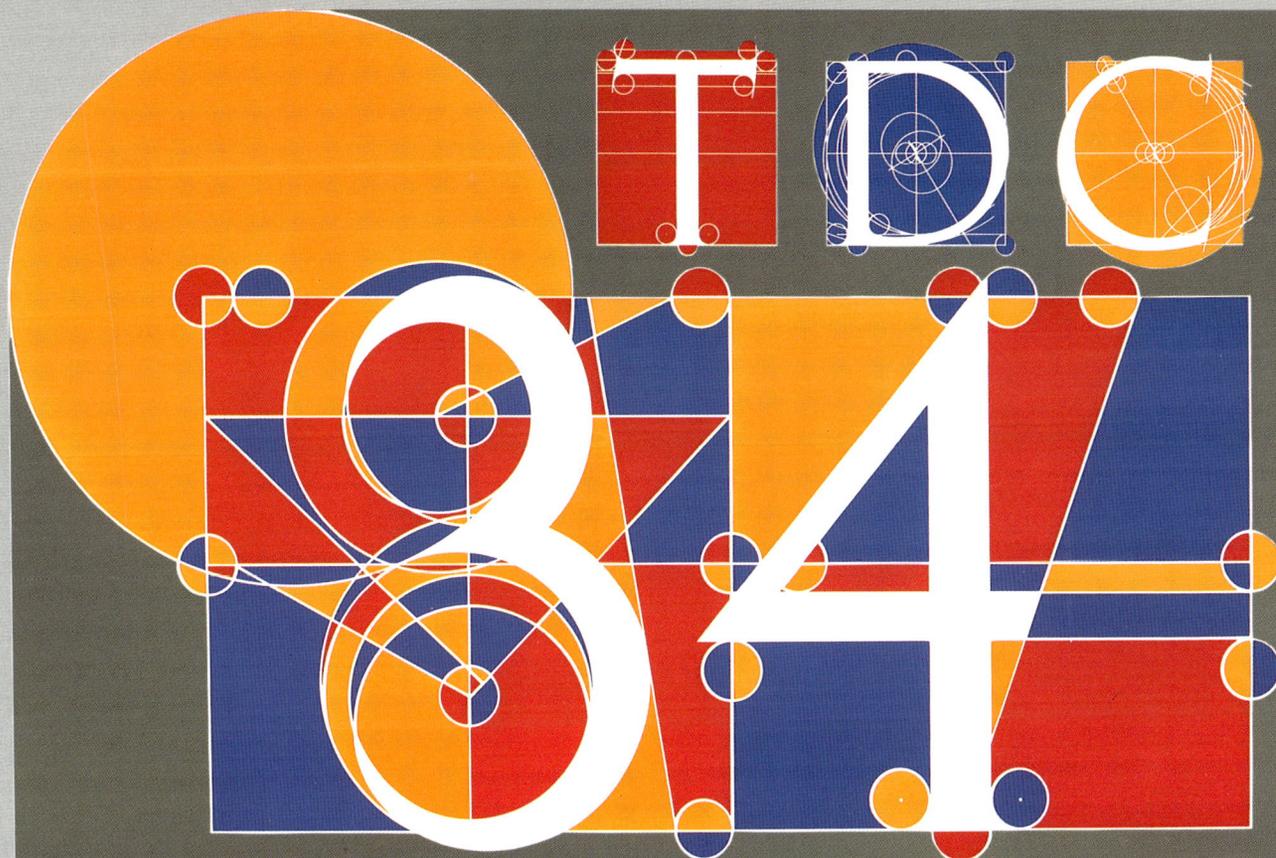

TDC 34

THE CONTEST

For the 34th year, the Type Directors Club (TDC) announces an open call for entries in an international competition to measure excellence in the use of typography, calligraphy, handlettering and other letterforms. The winners of this competition will be exhibited and published in *Typography 9,* the all-color annual of the competition. The Type Directors Club, founded in 1947, is a professional organization of typographic designers and users of typography.

Entries may be in the form of the actual piece or a photographic *print* in a minimum size of 8" x 10" (20 cm x 25 cm). Under *no circumstances* can transparencies, slides, or motion picture film be accepted. Videotapes (3/4 inch NTSC standard) will be accepted for judging, but winners will be asked to submit frames as photographic prints for the exhibition and annual book. All entries will be judged early in 1988 by a select group of graphic arts professionals chosen by the TDC Board of Directors.

All entries must have been *published or produced in 1987.* Graphic design that demonstrates the creative use of type, calligraphy and letterforms is eligible. Entries may be submitted by anyone directly or indirectly associated with the work. Pieces designed for or on behalf of the TDC may not be submitted.

CATEGORIES

Although classifications are flexible, work is generally judged in groups such as typography for advertising, magazines, books, book jackets, newspapers, packaging, corporate identity, brochures, catalogs, record albums, point of purchase, posters, annual reports, programs, menus, announcements, signage, film and television.

FEES

Each individual entry must be accompanied by a US$10 entry fee. Stationery, including letterhead, billhead, envelope and business card will be considered as one entry; however, logotypes are separate entries.

Campaign entries must be accompanied by a US$30 fee. The following will be accepted as campaigns: series of *more than two and up to six* typographically and conceptually related items such as posters, advertisements, booklets, packages, or pieces used in a corporate identity program (except stationery, see above).

Winners will be charged a US$75 hanging fee for each individual entry and US$125 for each campaign entry to be included in the annual exhibition. The hanging fee will be waived to ALL TDC MEMBERS.

Fees from all countries outside the U.S. must be in the form of international money orders or drafts drawn on New York banks, payable in U.S. dollars.

DEADLINE

All entries must be delivered to TDC in New York by January 15, 1988 (see *Shipping*).

ENTRY FORMS

Each entry form must contain a short descriptive identification of the piece and an indication whether it is a single or campaign entry (indicate number of pieces). An entry form is printed on this poster. If additional forms are needed make machine copies. An entry form must be attached to the back of each entry. *Fasten only at the top of the form.* The lower part will be removed prior to judging.

AWARDS

Entries selected by the jury will receive *Certificates of Typographic Excellence.* They will be exhibited and published in *Typography 9,* the annual for the 34th TDC Exhibition. The exhibition will be held in New York City in June and continue through August, 1988. Winners will be asked to supply five additional copies of winning entries for use in exhibitions outside New York. The shows will travel in North America, South America, Australia, New Zealand, Europe and Eastern Asia. Credits of individuals and firms having contributed to each entry will be included in the exhibition and in *Typography 9.*

SHIPPING

All entries, together with entry fees, should be sent to:

TDC-34/Type Directors Club
60 East 42nd Street, Suite 1130
New York, NY 10165-0015
USA

If more than one package is shipped, indicate this outside each package. Packages must be delivered prepaid. Non-U.S. contestants should mark each package "Material for contest entry. No commercial value." No provision will be made by TDC for U.S. Customs or airport pickup. Therefore, international entries should be sent by mail, *not by air freight.* Entries must be received by *January 15, 1988.* **No Entries Will Be Returned.**

JURY

Jurors for this year's competition include the following:
Charles Spencer Anderson/Duffy Design Group
David Brier/David Brier Design-Works
James Craig/Watson-Guptill Publications
Alan Fletcher/Pentagram Design Limited/London
Carin Goldberg/Carin Goldberg Design
Diana Graham/Diagram Design Marketing & Communications, Inc.
Nancy Rice/Rice & Rice Advertising, Inc.
Chairman, Ed Benguiat/Photo-Lettering, Inc.
Carol Wahler/Executive Administrator

Poster Design: Alan Peckolick/Lettering: John Jay/Typography: Cardinal Type Service, Inc./Printing: Trabon Printing, Kansas City

POSTER AND STICKER
TYPOGRAPHY/DESIGN *Robert Valentine, New York, New York* **TYPOGRAPHIC SUPPLIER** *Photo-Lettering, Inc.*
STUDIO *Bloomingdale's—Design* **CLIENT** *Bloomingdale's* **PRINCIPAL TYPES** *Berkeley Old Style and Caslon*
DIMENSIONS *Poster: 21 × 27 in. (53.3 × 68.6 cm), Sticker: 2⅛ × 3 in. (5.4 × 7.6 cm)*

POSTER
TYPOGRAPHY/DESIGN *Deb Miner, Minneapolis, Minnesota* **TYPOGRAPHIC SUPPLIER** *Letterworx* **AGENCY** *McCool & Company*
CLIENT *Donaldson's Department Store* **PRINCIPAL TYPE** *Carpenter* **DIMENSIONS** *29 × 38½ in. (73.7 × 97.8 cm)*

1889-1989
THE CENTENNIAL
CAMPAIGN FOR
AGNES SCOTT
COLLEGE

BOOKLET
TYPOGRAPHY/DESIGN *Domenica Genovese and Elizabeth G. Clark, Baltimore, Maryland*
TYPOGRAPHIC SUPPLIER *Charles Street Graphics* **AGENCY** *The North Charles Street Design Organization*
CLIENT *Agnes Scott College* **PRINCIPAL TYPE** *Goudy Old Style* **DIMENSIONS** *7 × 11 in. (17.8 × 27.9 cm)*

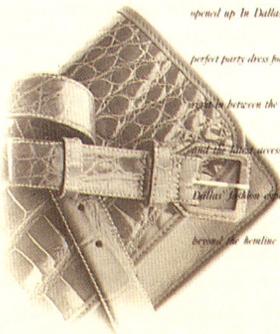

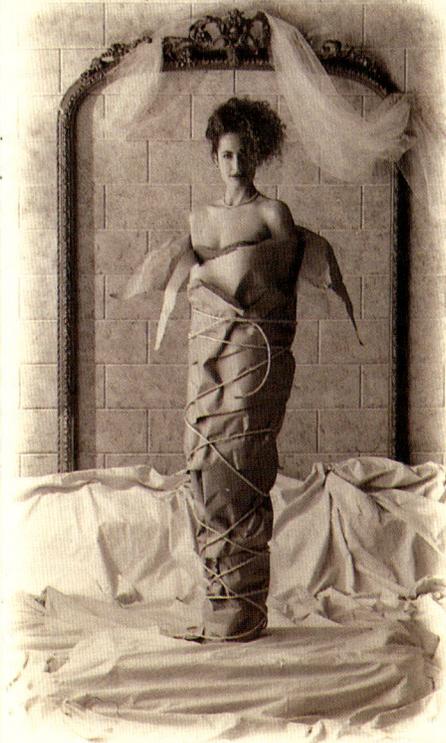

BROCHURE
TYPOGRAPHY/DESIGN *Clay Freeman, Dallas, Texas* **TYPOGRAPHIC SUPPLIER** *Dallas Times Herald (in-house)*
STUDIO *Dallas Times Herald Promotion Art* **CLIENT** *Dallas Times Herald* **PRINCIPAL TYPES** *Bodoni Open and Caslon No. 540 Italic*
DIMENSIONS *6½ × 10½ in. (16.6 × 26.7 cm)*

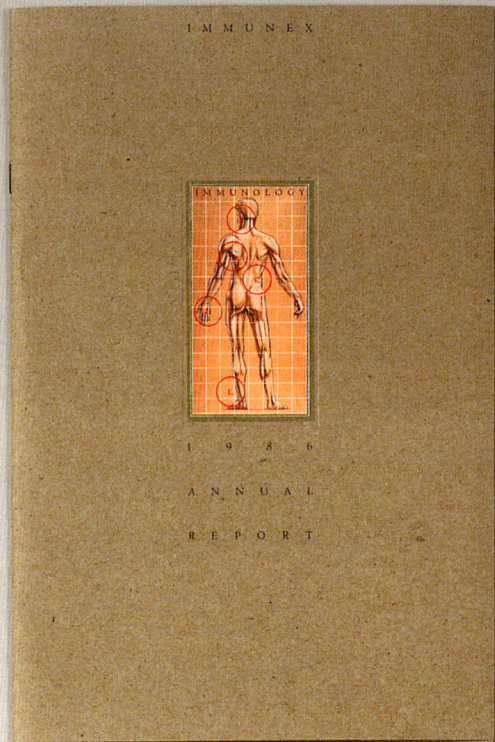

ANNUAL REPORT
TYPOGRAPHY/DESIGN *Belle How, San Francisco, California* **ART DIRECTOR** *Kit Hinrichs, San Francisco, California*
TYPOGRAPHIC SUPPLIER *Reardon & Krebs* **STUDIO** *Pentagram Design* **CLIENT** *Immunex Corporation* **PRINCIPAL TYPE** *Centaur*
DIMENSIONS *Various*

POSTER
TYPOGRAPHY/DESIGN *Vásken Kalayjian, New York, New York* **LETTERER** *Garabet Kasparian*
TYPOGRAPHIC SUPPLIER *JCH Graphics Ltd.* **STUDIO** *Glazer and Kalayjian, Inc.* **CLIENT** *The Armenian Apostolic Church*
PRINCIPAL TYPE *Poster Bodoni Condensed* **DIMENSIONS** *18 × 24 in. (45.7 × 61 cm)*

JOSEPH

Schwantner

A SUDDEN RAINBOW

SPARROWS

LUCY SHELTON · SOPRANO

DISTANT RUNES AND INCANTATIONS

URSULA OPPENS · PIANO

SAINT LOUIS SYMPHONY ORCHESTRA

LEONARD SLATKIN

CONDUCTOR

RECORD ALBUM COVER
TYPOGRAPHY/DESIGN *Carin Goldberg, New York, New York* **TYPOGRAPHIC SUPPLIER** *The Type Shop*
STUDIO *Carin Goldberg Graphic Design* **CLIENT** *Nonesuch Records* **PRINCIPAL TYPES** *Eagle Bold and Bank Script*
DIMENSIONS *12³⁄₈ × 12³⁄₈ in. (31.5 × 31.5 cm)*

RECORD ALBUM COVER
TYPOGRAPHY/DESIGN *Carin Goldberg, New York, New York* **TYPOGRAPHIC SUPPLIER** *The Type Shop*
STUDIO *Carin Goldberg Graphic Design* **CLIENT** *Nonesuch Records* **PRINCIPAL TYPES** *Radiant Bold Condensed and Bank Script*
DIMENSIONS *12³⁄₈ × 12³⁄₈ in. (31.5 × 31.5 cm)*

POSTER
TYPOGRAPHY/DESIGN *Kenn Waplington and Ed Cleary, Toronto, Canada* **TYPOGRAPHIC SUPPLIERS** *The Composing Room and Headliners of Canada* **AGENCY** *Waplington, Forty, McGall, Inc.* **STUDIO** *The Composing Room* **CLIENTS** *Cooper & Beatty and Society of Graphic Designers of Canada* **PRINCIPAL TYPES** *Various* **DIMENSIONS** *27¼ × 9½ in. (69.2 × 24.1 cm)*

POSTER
TYPOGRAPHY/DESIGN *Harald Schlüter, Essen, West Germany* **AGENCY** *Harald Schlüter Werbeagentur GmbH*
CLIENT *Theater & Philharmonie GmbH* **PRINCIPAL TYPE** *British Inserat* **DIMENSIONS** *23⅝ × 33¹/₁₆ in. (60 × 84 cm)*

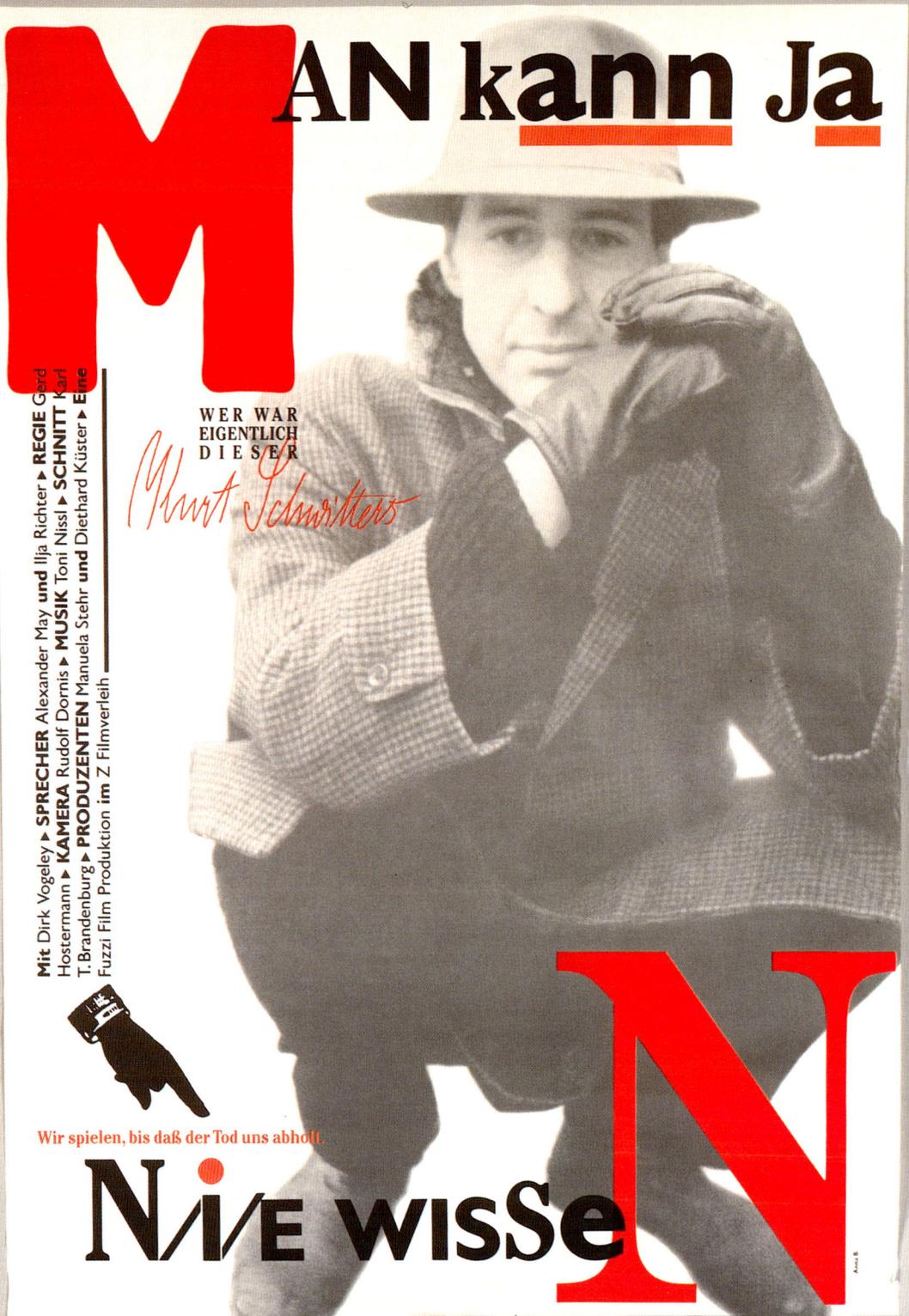

POSTER
TYPOGRAPHY/DESIGN *Anna Berkenbusch, Berlin, West Germany* **TYPOGRAPHIC SUPPLIER** *Nagel Fototype* **AGENCY** *DENK NEU!*
CLIENT *Fuzzi Film Produktion* **PRINCIPAL TYPES** *Gill Sans Regular and Bold, Century Bold, Block Condensed, Futura Bold, and Cheltenham Bold Condensed* **DIMENSIONS** *23³⁄₈ × 33¹¹⁄₁₆ in. (59.4 × 84 cm)*

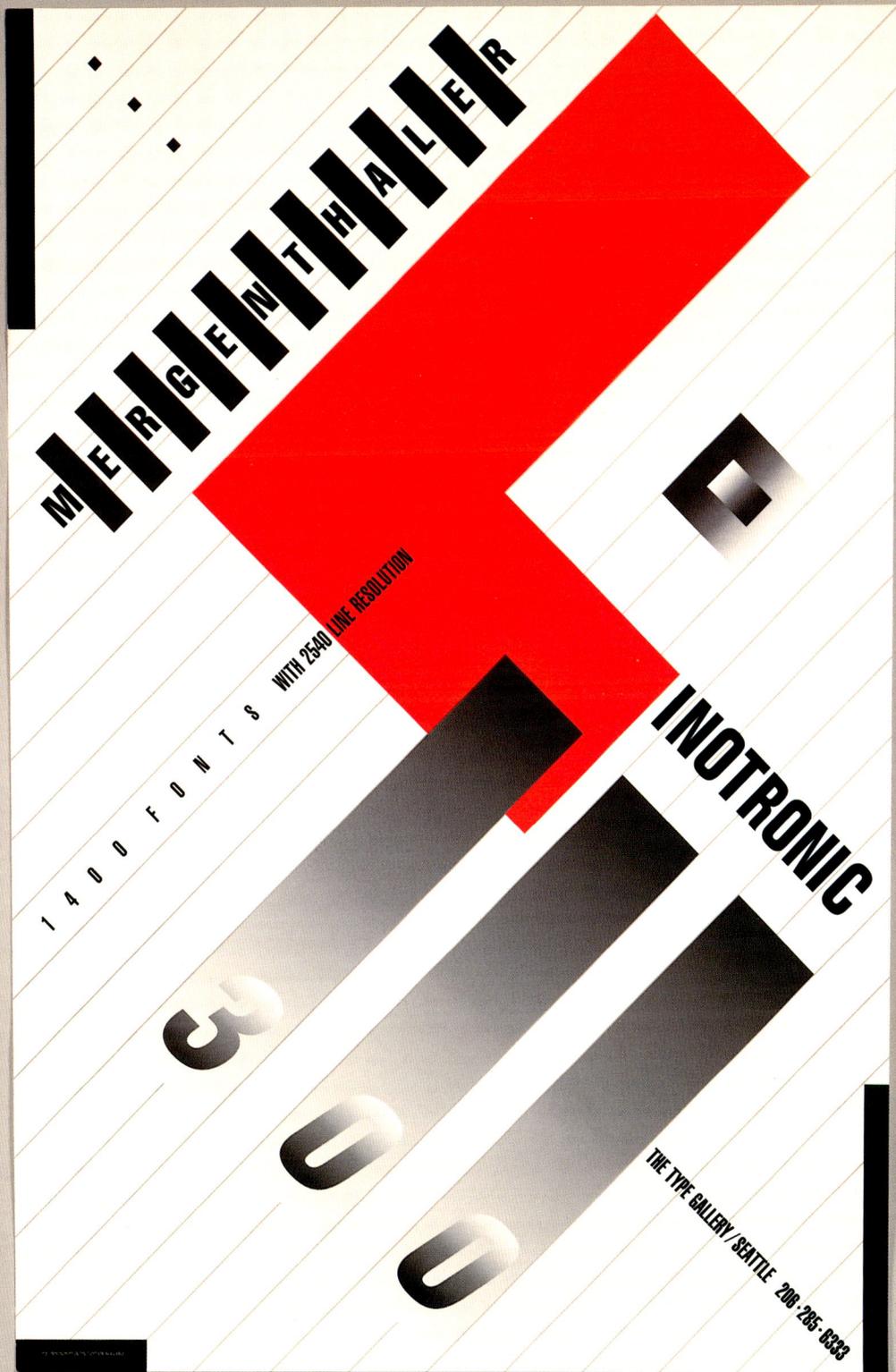

POSTER
TYPOGRAPHY/DESIGN *Rick Eiber, Seattle, Washington* **TYPOGRAPHIC SUPPLIER** *The Type Gallery/Seattle*
STUDIO *Rick Eiber Design (RED)* **CLIENT** *The Type Gallery/Seattle* **PRINCIPAL TYPE** *Helvetica*
DIMENSIONS *24 × 36 in. (61 × 91.4 cm)*

POSTER
TYPOGRAPHY/DESIGN *Anna Berkenbusch, Berlin, West Germany* **TYPOGRAPHIC SUPPLIER** *Nagel Fototype* **AGENCY** *DENK NEU!*
CLIENT *Fuzzi Film Produktion* **PRINCIPAL TYPES** *Various* **DIMENSIONS** *16½ × 23⅜ in. (42 × 59.4 cm)*

DAS **UR** **!** TEIL IST EIN TEIL DER

U

H

R

JEDOCH EIN KLEINES TEIL chen n **UR.**

POSTER
TYPOGRAPHY/DESIGN *Anna Berkenbusch, Berlin, West Germany* **TYPOGRAPHIC SUPPLIER** *Nagel Fototype* **AGENCY** *DENK NEU!*
CLIENT *Fuzzi Film Produktion* **PRINCIPAL TYPES** *Various* **DIMENSIONS** *16½ × 23⅜ in. (42 × 59.4 cm)*

POSTER
TYPOGRAPHY/DESIGN *Mieko Oda, New York, New York* **ART DIRECTOR** *Richard Poulin, New York, New York*
TYPOGRAPHIC SUPPLIER *UltraTypographic Services, Inc.* **STUDIO** *de Harak & Poulin Associates, Inc.* **CLIENT** *Cooper Union*
PRINCIPAL TYPE *Helvetica Extra Compressed* **DIMENSIONS** *21³/₈ × 37³/₈ in. (54.3 × 95 cm)*

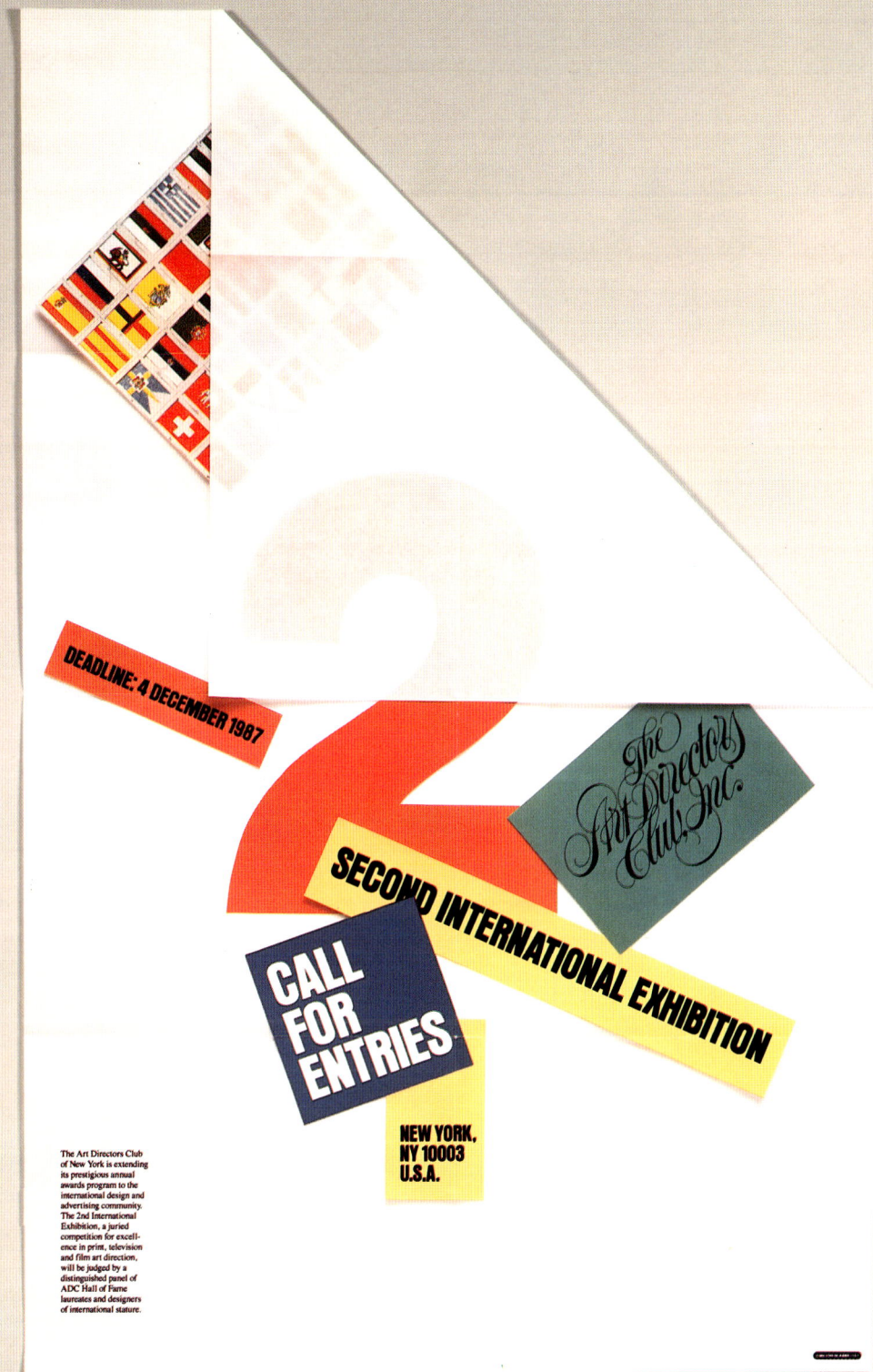

POSTER
TYPOGRAPHY/DESIGN *Milton Glaser, New York, New York* **TYPOGRAPHIC SUPPLIER** *Phoenix Typographers, Inc.*
STUDIO *Milton Glaser, Inc.* **CLIENT** *Art Directors Club of New York* **PRINCIPAL TYPE** *Anzeigen Grotesque*
DIMENSIONS *24 × 36 in. (61 × 91.4 cm)*

Woodward's Annual Report for the fiscal year ended January 31, 1987.

Woodward's is well on its way to becoming *the* store to check first for the latest fashions in family apparel and home products. We are carving out a unique market niche by offering our customers the innovations and product depth of a specialty

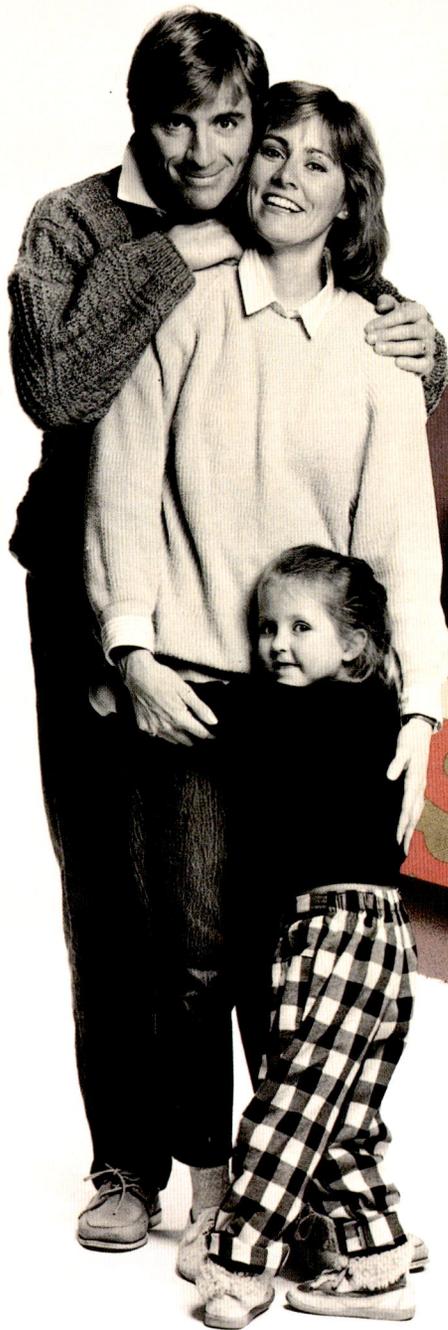

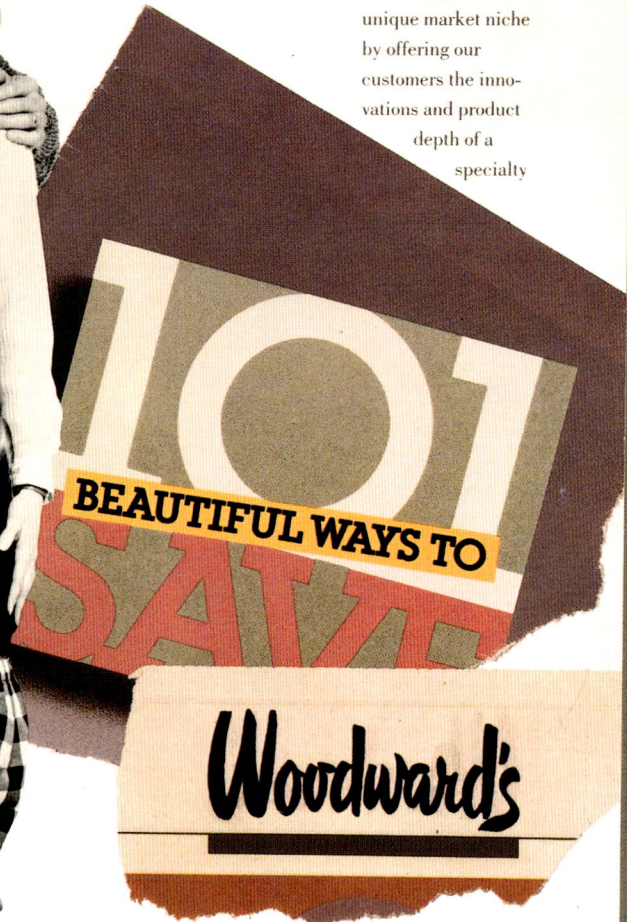

ANNUAL REPORT
TYPOGRAPHY/DESIGN *John Van Dyke, Seattle, Washington* **TYPOGRAPHIC SUPPLIER** *Pola Graphics* **AGENCY** *Van Dyke Company*
CLIENT *Woodward's, Ltd.* **PRINCIPAL TYPE** *Bodoni Book* **DIMENSIONS** *9 × 12 in. (22.9 × 30.5 cm)*

BROCHURE
TYPOGRAPHY/DESIGN *Kit Hinrichs and Neil Shakery, San Francisco, California* **TYPOGRAPHIC SUPPLIER** *Reardon & Krebs*
STUDIO *Pentagram Design* **CLIENT** *Art Center College of Design* **PRINCIPAL TYPE** *Bodoni Book*
DIMENSIONS *9¹¹/₁₆ × 14 in. (23 × 35.5 cm)*

TABLOID
TYPOGRAPHY/DESIGN *Lenore Bartz, San Francisco, California* **ART DIRECTOR** *Kit Hinrichs, San Francisco, California*
TYPOGRAPHIC SUPPLIER *Reardon & Krebs* **STUDIO** *Pentagram Design* **CLIENT** *Art Center College of Design*
PRINCIPAL TYPE *Bodoni Book* **DIMENSIONS** *11 × 17 in. (27.9 × 43.2 cm)*

TABLOID
TYPOGRAPHY/DESIGN *Lenore Bartz, San Francisco, California* **ART DIRECTOR** *Kit Hinrichs, San Francisco, California*
TYPOGRAPHIC SUPPLIER *Reardon & Krebs* **STUDIO** *Pentagram Design* **CLIENT** *Art Center College of Design*
PRINCIPAL TYPE *Bodoni Book* **DIMENSIONS** *11 × 17 in. (27.9 × 43.2 cm)*

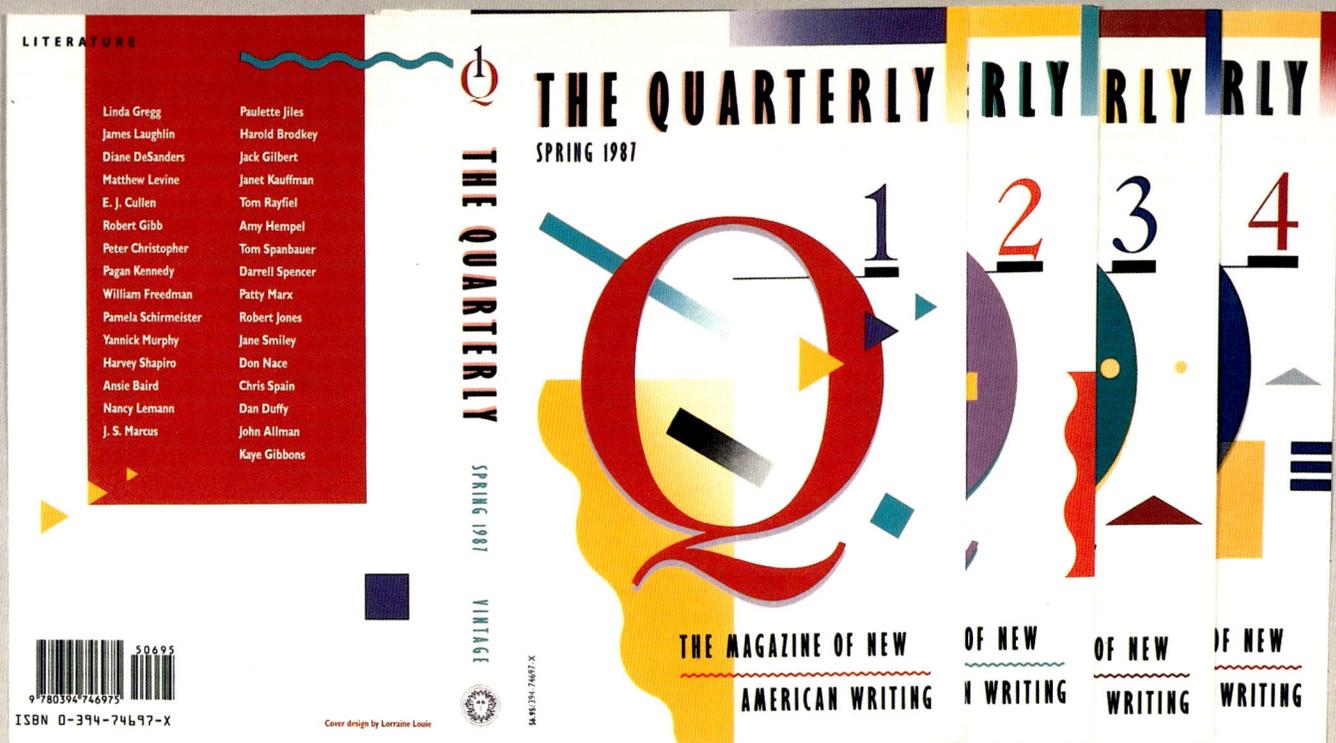

LITERATURE

Linda Gregg	Paulette Jiles
James Laughlin	Harold Brodkey
Diane DeSanders	Jack Gilbert
Matthew Levine	Janet Kauffman
E. J. Cullen	Tom Rayfiel
Robert Gibb	Amy Hempel
Peter Christopher	Tom Spanbauer
Pagan Kennedy	Darrell Spencer
William Freedman	Patty Marx
Pamela Schirmeister	Robert Jones
Yannick Murphy	Jane Smiley
Harvey Shapiro	Don Nace
Ansie Baird	Chris Spain
Nancy Lemann	Dan Duffy
J. S. Marcus	John Allman
	Kaye Gibbons

50695

9 780394 746975

ISBN 0-394-74697-X

Cover design by Lorraine Louie

$6.95/394-74697-X

THE QUARTERLY

SPRING 1987

VINTAGE

Q

THE QUARTERLY

SPRING 1987

1

THE MAGAZINE OF NEW

AMERICAN WRITING

2

OF NEW

WRITING

3

OF NEW

WRITING

4

OF NEW

WRITING

BOOK COVER
TYPOGRAPHY/DESIGN *Lorraine Louie, New York, New York* **TYPOGRAPHIC SUPPLIER** *The Type Shop, Inc.*
STUDIO *Lorraine Louie Design* **CLIENT** *Vintage Books* **PRINCIPAL TYPES** *Gill Sans Extra Bold Condensed and Caslon No. 540*
DIMENSIONS $5^{3}/_{16} \times 8$ *in. (13.2 × 20.3 cm)*

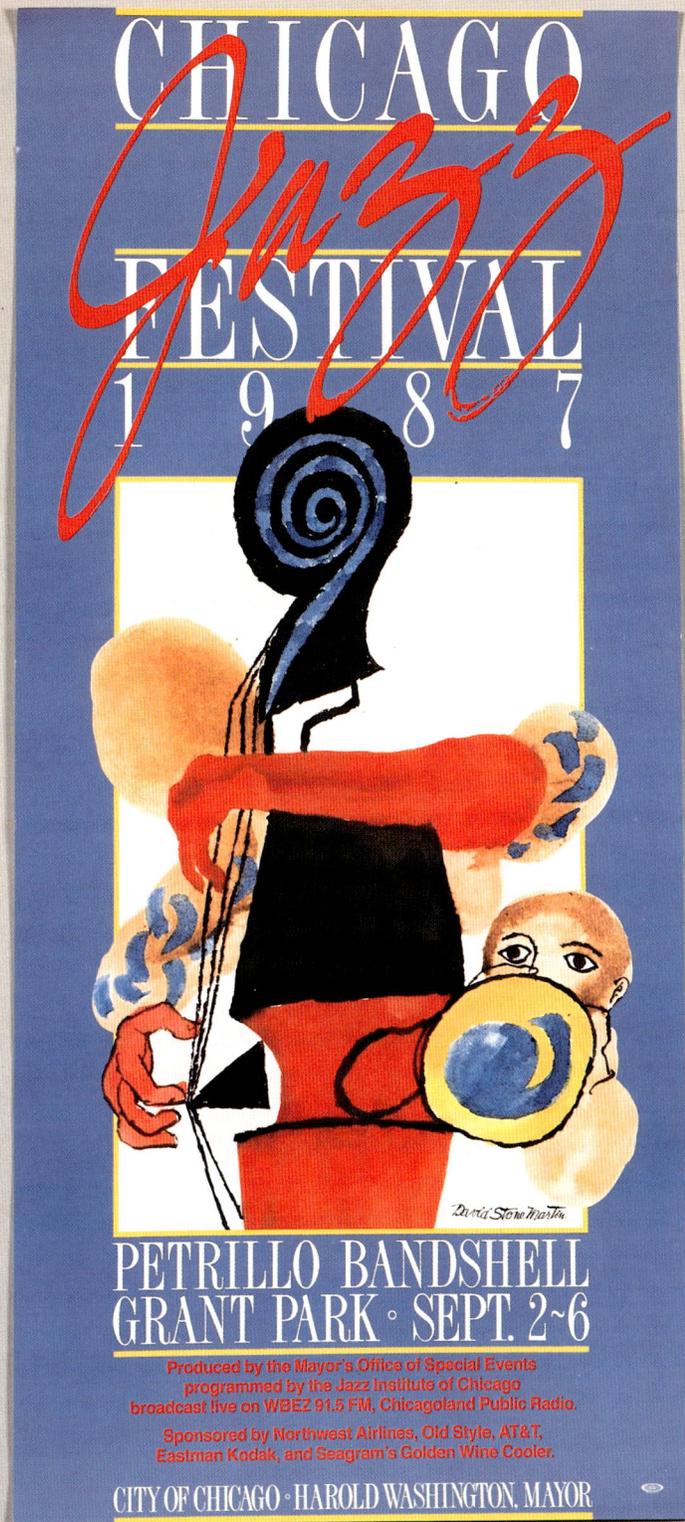

POSTER
TYPOGRAPHY/DESIGN *Robert D'Amato, Chicago, Illinois* **CALLIGRAPHER** *Marilyn Maas, Chicago, Illinois* **TYPOGRAPHIC**
SUPPLIER *Design Typographers, Inc.* **AGENCY** *Panebianco, Inc.* **CLIENT** *City of Chicago, Mayor's Office of Special Events*
PRINCIPAL TYPE *Fashion Compressed* **DIMENSIONS** *37⅛ × 17 in. (95 × 43.2 cm)*

POSTER
TYPOGRAPHY/DESIGN *Craig Frazier, San Francisco, California* **LETTERER** *Craig Frazier*
TYPOGRAPHIC SUPPLIER *Display Lettering & Copy* **STUDIO** *Frazier Design* **CLIENT** *American Institute of Graphic Arts (AIGA),*
San Francisco **PRINCIPAL TYPES** *Bodoni (modified) and Futura* **DIMENSIONS** *23 × 34 in. (58.4 × 86.4 cm)*

POSTER
TYPOGRAPHY/DESIGN *Mark Steele, Dallas, Texas* **TYPOGRAPHIC SUPPLIER** *Dallas Times Herald (in-house)*
STUDIO *Dallas Times Herald Promotion Art* **CLIENT** *Dallas Symphony Orchestra* **PRINCIPAL TYPE** *Helvetica*
DIMENSIONS *24 × 36 in. (61 × 91 cm)*

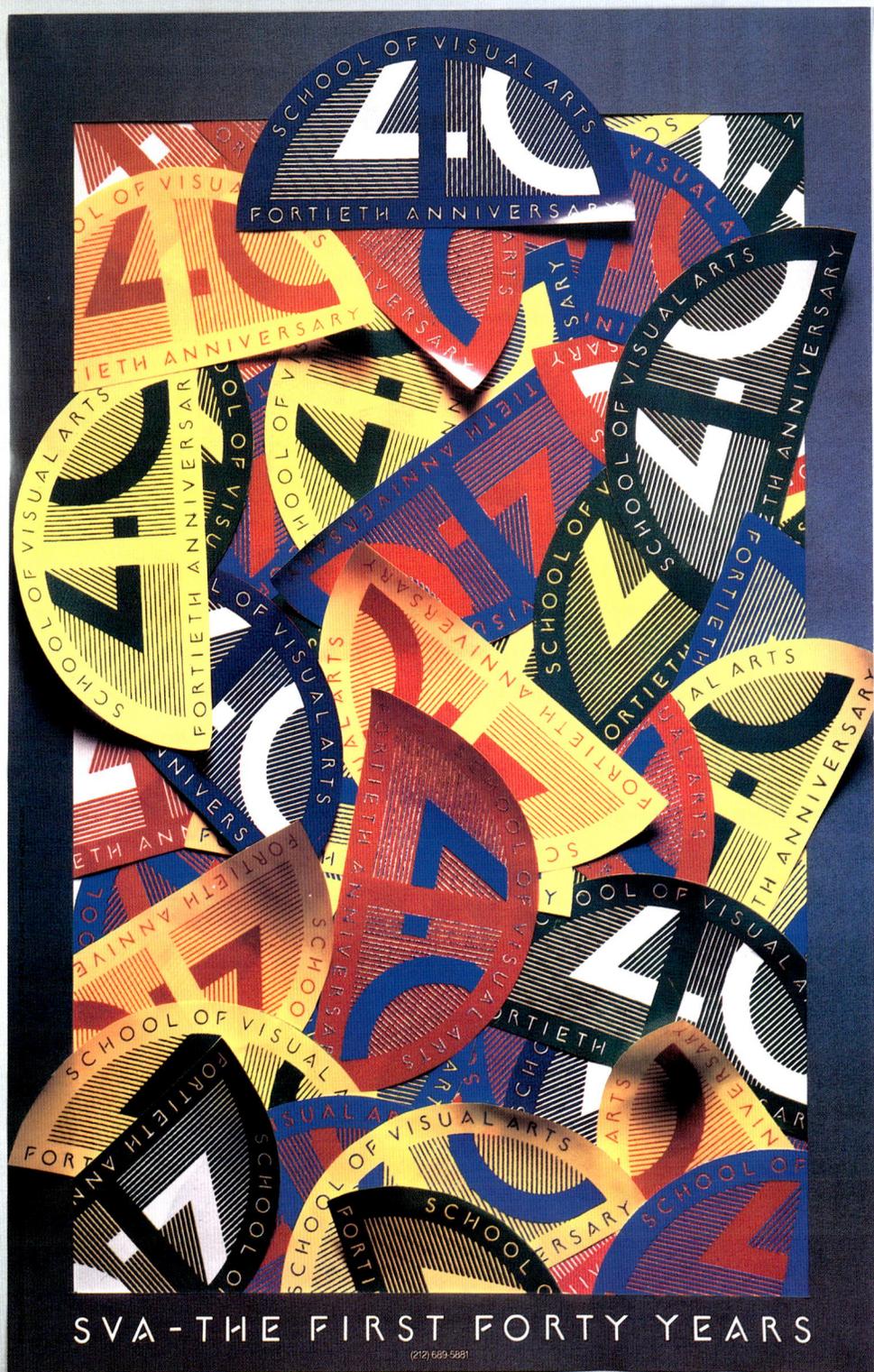

POSTER
TYPOGRAPHY/DESIGN *Milton Glaser, New York, New York* **LETTERER** *George Leavitt, New York, New York*
STUDIO *Milton Glaser, Inc.* **CLIENT** *The School of Visual Arts* **PRINCIPAL TYPES** *Einstein Bold and Handlettering*
DIMENSIONS *30 × 44¾ in. (76.2 × 113.7 cm)*

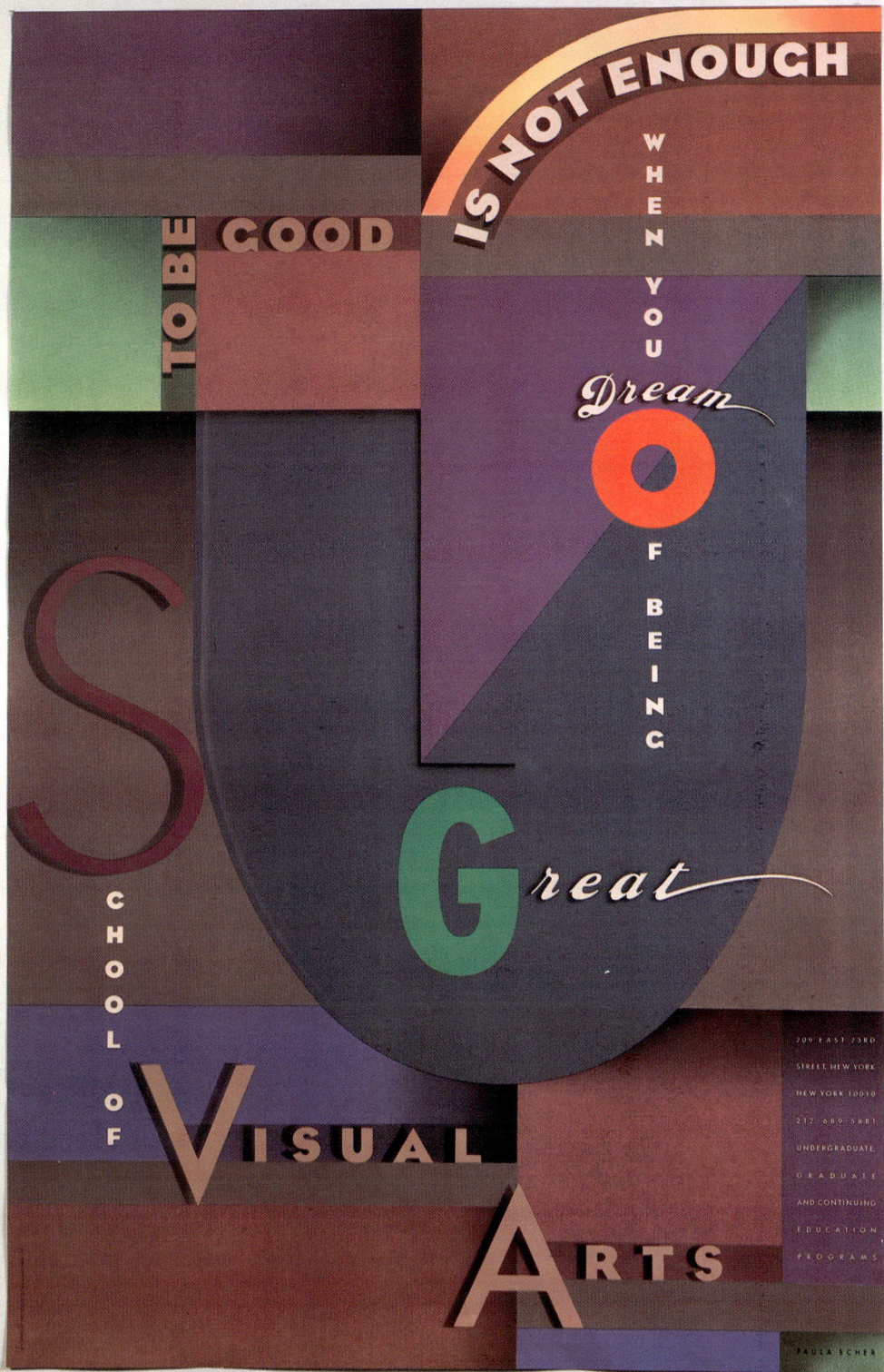

POSTER
TYPOGRAPHY/DESIGN *Paula Scher, New York, New York* **LETTERER** *Paula Scher* **TYPOGRAPHIC SUPPLIER** *The Type Shop*
STUDIO *Koppel & Scher* **CLIENT** *The School of Visual Arts* **PRINCIPAL TYPES** *Eagle Bold and Handlettering*
DIMENSIONS *30 × 40 in. (76.2 × 101.6 cm)*

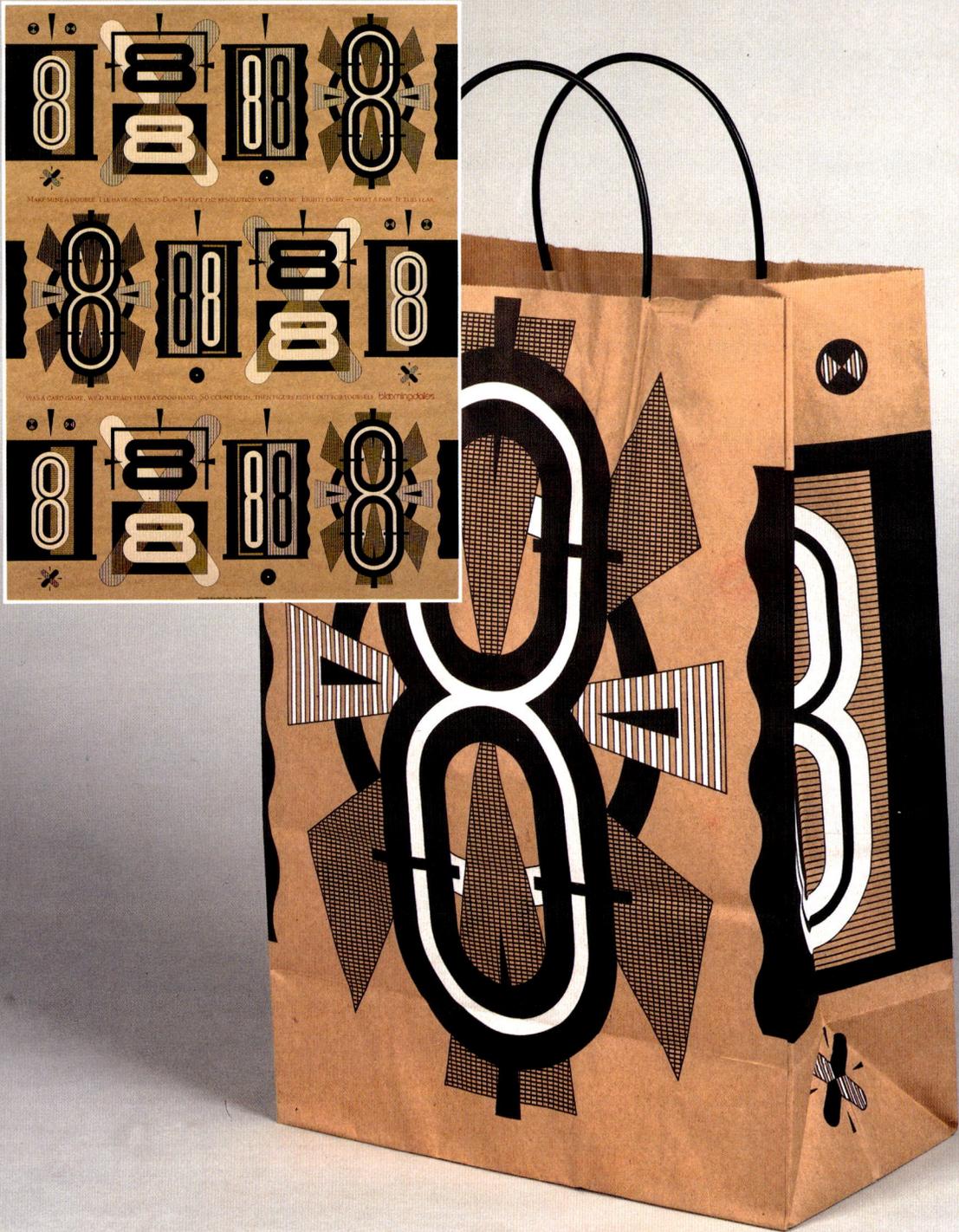

POSTER AND SHOPPING BAG
TYPOGRAPHY/DESIGN *Robert Valentine, New York, New York, and Neville Brody, London, England* **LETTERER** *Neville Brody*
TYPOGRAPHIC SUPPLIER *Franklin Typographers, Inc.* **STUDIO** *Bloomingdale's—Design* **CLIENT** *Bloomingdale's*
PRINCIPAL TYPE *Berkeley Old Style* **DIMENSIONS** *21 × 27 in. (53.3 × 68.6 cm)*

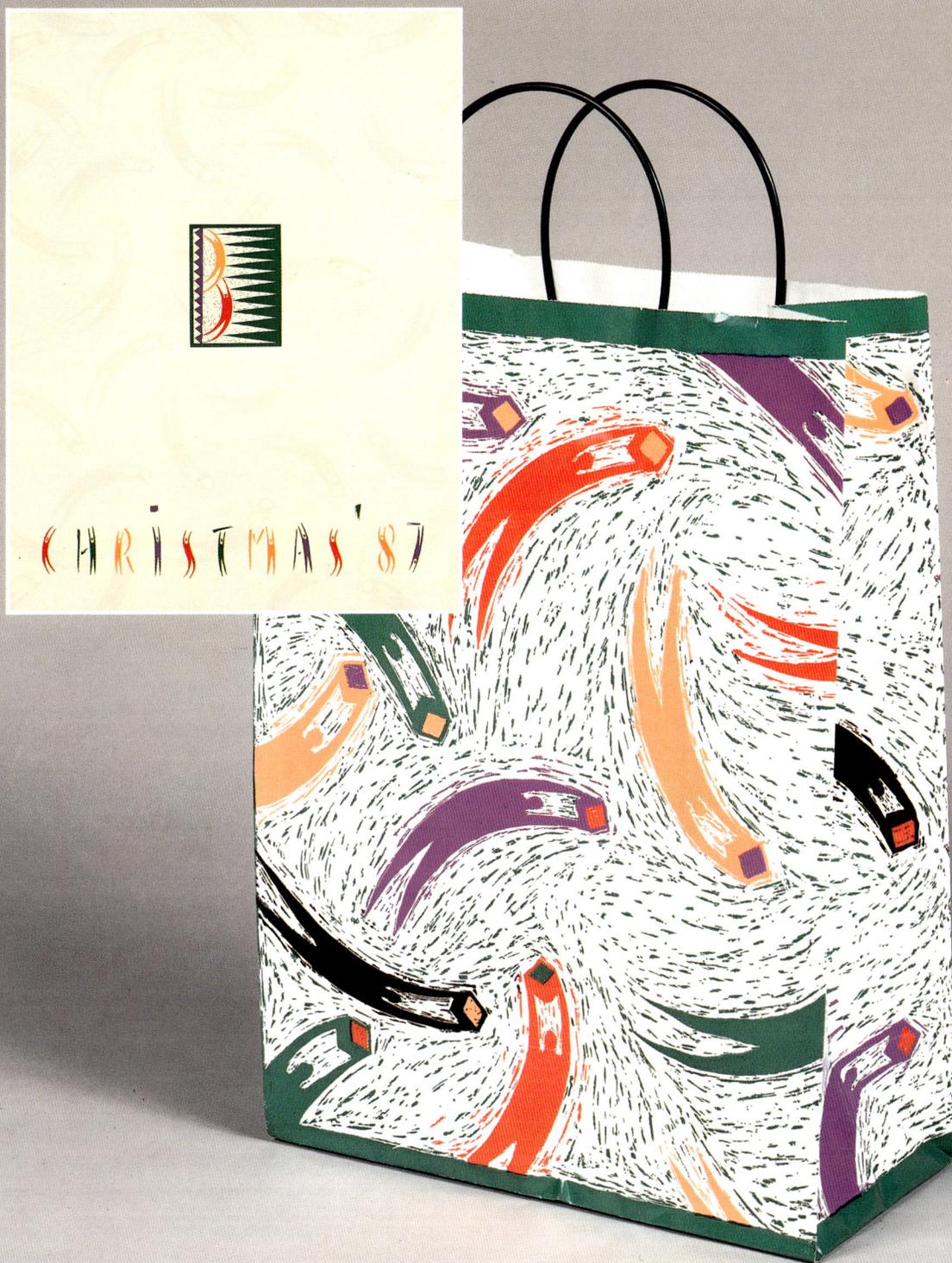

POSTER AND SHOPPING BAG
TYPOGRAPHY/DESIGN *Robert Valentine and José Ortega, New York, New York* **CALLIGRAPHER** *José Ortega*
STUDIO *Bloomingdale's—Design* **CLIENT** *Bloomingdale's* **DIMENSIONS** *21 × 27 in. (53.3 × 68.6 cm)*

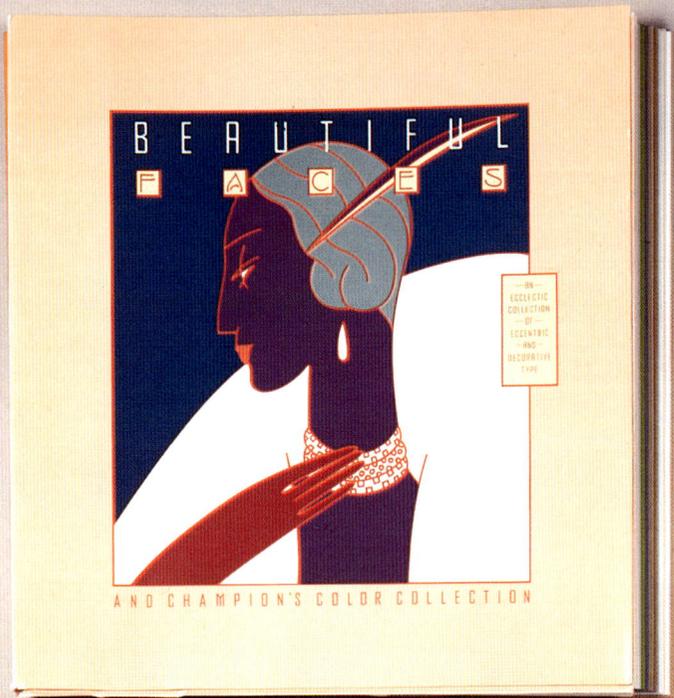

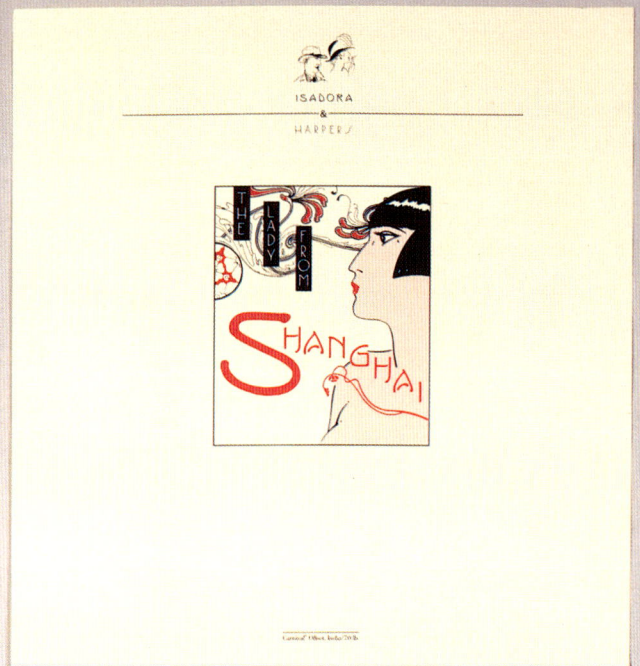

PROMOTION
TYPOGRAPHY/DESIGN *Paula Scher, New York, New York* **TYPOGRAPHIC SUPPLIER** *Personal collection of Paula Scher*
STUDIO *Koppel & Scher* **CLIENT** *Champion Papers* **PRINCIPAL TYPES** *Various* **DIMENSIONS** *11½ × 11½ in. (29.2 × 29.2 cm)*

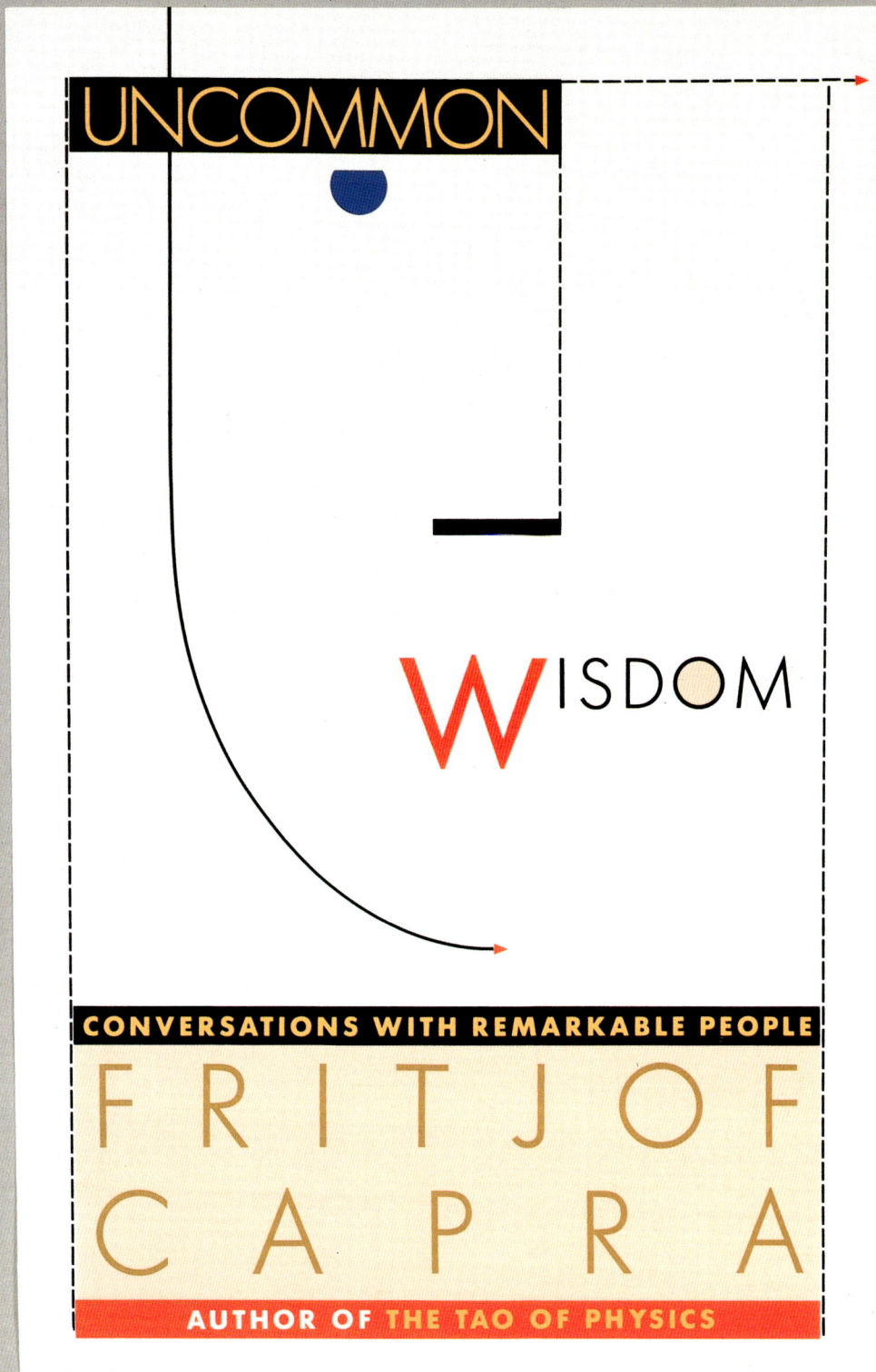

UNCOMMON

WISDOM

CONVERSATIONS WITH REMARKABLE PEOPLE

FRITJOF CAPRA

AUTHOR OF THE TAO OF PHYSICS

BOOK COVER
TYPOGRAPHY/DESIGN *Paula Scher, New York, New York* **TYPOGRAPHIC SUPPLIER** *The Type Shop* **STUDIO** *Koppel & Scher*
CLIENT *Simon and Schuster* **PRINCIPAL TYPE** *Futura Light* **DIMENSIONS** *6 × 9 in. (15.2 × 22.9 cm)*

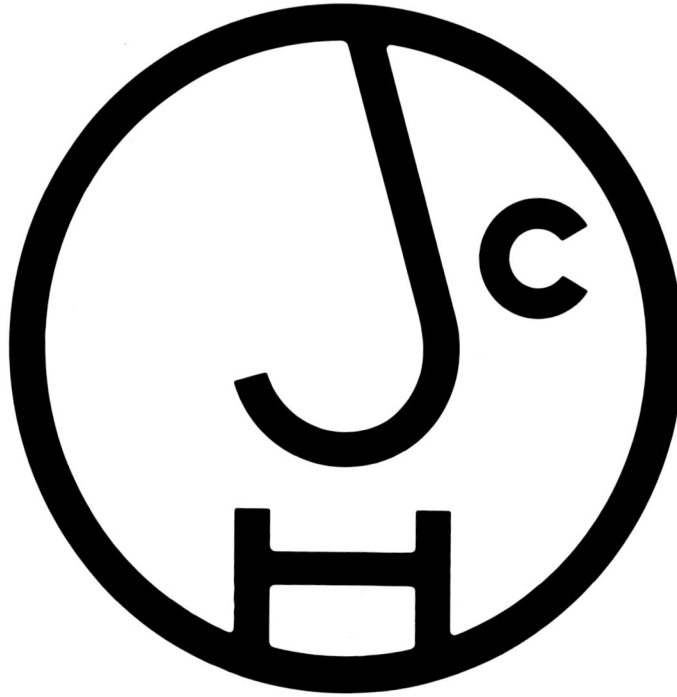

LOGOTYPE
TYPOGRAPHY/DESIGN *Michael McGinn and Takaaki Matsumoto, New York, New York* **LETTERER** *Steven Bennett, New York, New York*
TYPOGRAPHIC SUPPLIER *JCH TeleGraphics, Ltd.* **STUDIO** *M Plus M, Inc.* **CLIENT** *JCH TeleGraphics, Ltd.*

JCH Graphics, noted for its high quality standards and craftsmanship in the typographic field for almost a decade, is proud to announce a bold new initiative in the graphics industry...the introduction of JCH TeleGraphics.

As a division of the parent company, JCH TeleGraphics has been created to meet the needs and challenges of your publishing and graphic future. It combines the resources of our traditional typesetting services with the remarkable power of the Apple Macintosh™ and the entire Post-Script™ environment.

You need only look as far as your desktop and JCH TeleGraphics to appreciate the graphic capabilities your Macintosh™ can provide to you. Just send us your Mac disk, or telecommunicate to us via modem, and have laser type from our Linotronic 300 returned to you at an affordable cost.

Our research and development department has been keeping up with and developing areas directly related to this important trend in the industry. We also offer enthusiastic customer and technical support in order to bring you the finest product and service.

JCH TeleGraphics invites you to join us now. The trip into the future of publishing will be shorter with JCH TeleGraphics.

JCH TeleGraphics
31 East 28th Street
New York, NY 10016

Telephone
212-889-2500
Facsimile
212-686-1206
Telecommunications
212-679-5739

This announcement was set in PostScript™ on a Macintosh™ SE and Linotronic 300 using 9/9 ITC Franklin Gothic Demibold.

ANNOUNCEMENT
TYPOGRAPHY/DESIGN *Michael McGinn and Takaaki Matsumoto, New York, New York* **LETTERER** *Steven Bennett, New York, New York*
TYPOGRAPHIC SUPPLIER *JCH TeleGraphics, Ltd.* **STUDIO** *M Plus M, Inc.* **CLIENT** *JCH TeleGraphics, Ltd.*
PRINCIPAL TYPE *Franklin Gothic Demibold* **DIMENSIONS** *11 × 11 in. (27.9 × 27.9 cm)*

ANNUAL REPORT
TYPOGRAPHY/DESIGN *Pat and Greg Samata, Dundee, Illinois* **TYPOGRAPHIC SUPPLIER** *Typographic Resource*
STUDIO *Samata Associates* **CLIENT** *Leaf, Inc.* **PRINCIPAL TYPE** *Bodoni Book Italic* **DIMENSIONS** *8 × 11½ in. (20.3 × 29.2 cm)*

42

F A

C

E

CALENDAR 1988

FACE RONCHETTI LIMITED 6 HANWAY PLACE LONDON W1P 9DF TELEPHONE 01-636 2746
DESIGNED BY PENTAGRAM

CALENDAR
TYPOGRAPHY/DESIGN *John McConnell and Martin Tilley, London, England* **TYPOGRAPHIC SUPPLIER** *FACE Photosetting Limited*
STUDIO *Pentagram Design* **CLIENT** *FACE Photosetting Limited* **PRINCIPAL TYPE** *Franklin Gothic*
DIMENSIONS *23½ × 16½ in. (59.7 × 42 cm)*

ANNUAL REPORT
TYPOGRAPHY/DESIGN *John Van Dyke, Seattle, Washington* **TYPOGRAPHIC SUPPLIER** *Typehouse*
AGENCY *Van Dyke Company* **CLIENT** *Weyerhaeuser Paper Company* **PRINCIPAL TYPES** *Sabon and American Typewriter*
DIMENSIONS *8½ × 11½ in. (21.6 × 29.2 cm)*

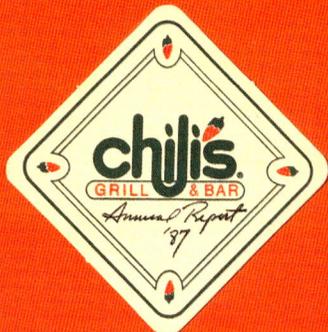

ANNUAL REPORT
TYPOGRAPHY/DESIGN *Brian Boyd, Dallas, Texas* **CALLIGRAPHER** *Brian Boyd* **TYPOGRAPHIC SUPPLIER** *Southwestern Typographics, Inc.* **AGENCY** *The Richards Group* **STUDIO** *Richards Brock Miller Mitchell & Associates* **CLIENT** *Chili's, Inc.*
PRINCIPAL TYPES *Baskerville and Handlettering* **DIMENSIONS** *8½ × 11 in. (21.6 × 27.9 cm)*

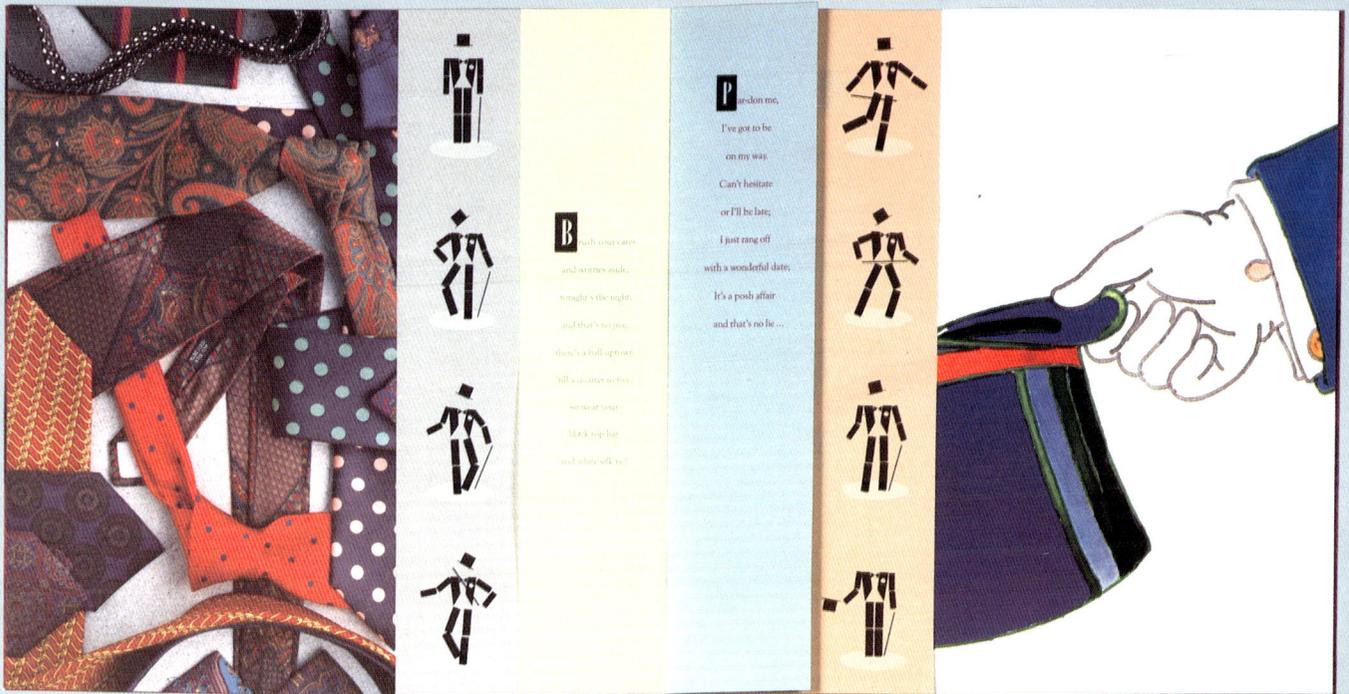

A Passion for Silk

BROCHURE
TYPOGRAPHY/DESIGN *James Sebastian, Margaret Wollenhaupt, Michael McGinn, and Gretchen Grace, New York, New York*
PHOTOGRAPHER *Peter Bosch, New York, New York* **ILLUSTRATORS** *Seymour Chwast, David Monteil, Paul Yalowitz, and Michael McGinn* **TYPOGRAPHIC SUPPLIER** *Typogram* **STUDIO** *Designframe, Inc.* **CLIENT** *Hopper Papers/Georgia Pacific*
PRINCIPAL TYPE *Goudy Old Style* **DIMENSIONS** *11 × 11 in. (27.9 × 27.9 cm)*

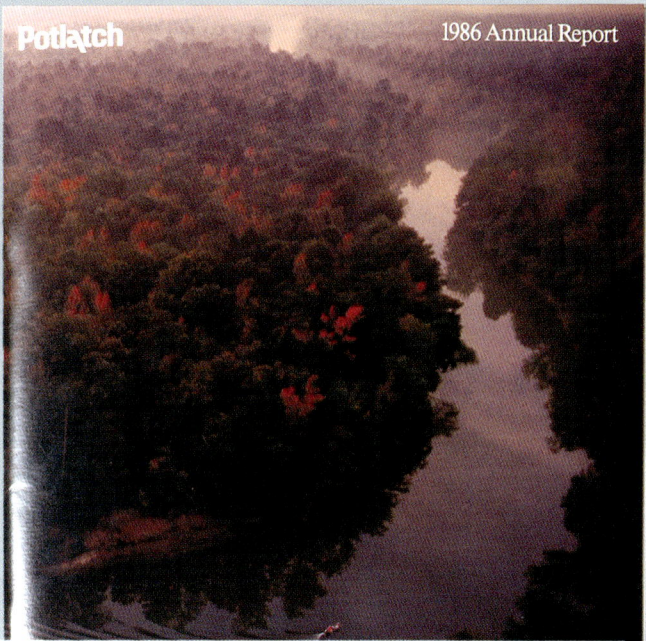

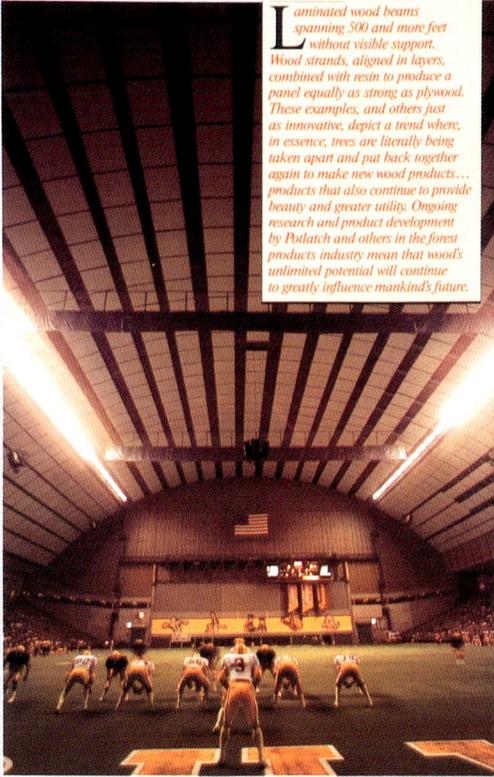

ANNUAL REPORT
TYPOGRAPHY/DESIGN *Lenore Bartz, San Francisco, California* **ART DIRECTOR** *Kit Hinrichs, San Francisco, California*
TYPOGRAPHIC SUPPLIER *Reardon & Krebs* **STUDIO** *Pentagram Design* **CLIENT** *Potlatch Corporation*
PRINCIPAL TYPE *Times Roman* **DIMENSIONS** *8½ × 11 in. (21.6 × 27.9 cm)*

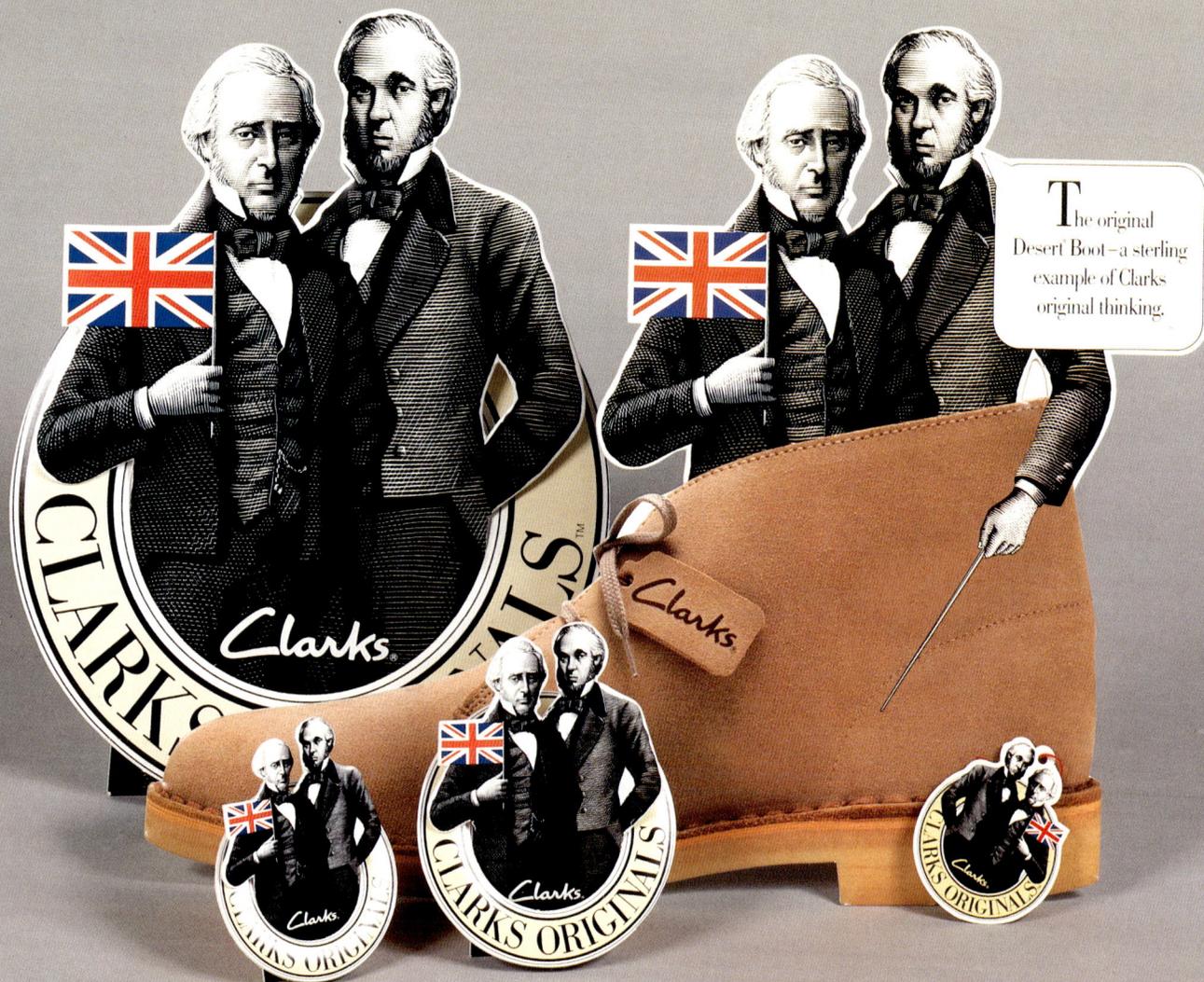

POINT OF PURCHASE
TYPOGRAPHY/DESIGN *Alisa Rudloff and Karen Berndt, San Francisco, California* **ART DIRECTOR** *Kit Hinrichs, San Francisco, California* **TYPOGRAPHIC SUPPLIER** *Reardon & Krebs* **STUDIO** *Pentagram Design* **CLIENT** *Clarks of England*
PRINCIPAL TYPE *Bodoni* **DIMENSIONS** *Various*

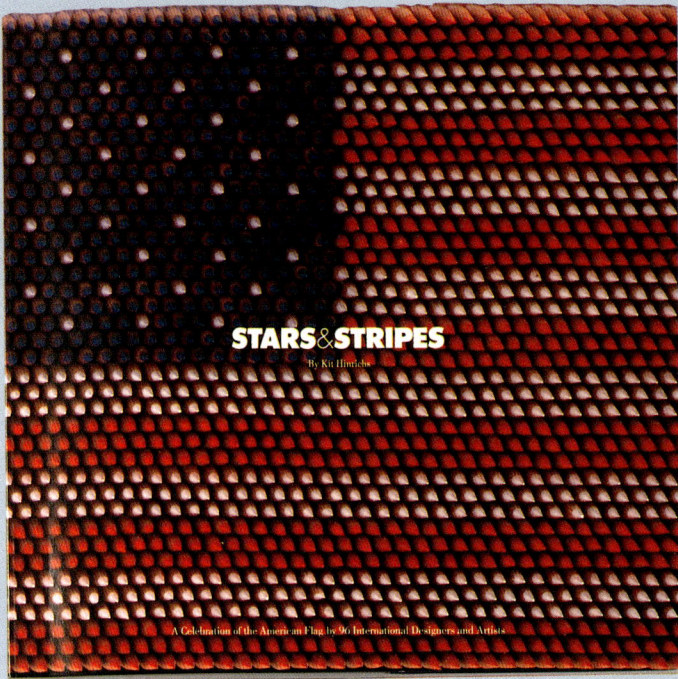

STARS&STRIPES
By Kit Hinrichs

A Celebration of the American Flag by 96 International Designers and Artists

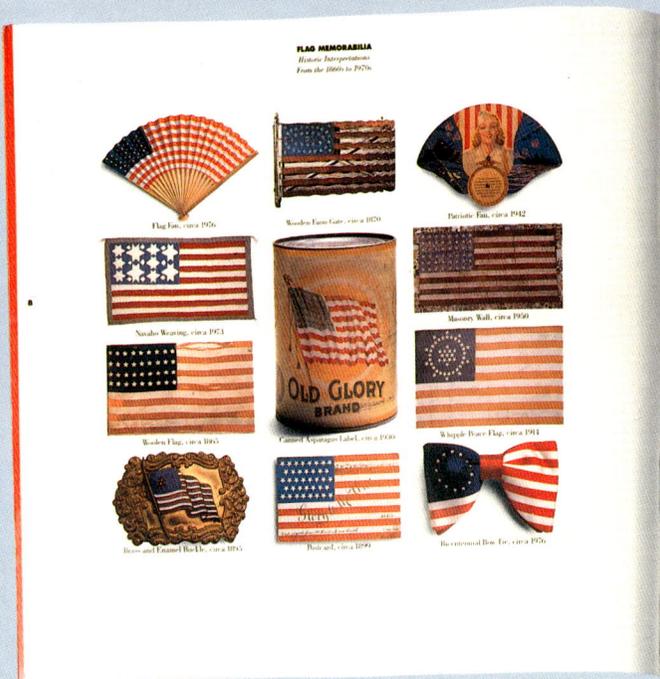

FLAG MEMORABILIA
*Historic Interpretations
From the 1860s to 1970s*

Flag Fan, circa 1976

Wooden Farm Gate, circa 1870

Patriotic Fan, circa 1942

Navaho Weaving, circa 1974

Masonry Wall, circa 1950

Wooden Flag, circa 1865

Canned Asparagus Label, circa 1930

Whipple Peace Flag, circa 1911

Brass and Enamel Buckle, circa 1876

Rush, circa 1899

Bicentennial Bow Tie, circa 1976

STARS AND STRIPES QUILT
New Jersey, 1898

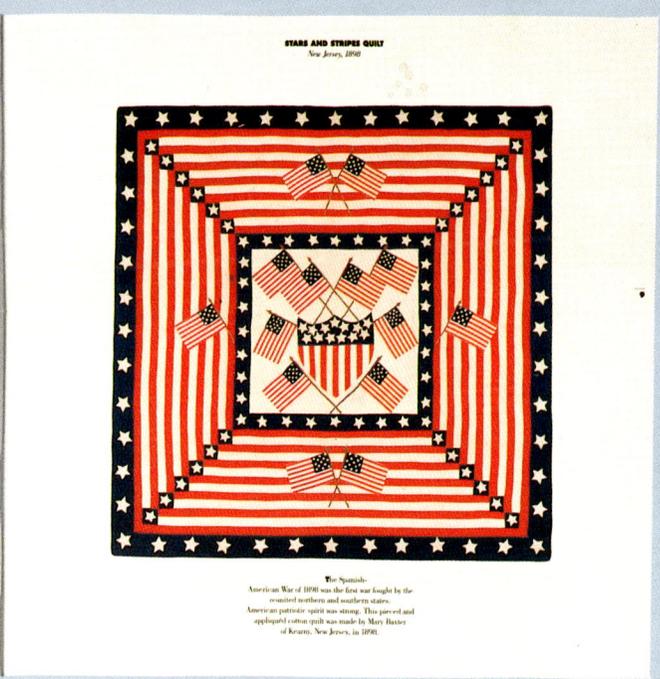

The Spanish-
American War of 1898 was the first war fought by the
reunited northern and southern states.
American patriotic spirit was strong. This pieced and
appliquéd cotton quilt was made by Mary Baxter
of Kearny, New Jersey, in 1898.

BOOK
TYPOGRAPHY/DESIGN *Kit Hinrichs, San Francisco, California* **TYPOGRAPHIC SUPPLIER** *On Line Typographers*
STUDIO *Pentagram Design* **CLIENT** *Chronicle Books* **PRINCIPAL TYPE** *Bodoni Book* **DIMENSIONS** *9⅝ × 10 in. (24.4 × 25.4 cm)*

TRADEMARK
TYPOGRAPHY/DESIGN *Gregory Thomas, Los Angeles, California* **STUDIO** *Gregory Thomas Associates*
CLIENT *Barry Zauss & Associates*

EPÄONNISTUNEEN MAINONNAN SYISTÄ.

Kun mainostoimiston edustaja oli lopettanut mainossuunnitelma ja mainosmäärärahoja koskevan raporttinsa, astui yhtiön johtaja esiin.

✓ »Hyvät herrat, tämä raportti on huolellisesti laadittu ja se merkitsee monen tuhannen dollarin menoerää. Uskon sen sisältävän oikeita tilannetta kuvaavia tosiasioita. Meidän on mainostettava, tuotteittemme puolisen sata vuotta vanhasta mainosta huolimatta ellemme halua päästä kilpailijoistamme jälkeen. Olen keskustellut asiasta johtokunnan jäsenten kanssa ja havainnut heidän kaikkien olevan samaa mieltä. Tässä raportissa mainostamme varten ehdotettu määräraha vastaa sekä toimeenpanevan komiteamme, että mainostoimiston medipäättä olen valmis hyväksymään sen viipymättä.»

✓ Mainostmiessa nemuitsi nähdessään selvän hyväksymisen kuvastuvan lasnäolijain kasvoista. Hän ajatteli voittoaan – vihdoinkin vanhaista tunnetusta toiminimesta, koko oman teollisuudenalansa selkärangasta tulisi ilmoittaja ja hänen asiakkaansa. Mutta jokinksa tykäisy teki lopun hänen haaveiluastaan.

✓ Mainosmiestä oli varoitettu Bronsonin suhteen. Vanha katsastelija, sanoivat eräät johtokunnnrankin miehestä mies oli »turhantarkka» joka monesta toimenpiteestä neuvoteltaessa asettui poikitelloin pidentien usein

✓ Kummankin tehtaan mainonta on samalla tasolla, mutta toinen vanha tehdas, on tottunut myymään tuotteitaan niiden laadun perusteella eikä mainonnan. Kuulin heidän myyntipäällikkönsä sanoneen tehtaan jälleenmyyjille, että heidän olisi myytävä pelkän ilmoittelun perusteella eikä korostaa tuotteitten monia etuja, kun tuotteilla kuitenkin. Jälleenmyyjien mielestä, olisi rittävästi kysymtä. Mutta jonkin tuo räennäisesti pieni seikka, jälleenmyyjien tottumattomuus toimia mainoshyökkäyksen eteenpäinviejinä, auttapna ja hyökkäyksen aiheuttaman suurentuneen kysynnän tyydyttäjinä aiheutti pettymyksen. Se oli se soraääni, joka muuten oivallisessa organisaatiossa tunneli koko asian. Pahinta oli, että tehtailija tästä tuskastuneena ryhtyi uhkailemaan asiakkaitaan ja pakottamaan heitä ostamaan hänen eikä kilpailijan tuotteita. Asiakkaat tosin pelästyksissään ostivat hänen tuotteitaan, mutta kun hän sitten menetti monopoliasemansa, luopuivat asiakkaat hänestä hänen tyrkyttävien ja omavaltaisten myyntitapojensa takia. Jos hän olisi ollut enemmän diplomaatti, olisi hän edelleen alansa johtava liikemies – nyt hänen tehtaansa valmistaa ja myy yhä

sähemmän. Tämä tapaus on selvä todistus siitä ettei »vähät yleisistä »-periaate on väärä ja hylättävä. Ja nmpa Tekin varmaan olette huomanneet miten suuret ja menestyväät liikkeet järjestävät hyvät suhteet - sekä mainonnan että jälleenmyyjiensä avulla - ostavaan yleisöön

✓ Sitten taaila on kaksi ruokatavaratoertaja joiden mainonta myös on samalla tasolla, mutta tulukset erilaista. Olette kai havainnut että se heistä, jonka mainonnalla on ollut paremmat tulokset, Harding & Co., on keskittänyt 90 % mainonnastaan kasitikelmoittelun, kun taas kilpailevo tehdas mainostaa tasapoloisesti kaikkia tärkeimpä tuotteitaan. Seurauksena on, että jakaisen maustekauppiaan on pidettävä varastossaan Hardingin kastiketta sen vilkkain, jatkuvan kysynnän vuoksi. Kastikemainonta luo nimeä ja mainetta kaikille Hardingin tuotteille - se on se kulta jolla erisinna avaa nimelle Hardingin ten ihmisten mielin Kilpailevien yhtiöiden tuoteita tietysti kysytään, mutta niiden kysyntä ei ole niin kestävä ja kiintea, etta se paikoittaisi kauppiaita pitämään niitä aina saatavilla. Yleensä on jokaisen tuottajan vaikea kehittää kysyntää kaikille tuotteilleen - edullisempaa ja helpompaa on mainostaa yhtä tuotetta ja tehdä siitä tähtimerkkä.

✓ Silta sitten tulee naihin kahteen kauneudenhoitovalmistoseen, ei niitä oikeastaan voi verrata mainonnan kannalta. Asia on vain siten että se joka on päässyt hyvän tuloksiin, vaihto pakkaukserisa ulkoruikäi vuotta ennen kun hänen kilpailijansa ehti sita tehdä ja saavutti täten niin suuren suosion, että kilpailija ei ole tänäkään päivänä pystynyt sen rinnalle nousemaan. Täten voi mukin räennäisesti pieni asia kuin pakkauksen muutos ehyttää yleisön mielenkiinnon ja säilyttä jatkuvasti kysynnän suurena

✓ Näiden rakennustarviketehtailijain erilainen menestys taas johtuu siitä että he käyttivät erilaisia mainoskohteita. Toinen koholtaisi ilmoittelunsa

yksinomaan kuluttajille ja saavutti vain keskinkertaisia tuloksia, toinen taas ilmoitti arkkitehdeille ja urakoitsijoille heidän ammattilehtinsä ja myyntikirjeiden välityksellä ja sijoitti tämän lisäksi rahoja myöskin kuluttajamainontaan. Hän saavutti hyviä tuloksia. Miksi? Siksi, että arkkitehti on asemansa vuoksi tämän erikosteollisuuden alan avain. Vaikka näyttää johdonmukaiselta osoittaa mainossanoma suoraan todellisele ostajalle, on kiertotie tässä tapauksessa kuitenkin paras tie hyvin myyntituloksiin. Maksetun neuvonantajan ja asiantuntijan, arkkitehdin, yksi ainoa sana tai puhuva oikopäiden kohautus merkitsee puljon enemmän kuin pitkät myyntipuheet ja mutkalliset laskelmat ja taulukot. Tästä syystä pääsi kilpailussa edelle se tuottaja, joka kohdisti ilmoittelunsa, paitsi ostajalle, myöskin arkkitehdeille

✓ Sama rohdostehtaat taas voivat erilaisia myyntituloksistaan kiittää sita, että toisen tehtaan myyntipäällikkö oli ihan kaunavenenen. Hän kyllä listyi jälleenmyyjien tapaan alentaa myyntihintaa. Hän päätti hinnoittaa tavaran niin että kauppiaat eivät voi enää sen hintaa alentaa tappiotta kärsimättä. Ja niin hän alensi kauppaalle tulevan voiton varvaistin 10 % sijoittaen jäännök-

sen kuluttajamainontaan. Kysyntä lisääntyikin, mutta kauppiaiden vastarinta vei tehtaan melkein perikadon partaalle. Ei auttanut muu kuin suosittaa myyntipäällikön vaihdos. koivottaa kauppaiden myyntiprosentta ja täten rauhoittaa tuirmistunee jälleenmyyjät.

✓ Tämä huonekaluthetaan tapaus on mielenkiintoinen. Toiminnen paajohtaja on kelseelias nero, jolla on hyviä ajatuksia - paha vain, että nitä on liikaa ja että ne ovat liian hyviä. Seuraus on se, että tehtaan tuoteet ovat tuskin ehtineet markkinoille kun uhdas jällen valmistaa uuden, parantetun huonekalun. Kauppiaat ja valitajat kärsivät jatkuvaa tappiota, laska he ovat sa myydyksi liponekaluja, joita joka päivä tulevat vanhanmallaisiksi niiden uusien huonekalujen rinnalla, joiden parannuksista tehtaan mainonta alitamisti hyö rumpua. Tämä sama seikka on muuten havaittavissa monella alalla - muotesineiden, radioiden ym. Aina on tulossa jokin uusi malli, uusi parannus - kauppias ei uskalla pitää hallussaan suuria varastoja mitään tavarosta eikä yleisö osta niitä paitsi nyt, vaan siirtaa mielellään ostonsa aina tuoteenmaksi saadakseen viela parempaa, viela tunernkaisemmpaa »

✓ »Rittää, mwsi mies - tuhannet kutokset» puuhasi Bronson. »puheenne oli hyvin opettavainen. Toivon johtokuntamme ottavan huomioon sen opetukset ja nyt tiedän, että meidän on mainostaan käytettävä puljon rahaa, mutta samalla huolehditava siitä, etä jälleenmyyjämme täysin pystyvat tehtäväänsä. Vaadin siis, että mainosmääräraha ja »suunnitelma hyväksytään.»

TYPOSTUDIO OY

POSTER
TYPOGRAPHY/DESIGN *Asko Kekkonen and Matti Rönnberg, Helsinki, Finland* **TYPOGRAPHIC SUPPLIER** *Typostudio Oy*
AGENCY *Alform Oy* **CLIENT** *Typostudio Oy* **PRINCIPAL TYPE** *Berkeley Old Style* **DIMENSIONS** *23⅝ × 36¼ in. (60 × 92 cm)*

BROCHURE
TYPOGRAPHY/DESIGN *Andrew Pengilly, Paris, France* **TYPOGRAPHIC SUPPLIER** *Typo Gabor* **AGENCY** *Carré Noir*
CLIENT *Carré Noir* **PRINCIPAL TYPE** *Sabon Light* **DIMENSIONS** *5½ × 5½ in. (14 × 14 cm)*

INVITATION
TYPOGRAPHY/DESIGN *Michael and Lindy Dunlavey, Sacramento, California* **TYPOGRAPHIC SUPPLIER** *Ad Type Graphics*
STUDIO *The Dunlavey Studio, Inc.* **CLIENT** *The Dunlavey Studio, Inc.* **PRINCIPAL TYPES** *Frost, Freestyle Script, and Futura Condensed*
DIMENSIONS *4½ × 6¼ in. (11.4 × 15.9 cm)*

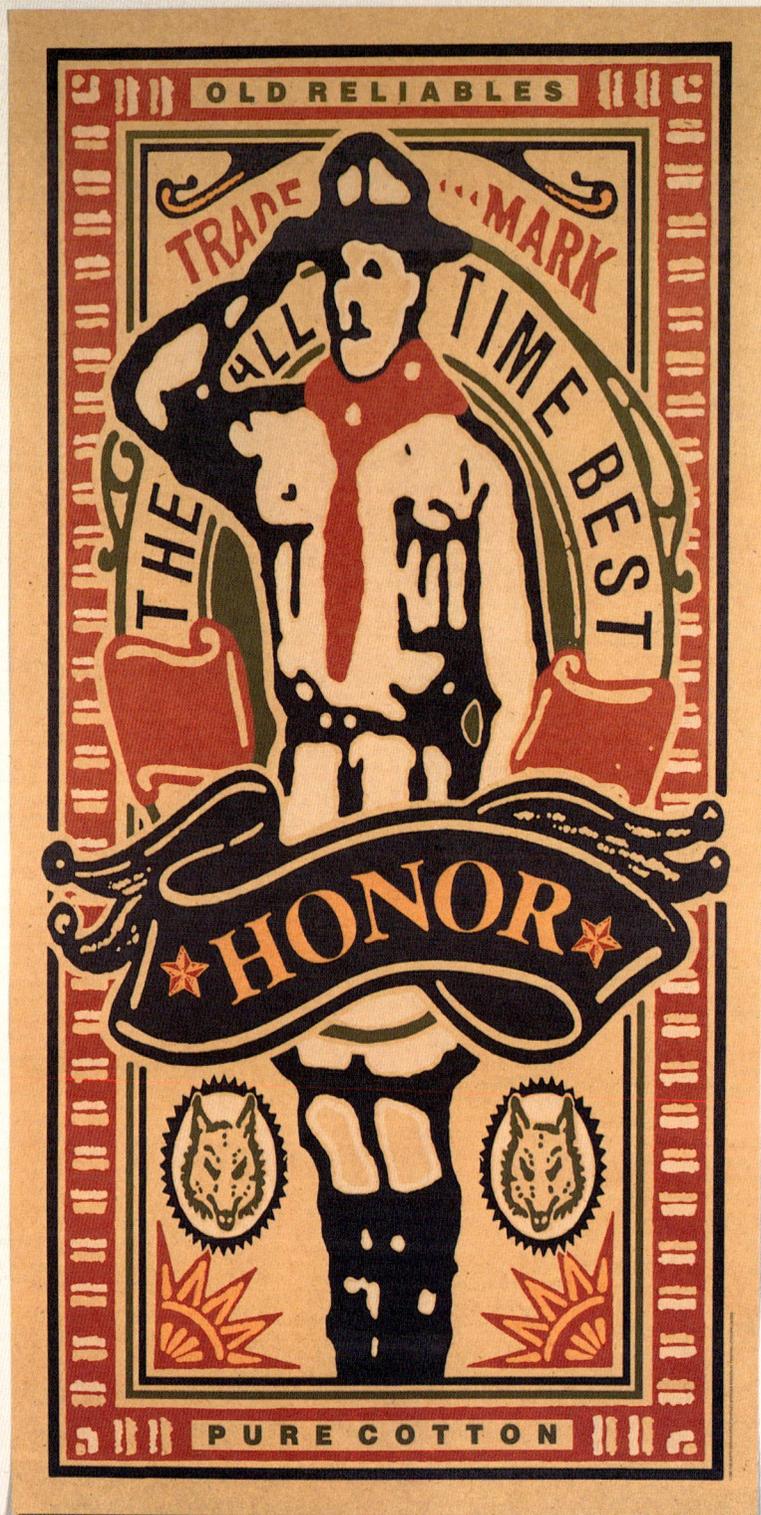

POSTER
TYPOGRAPHY/DESIGN *Charles S. Anderson, Minneapolis, Minnesota* **LETTERER** *Charles S. Anderson* **TYPOGRAPHIC**
SUPPLIER *Typeshooters* **STUDIO** *The Duffy Design Group* **CLIENT** *Chaps–Ralph Lauren* **PRINCIPAL TYPE** *Old Crust (by hand)*
DIMENSIONS *18½ × 35 in. (47 × 88.9 cm)*

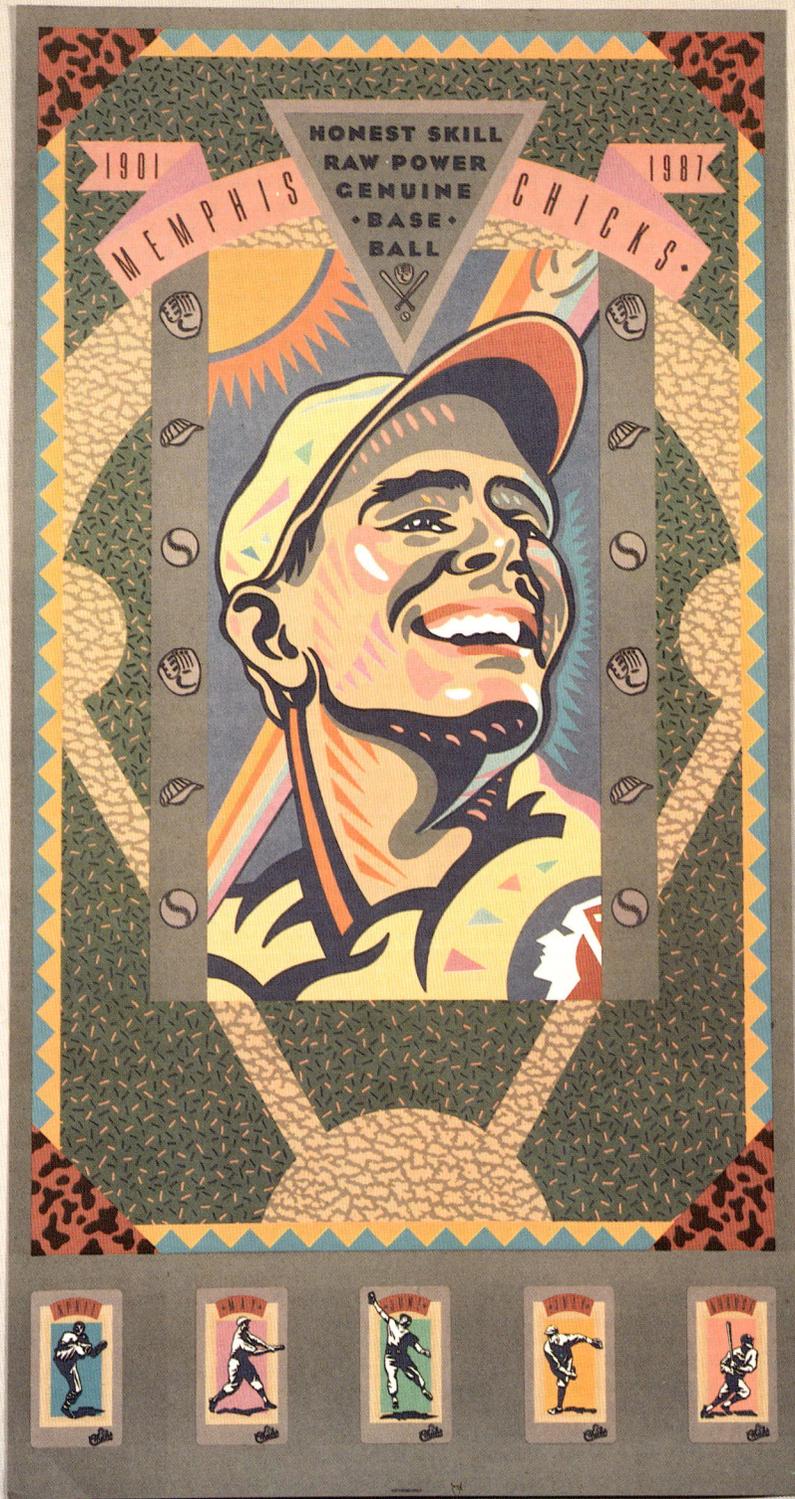

POSTER
TYPOGRAPHY/DESIGN *Joe Duffy, Minneapolis, Minnesota* **TYPOGRAPHIC SUPPLIER** *Typeshooters* **STUDIO** *The Duffy Design Group*
CLIENT *First Tennessee Bank* **PRINCIPAL TYPES** *Motion Picture No. 4 and Eagle Bold* **DIMENSIONS** *21 × 37 in. (53.3 × 94 cm)*

Cargill food
products bearing
a retailer's private
label or special
brand names are
found on grocery
shelves throughout
the country.

PAGE 10

CARGILL

BROCHURE
TYPOGRAPHY/DESIGN *John C. Reger and Chittamai Suvongse, Minnetonka, Minnesota* **TYPOGRAPHIC SUPPLIER** *Typeshooters*
STUDIO *Design Center* **CLIENT** *Cargill* **PRINCIPAL TYPE** *ITC Garamond Book* **DIMENSIONS** *9½ × 12 in. (24.1 × 30.5 cm)*

INVITATION
TYPOGRAPHY/DESIGN *Charles S. Anderson, Minneapolis, Minnesota* **LETTERER** *Charles S. Anderson* **TYPOGRAPHIC**
SUPPLIER *Typeshooters* **STUDIO** *The Duffy Design Group* **CLIENT** *American Institute of Graphic Arts* **PRINCIPAL TYPE** *Garamond*
DIMENSIONS *21½ × 9 in. (54.6 × 22.9 cm)*

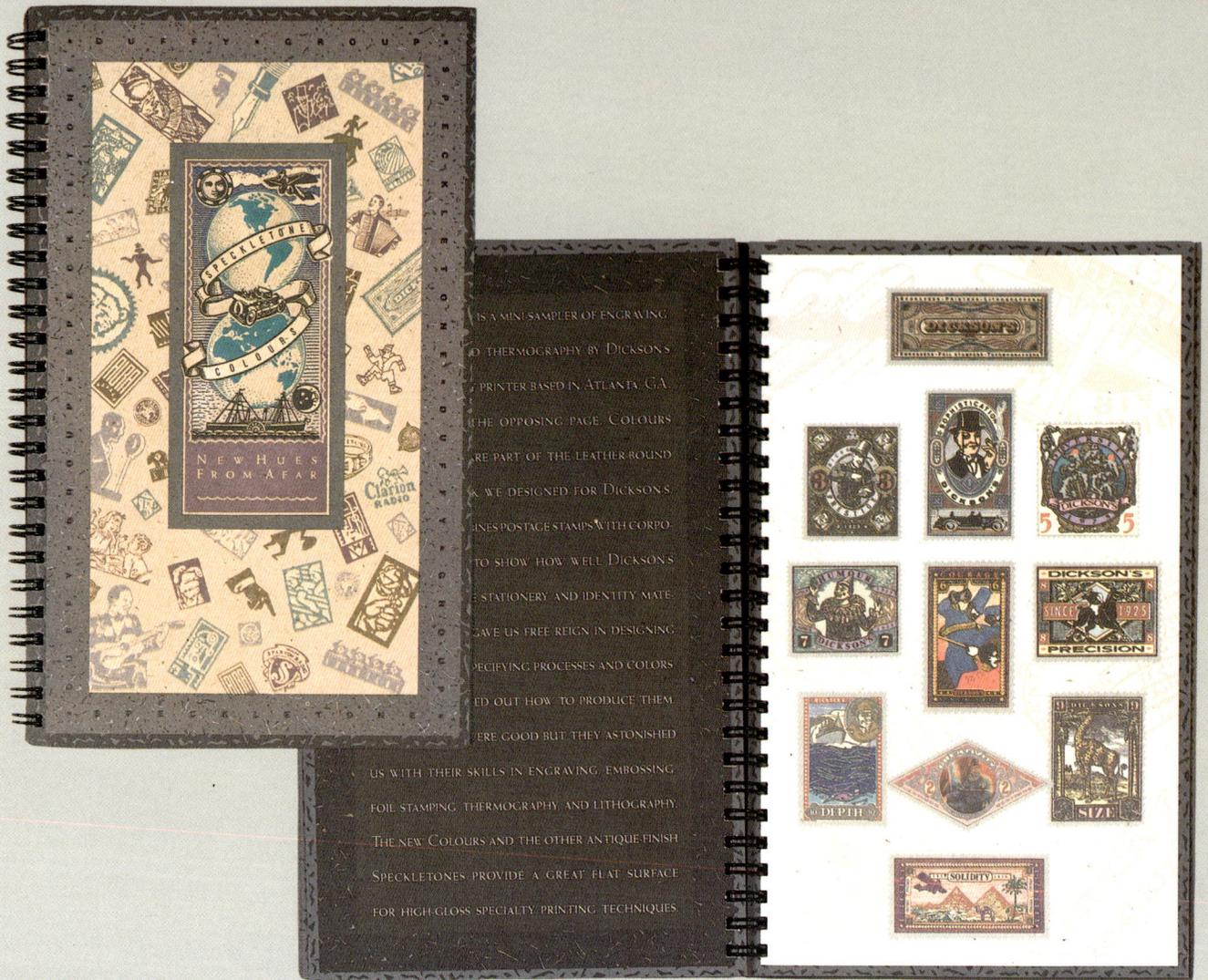

BOOK
TYPOGRAPHY/DESIGN *Charles S. Anderson and Joe Duffy, Minneapolis, Minnesota*
TYPOGRAPHIC SUPPLIER *Typeshooters* **STUDIO** *The Duffy Design Group* **CLIENT** *French Paper Company*
PRINCIPAL TYPE *Weiss* **DIMENSIONS** *10 × 6½ in. (25.4 × 16.5 cm)*

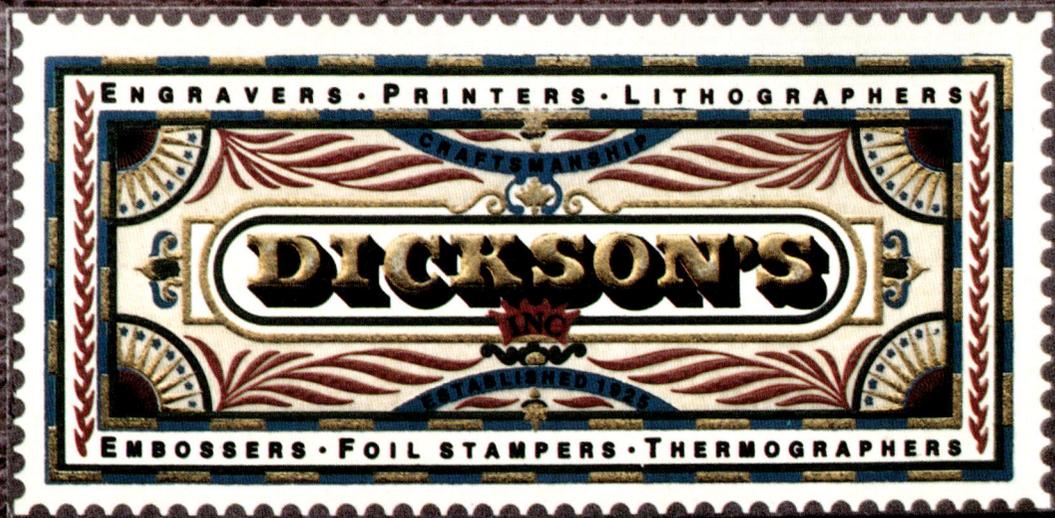

LOGOTYPE
TYPOGRAPHY/DESIGN *Joe Duffy, Minneapolis, Minnesota* **LETTERER** *Lynn Schulte, Minneapolis, Minnesota* **TYPOGRAPHIC**
SUPPLIER *Typeshooters* **STUDIO** *The Duffy Design Group* **CLIENT** *Dickson's, Inc.* **PRINCIPAL TYPE** *Cheltenham Book Italic*

This insert, featuring one of the stamps from Dickson's Stamp Collection, demonstrates how strongly multi-process specialty printing can communicate.

Like their capabilities book, which is designed to show new ways of thinking about letterhead design, it demonstrates how the combination of lithography, thermography, engraving, embossing, die-cutting and foil-stamping can help you create powerful messages on paper.

This insert combines lithography (three match colors), two runs of foil-stamping, five runs of engraving, embossing and thermography. The backside is 4/C process lithography only.

Atlanta
Chicago
New York
Washington, D.C.
5 Piedmont
Center
Suite
520
Atlanta,
Georgia
30305
(404)
233-4442

STATIONERY
TYPOGRAPHY/DESIGN *Sharon Werner and Joe Duffy, Minneapolis, Minnesota* **LETTERER** *Joe Duffy*
TYPOGRAPHIC SUPPLIER *Dickson's, Inc.* **STUDIO** *The Duffy Design Group* **CLIENT** *Dickson's, Inc.*
PRINCIPAL TYPE *Century Schoolbook Italic* **DIMENSIONS** *8½ × 11 in. (21.6 × 27.9 cm)*

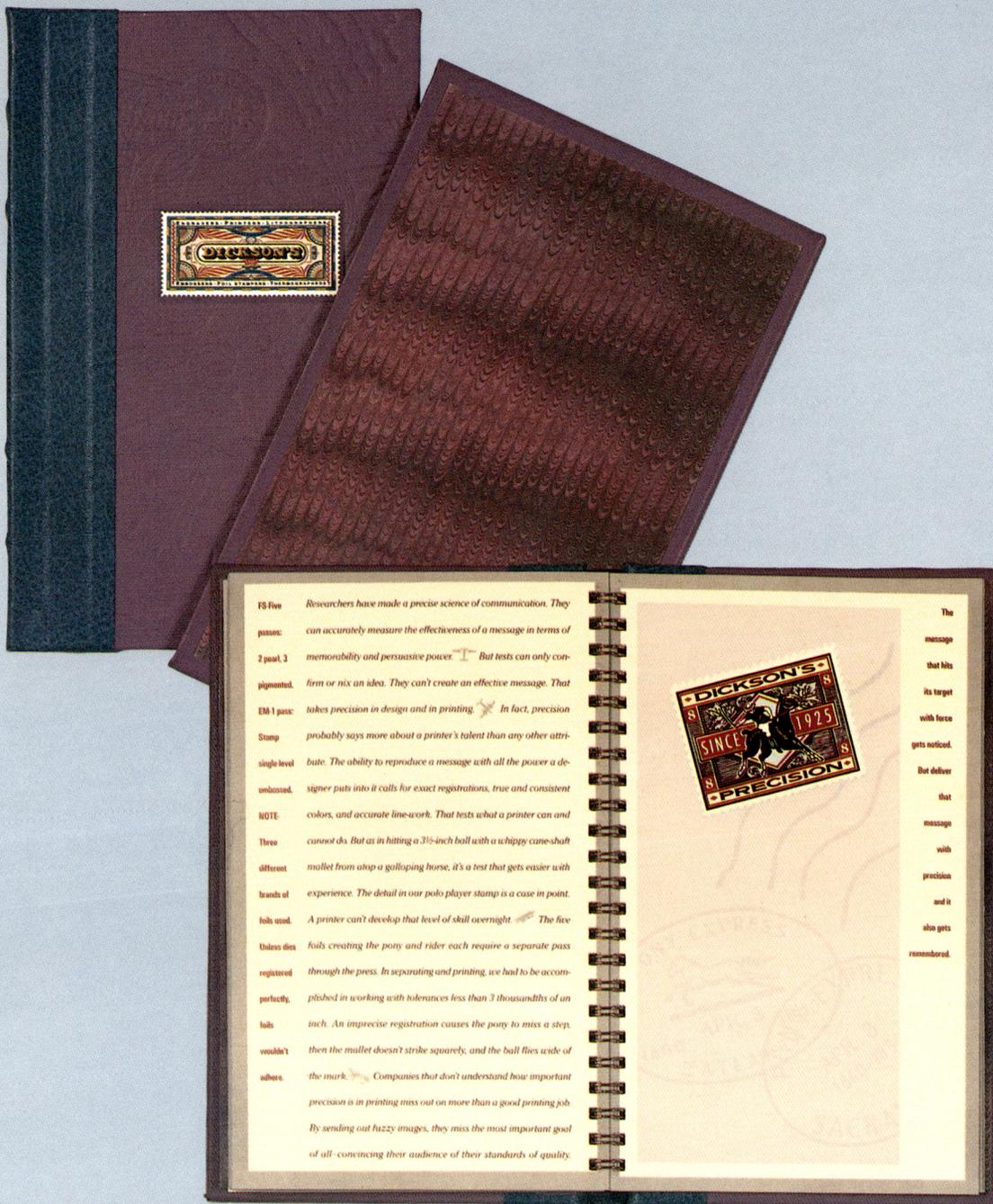

BOOK
TYPOGRAPHY/DESIGN *Joe Duffy, Charles S. Anderson, and Sharon Werner, Minneapolis, Minnesota*
TYPOGRAPHIC SUPPLIER *Dickson's, Inc.* **STUDIO** *The Duffy Design Group* **CLIENT** *Dickson's, Inc.*
PRINCIPAL TYPE *Century Schoolbook Italic* **DIMENSIONS** *8 × 5 in. (20.3 × 12.7 cm)*

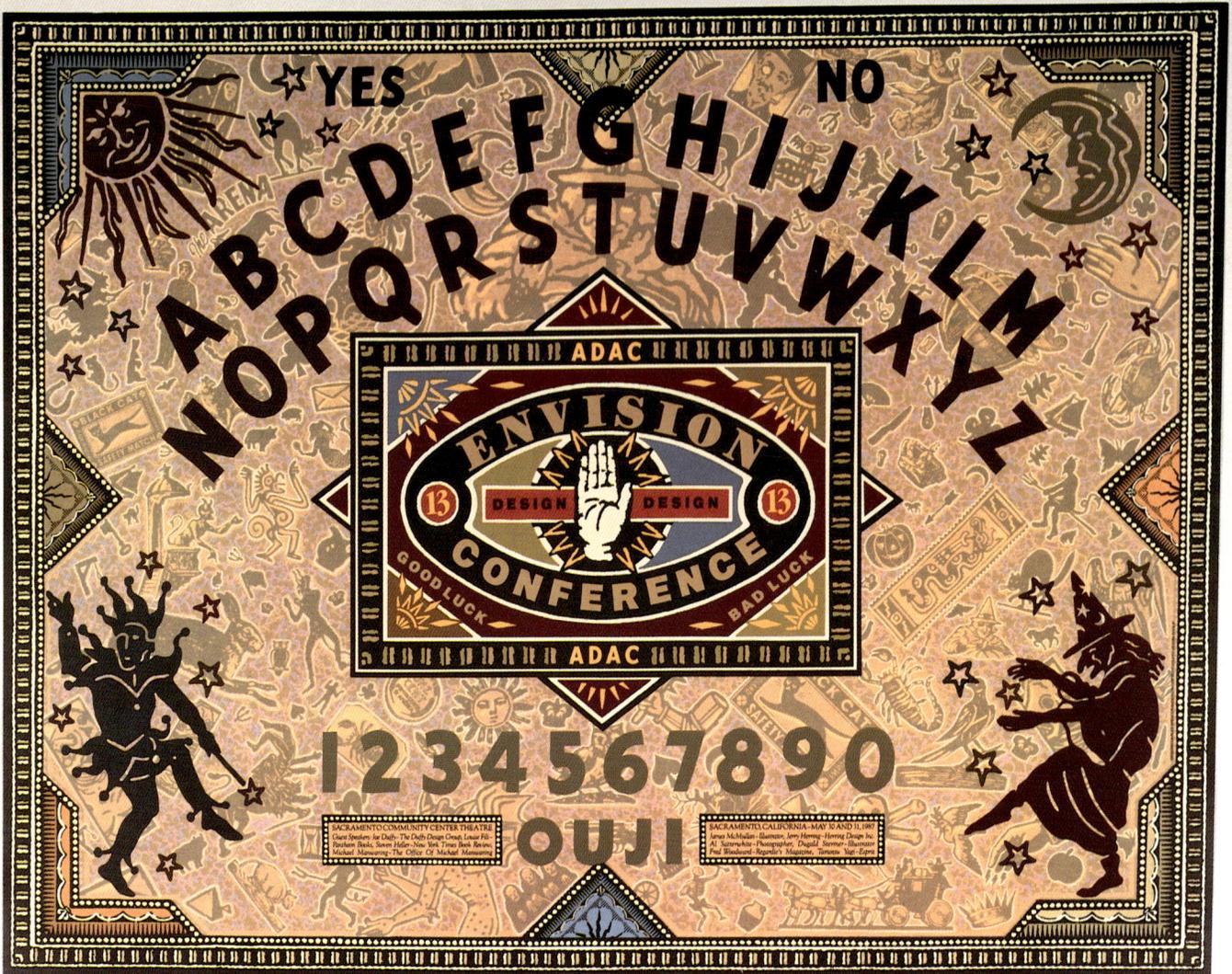

POSTER
TYPOGRAPHY/DESIGN *Charles S. Anderson and Joe Duffy, Minneapolis, Minnesota* **TYPOGRAPHIC SUPPLIER** *Typeshooters*
STUDIO *The Duffy Design Group* **CLIENT** *Sacramento Art Directors* **PRINCIPAL TYPE** *Hand Block Sans Serif (from Ouija Board)*
DIMENSIONS *21½ × 16¼ in. (54.6 × 41.3 cm)*

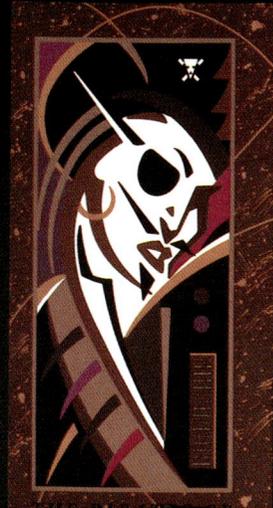

Designers Charles Spencer Anderson and Joe Duffy of the Duffy Design Group of Minneapolis have won numerous design awards. ▪ Many of their posters offered through Aura have been honored by The New York Society of Illustrators, Graphis, New York Art Directors, AIGA, and Communication Arts. Plus, two of their pieces have been chosen by the Library of Congress for its permanent collection. ▪ They've developed a style blending design and illustration. Within that style, they work with color palettes that have exceptional appeal with today's young and sophisticated poster customers. ▪ This collection of Duffy Group posters was created for a wide range of clients from youth volunteer groups, to banks, to baseball teams, to a music software company. In each case, they show a strong, cohesive message. ▪ Like the other Aura Design Posters, they are not like posters you've been used to seeing. They represent a new energy and a new direction in the poster industry.

As a serigraph announcing a production of Pirates of Penzance, this poster sold at $100 per copy. As a 5-color production with gold ink, it now sells for much less but still announces the Gilbert & Sullivan opera with class and integrity.

CATALOG
TYPOGRAPHY/DESIGN *Charles S. Anderson, Minneapolis, Minnesota* **LETTERER** *Charles S. Anderson* **TYPOGRAPHIC**
SUPPLIER *Typeshooters* **STUDIO** *The Duffy Design Group* **CLIENT** *Aura Editions* **PRINCIPAL TYPES** *Weiss and Garamond*
DIMENSIONS *10 × 6½ in. (25.4 × 16.5 cm)*

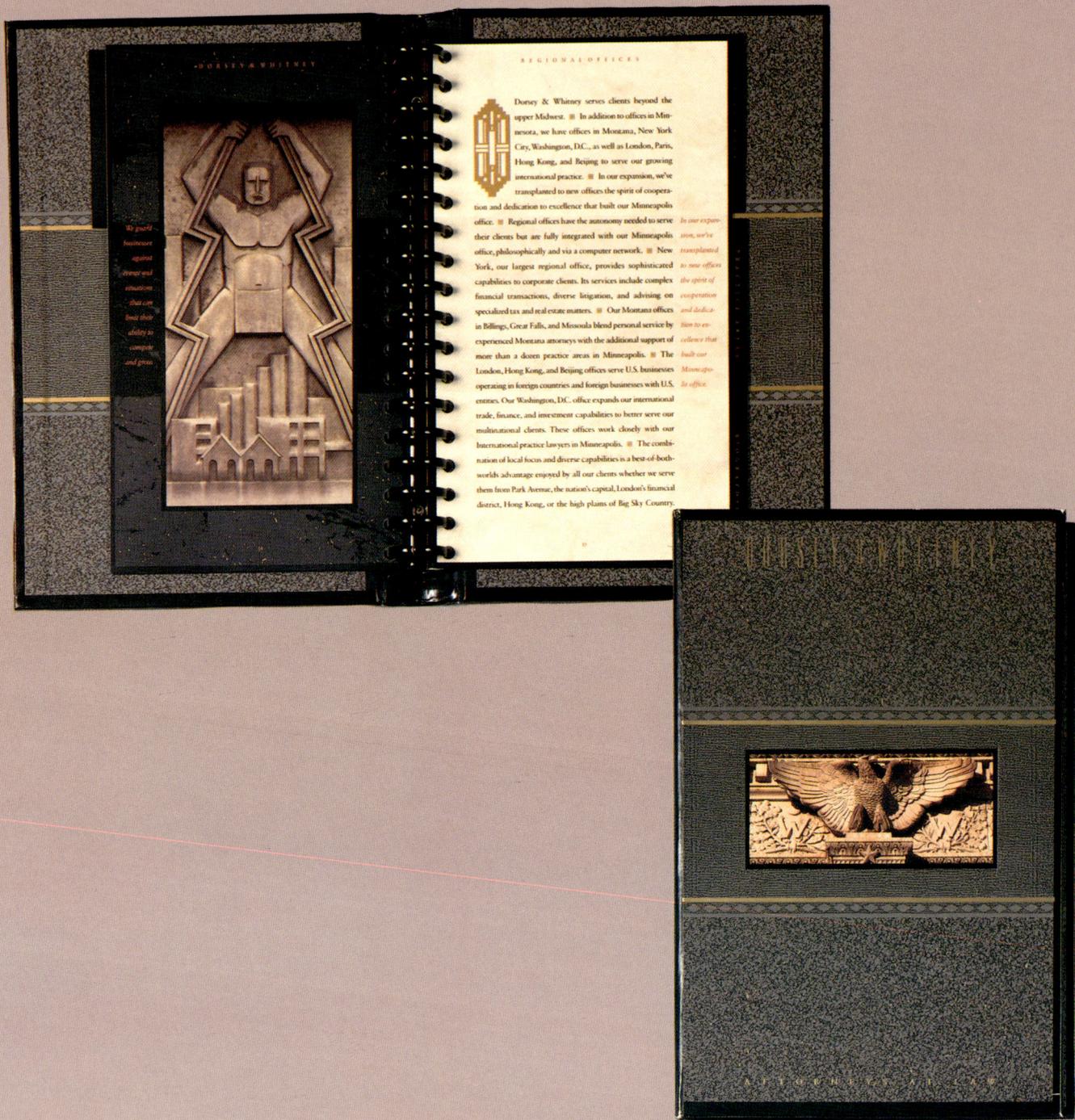

BOOK
TYPOGRAPHY/DESIGN *Charles S. Anderson, Joe Duffy, and Sara Ledgard, Minneapolis, Minnesota*
TYPOGRAPHIC SUPPLIER *Typeshooters* **STUDIO** *The Duffy Design Group* **CLIENT** *Dorsey & Whitney*
PRINCIPAL TYPES *Empire, Sabon, and Sabon Italic* **DIMENSIONS** *10 × 6½ in. (25.4 × 16.5 cm)*

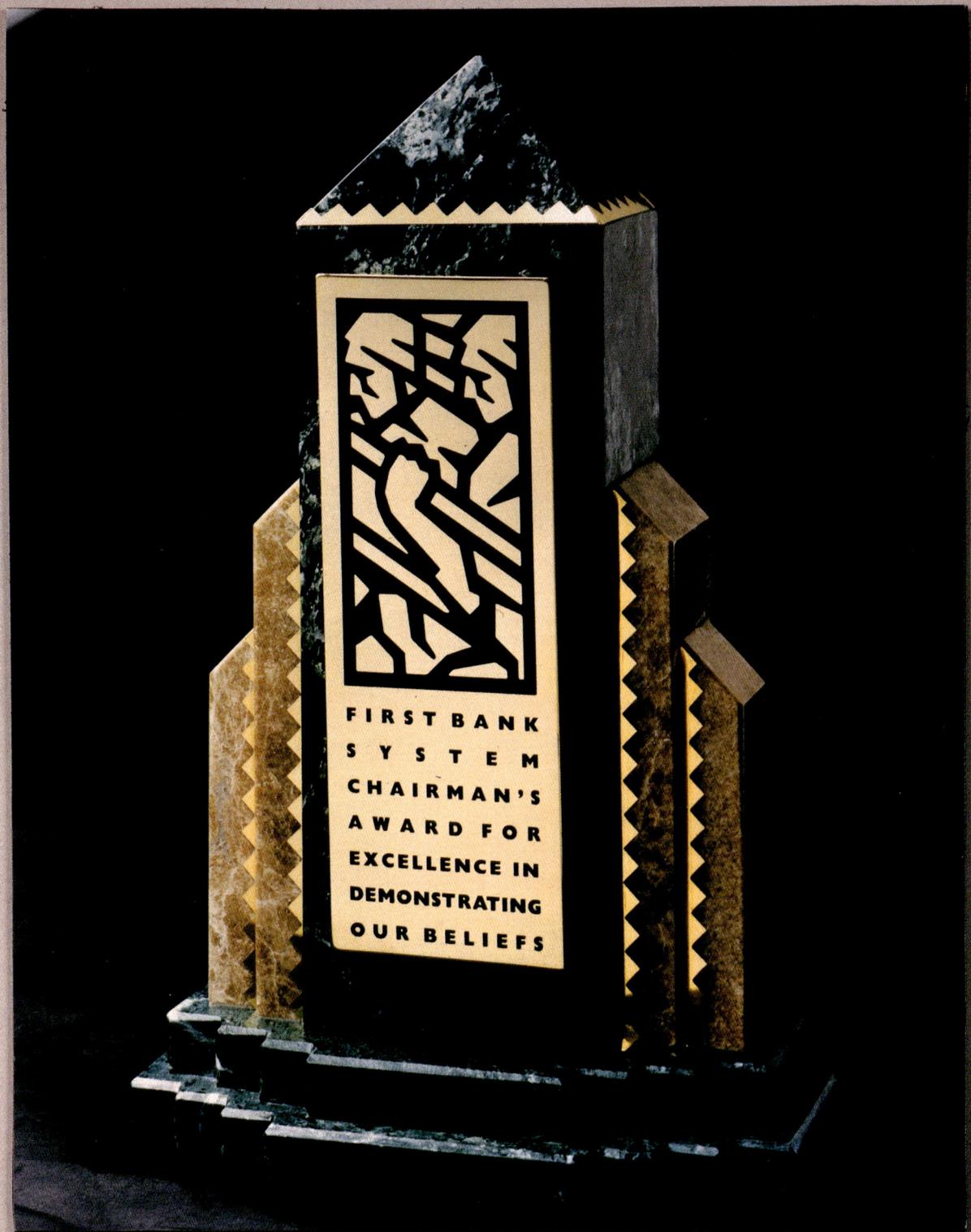

AWARD
TYPOGRAPHY/DESIGN *Charles S. Anderson and Sara Ledgard, Minneapolis, Minnesota* **TYPOGRAPHIC SUPPLIER** *Typeshooters*
STUDIO *The Duffy Design Group* **CLIENT** *First Bank System* **PRINCIPAL TYPE** *Eagle Bold* **DIMENSIONS** *9 × 5½ in. (22.9 × 14 cm)*

BROCHURE
TYPOGRAPHY/DESIGN *Birgit Fischötter, Frankfurt am Main, West Germany* **TYPOGRAPHIC SUPPLIERS** *Fotosatz Hoffmann and Oehms Printing Company* **STUDIO** *Linotype AG* **CLIENT** *Linotype AG* **PRINCIPAL TYPES** *Copperplate, Baskerville, Futura, Lubalin, Frutiger, and Garamond* **DIMENSIONS** *8½ × 10½ in. (21.6 × 26.7 cm)*

POSTER
TYPOGRAPHY/DESIGN *Mervyn Kurlansky and Herman Lelie, London, England* **CALLIGRAPHER** *Wolf Spoerl, London, England*
STUDIO *Pentagram Design* **CLIENT** *Kent State University* **PRINCIPAL TYPE** *Handlettering*
DIMENSIONS *33³/₇ × 27⁵/₈ in. (85.8 × 54.8 cm)*

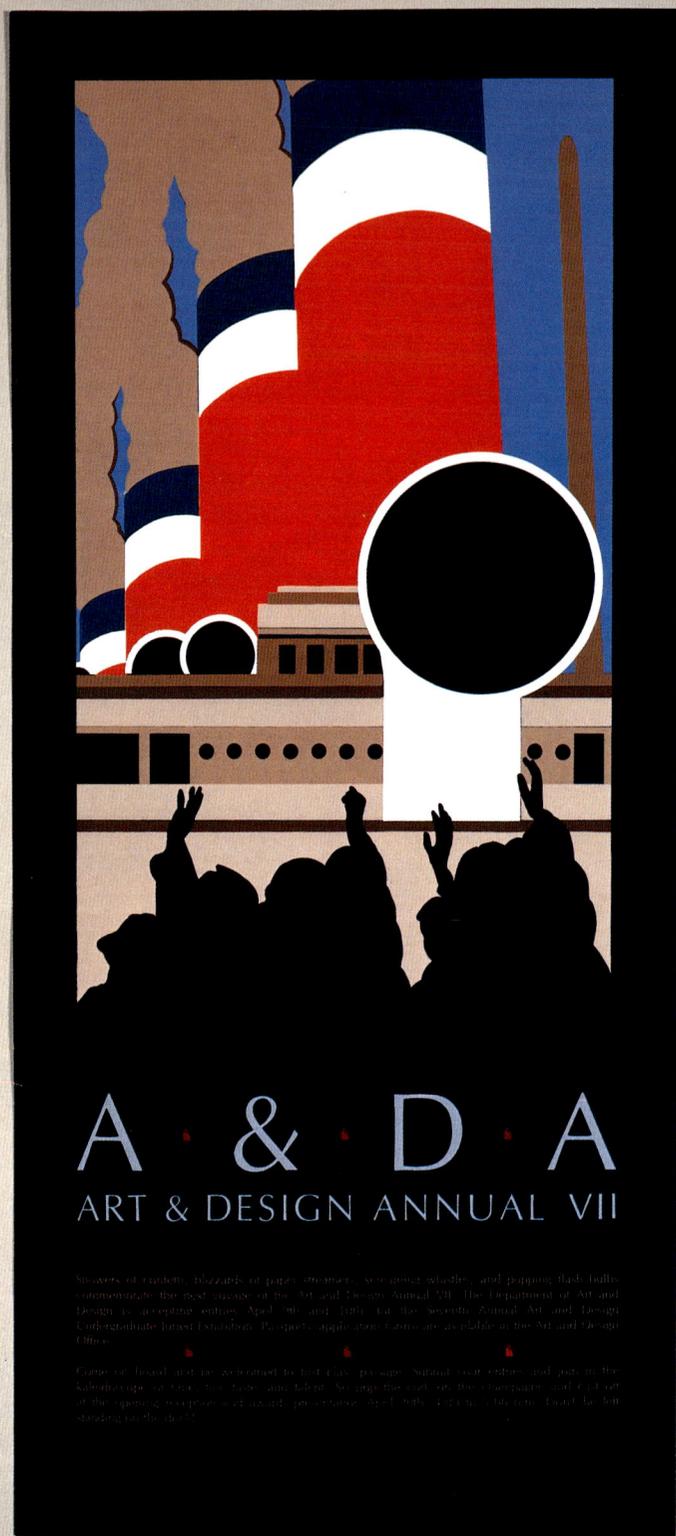

POSTER
TYPOGRAPHY/DESIGN *Alan Mickelson and Clint Hansen, Ames, Iowa* **TYPOGRAPHIC SUPPLIER** *Huess Printing*
AGENCY *Mickelson Design & Associates* **CLIENT** *Iowa State University* **PRINCIPAL TYPE** *Optima*
DIMENSIONS *33 × 15 in. (83.8 × 38.1 cm)*

Literature $7.95

This volume brings together everything that Franz Kafka himself published during his lifetime — all those works he thought finished enough to permit their publication. Included in this powerful collection are "The Judgment," "The Metamorphosis," "In the Penal Colony," "A Country Doctor," and "A Hunger Artist."

"Had one to name the artist who comes nearest to bearing the same kind of relation to our age that Dante, Shakespeare, and Goethe bore to theirs, Kafka is the first one would think of....Kafka is important to us because his predicament is the predicament of modern man."
— W. H. Auden

Cover illustration by Anthony Russo
Cover design by Louise Fili
Schocken Books, New York
3/88 Printed in the U.S.A. © 1988 Random House, Inc.
ISBN 0-8052-0849-6

50795
9 780805 208498

FRANZ KAFKA
THE METAMORPHOSIS, THE PENAL COLONY, AND OTHER STORIES
SCHOCKEN

FRANZ
KAFKA
THE METAMORPHOSIS,
THE PENAL COLONY,
AND OTHER STORIES

Schocken Classics

BOOK COVER
TYPOGRAPHY/DESIGN *Louise Fili, New York, New York* **TYPOGRAPHIC SUPPLIERS** *Louise Fili and the Type Shop*
CLIENT *Schocken Books/Pantheon Books* **PRINCIPAL TYPE** *Morgan No. 59* **DIMENSIONS** *5¼ × 8 in. (13.3 × 20.3 cm)*

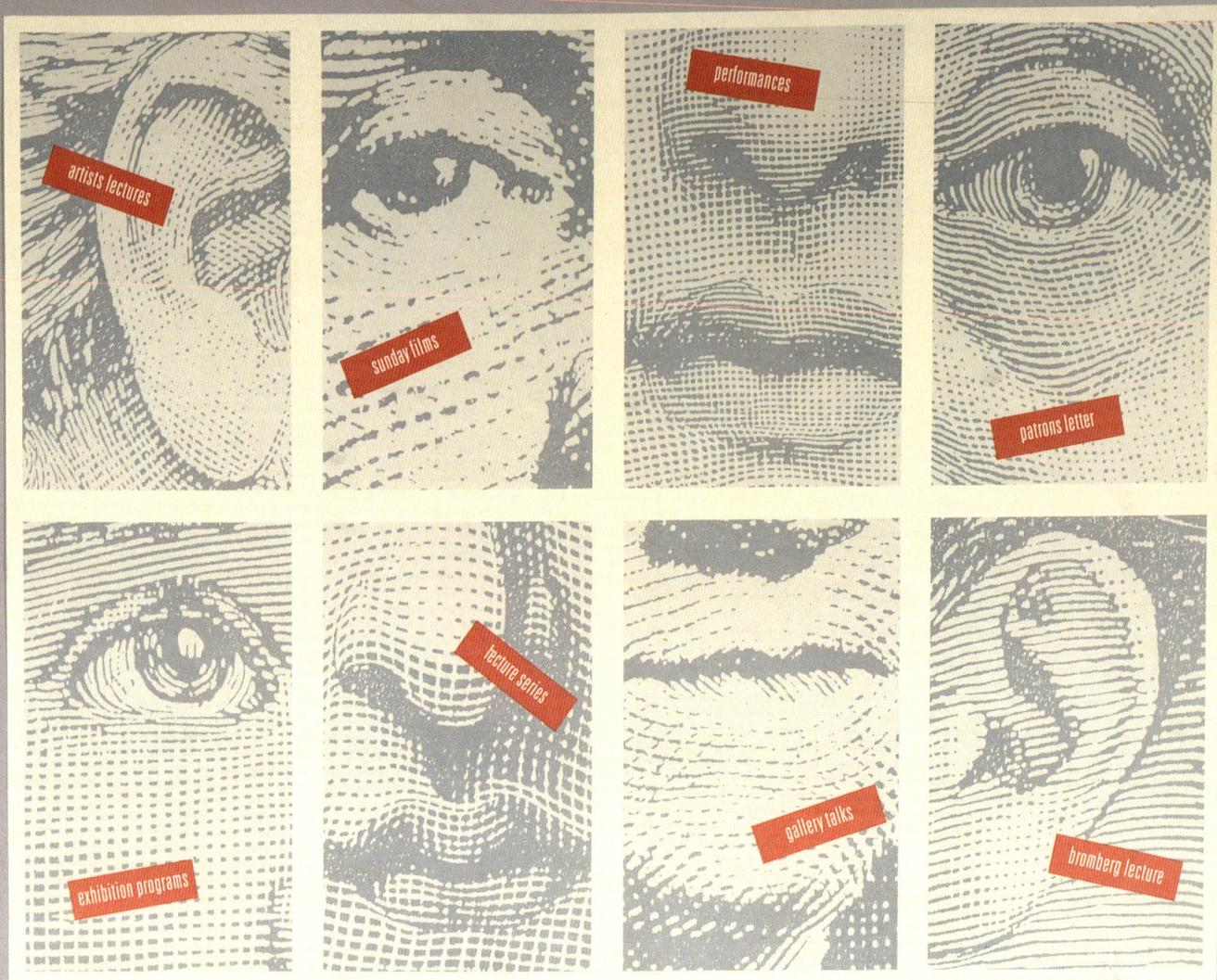

ANNOUNCEMENT
TYPOGRAPHY/DESIGN *Scott Paramski, Dallas, Texas* **TYPOGRAPHIC SUPPLIER** *Southwestern Typographics, Inc.*
STUDIO *Peterson & Company* **CLIENT** *Dallas Museum of Arts* **PRINCIPAL TYPES** *Univers 49 Light Ultra Condensed and Akzidenz-Grotesk Black* **DIMENSIONS** *5¾ × 8¾ in. (14.6 × 22.2 cm)*

EVENING WITH

TAMOTSU YAGI

GRAPHIC DESIGN

AND INFORMAL

DISCUSSION AT

THE INFOMART

THE IMAGE OF ESPRIT ART DIRECTOR TAMOTSU YAGI, OF THE ESPRIT GRAPHIC DESIGN STUDIO, AT THE MARCH 4TH MEETING OF THE DALLAS SOCIETY OF VISUAL COMMUNICATIONS.

JOIN US AT THE INFOMART, ROOM 7011. CASH BAR AND HORS D'OEUVRES AT 6 O'CLOCK PM. MEETING AT 7 O'CLOCK PM. MEMBERS FREE, NON-MEMBERS $5, STUDENTS $1 WITH ID.

ANNOUNCEMENT
TYPOGRAPHY/DESIGN *Douglas May and Lynn Bernick, Dallas, Texas* **TYPOGRAPHIC SUPPLIER** *Typography Plus*
STUDIO *Douglas May Design* **CLIENT** *Dallas Society of Visual Communications* **PRINCIPAL TYPE** *Helvetica*
DIMENSIONS *18 × 24 in. (45.7 × 61 cm)*

Lotus. The most powerful family in business.

The Lotus Solution

Information Products

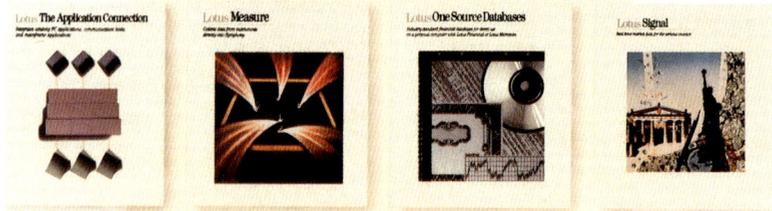

Analysis Products

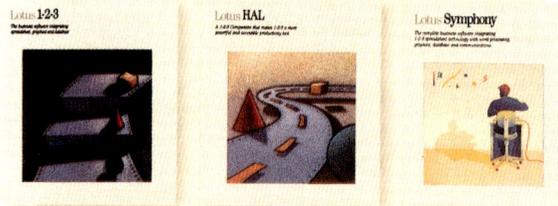

Presentation/Communications Products

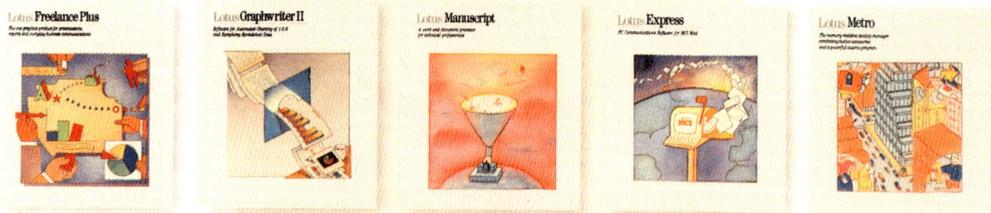

BROCHURE
TYPOGRAPHY/DESIGN *Tom Hughes, Cambridge, Massachusetts* **TYPOGRAPHIC SUPPLIER** *Lotus Graphic Services*
AGENCY *Lotus Creative Development* **CLIENT** *Lotus* **PRINCIPAL TYPES** *ITC Modern No. 216 and ITC Century Light*
DIMENSIONS *8½ × 11 in. (21.6 × 27.9 cm)*

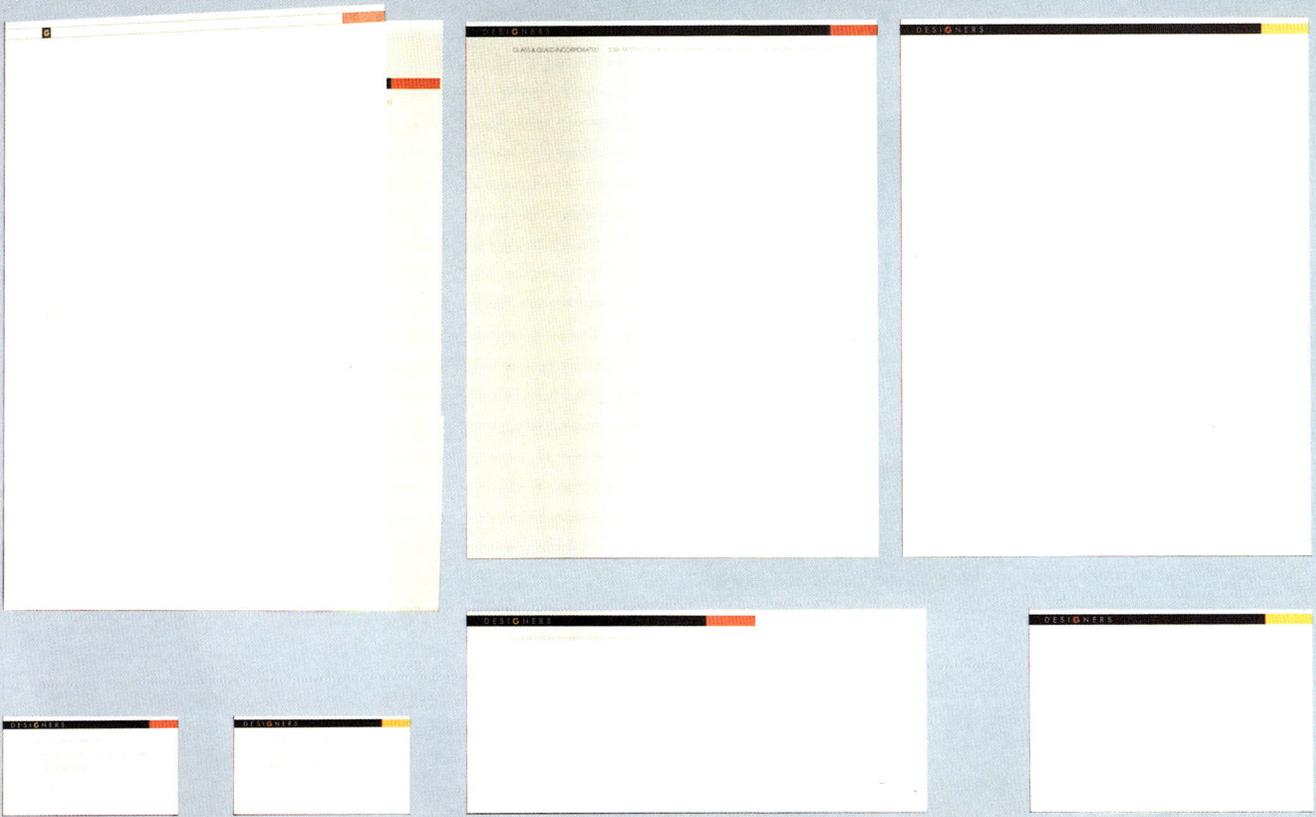

STATIONERY
TYPOGRAPHY/DESIGN *Al Glass, Washington, D.C.* **TYPOGRAPHIC SUPPLIER** *Type Foundry* **STUDIO** *Glass & Glass, Inc.*
CLIENT *Glass & Glass, Inc.* **PRINCIPAL TYPE** *Futura Light* **DIMENSIONS** *8½ × 11 in. (21.6 × 27.9 cm)*

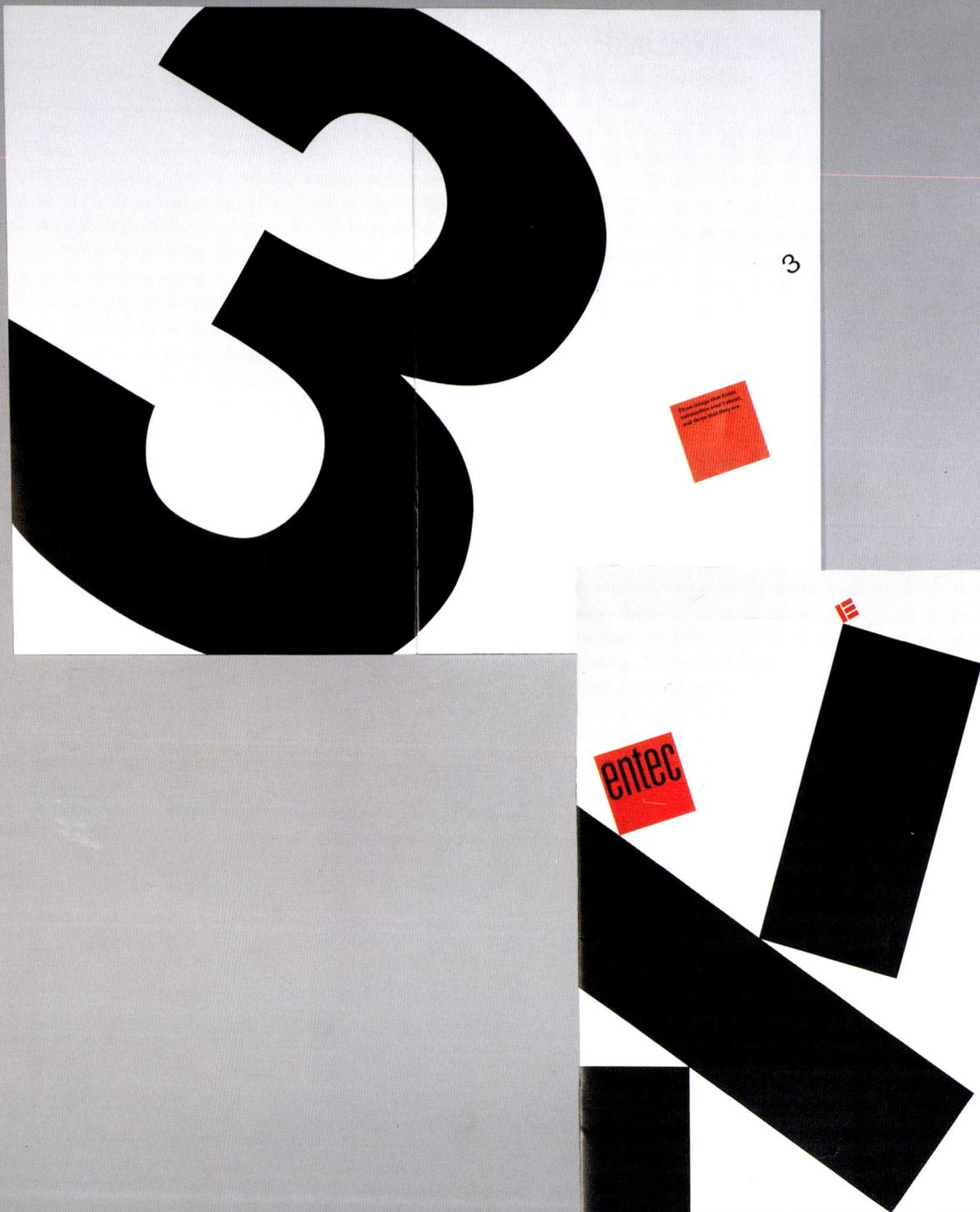

BROCHURE
TYPOGRAPHY/DESIGN *Mitchell Mauk, San Francisco, California* **TYPOGRAPHIC SUPPLIER** *Z Typography* **STUDIO** *Mauk Design*
CLIENT *Entertainment Technologies* **PRINCIPAL TYPE** *Univers* **DIMENSIONS** *11 .× 17 in. (27.9 × 43.2 cm)*

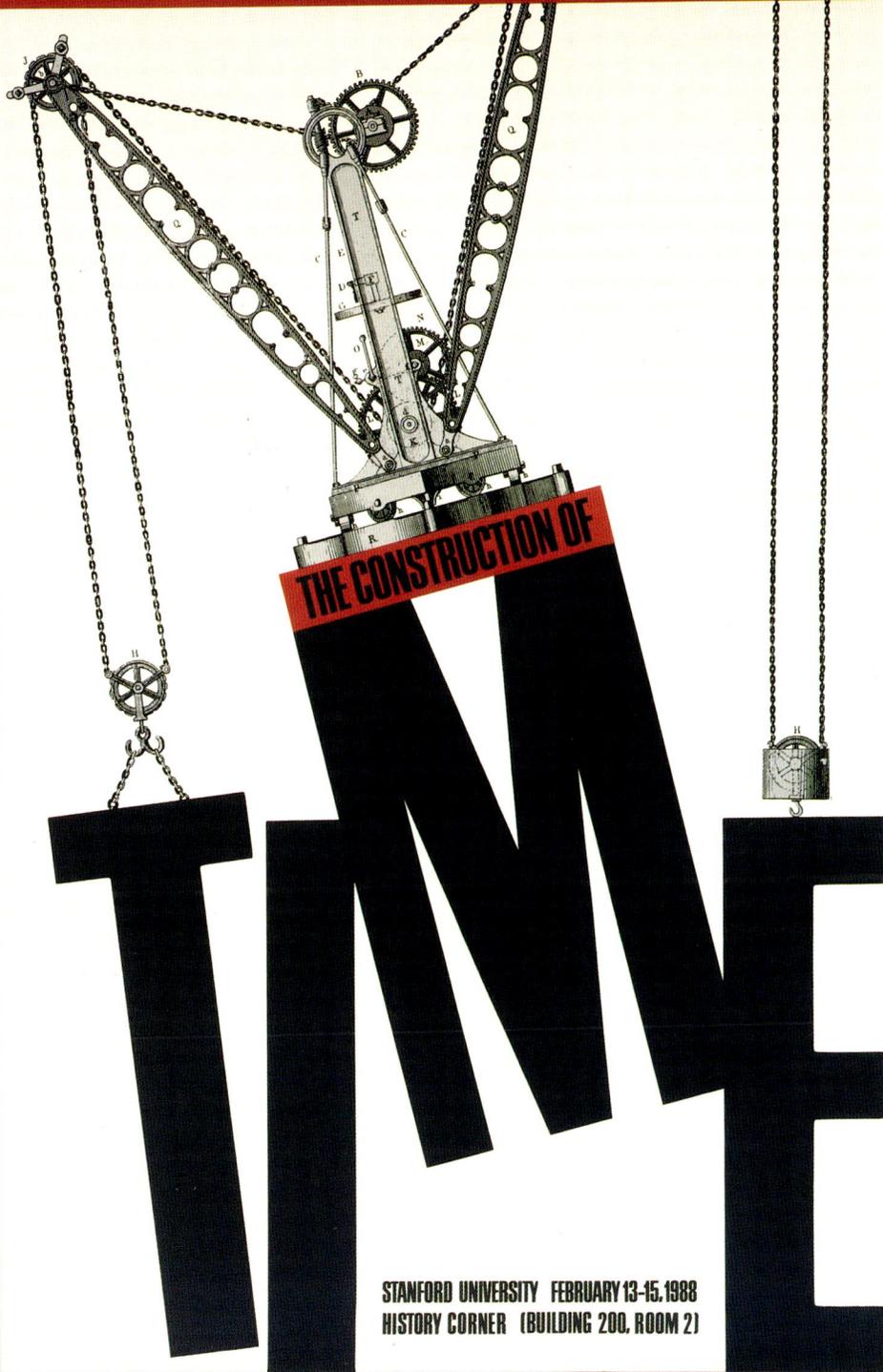

POSTER
TYPOGRAPHY/DESIGN *Barbara Mendelsohn, Stanford, California* **CALLIGRAPHER** *Ev Shiro, Stanford, California* **TYPOGRAPHIC SUPPLIERS** *Omnicomp and Z Typography* **STUDIO** *Stanford University News and Publications* **CLIENT** *Stanford University* **PRINCIPAL TYPES** *Permanent Headline and Franklin Gothic* **DIMENSIONS** *17½ × 23½ in. (14.4 × 29.6 cm)*

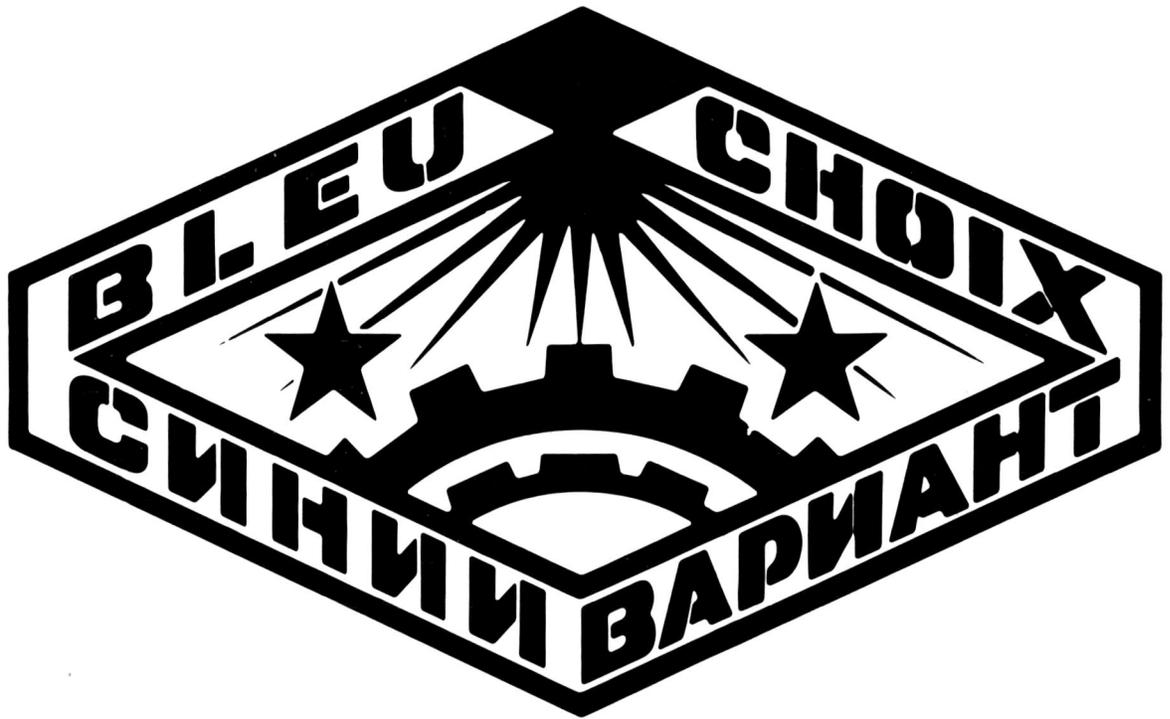

PRODUCT ACCESSORIES IDENTITY
TYPOGRAPHY/DESIGN *Tim Girvin, Seattle, Washington* **LETTERERS** *Tim Girvin and Anton Kimball* **STUDIO** *Tim Girvin Design, Inc.*
CLIENT *Generra Corporation* **PRINCIPAL TYPE** *Handlettering* **DIMENSIONS** *3 × 7 in. (7.6 × 17.8 cm)*

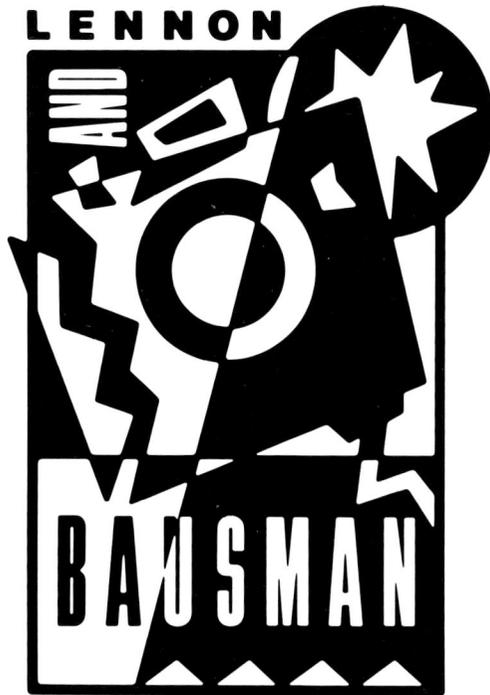

LOGOTYPE
TYPOGRAPHY/DESIGN *Sara Ledgard, Minneapolis, Minnesota* **LETTERER** *Sara Ledgard* **TYPOGRAPHIC SUPPLIER** *Typeshooters*
STUDIO *The Duffy Design Group* **CLIENT** *Lennon Bausman Photography* **PRINCIPAL TYPE** *Helvetica Extra Bold and Ultra Condensed*

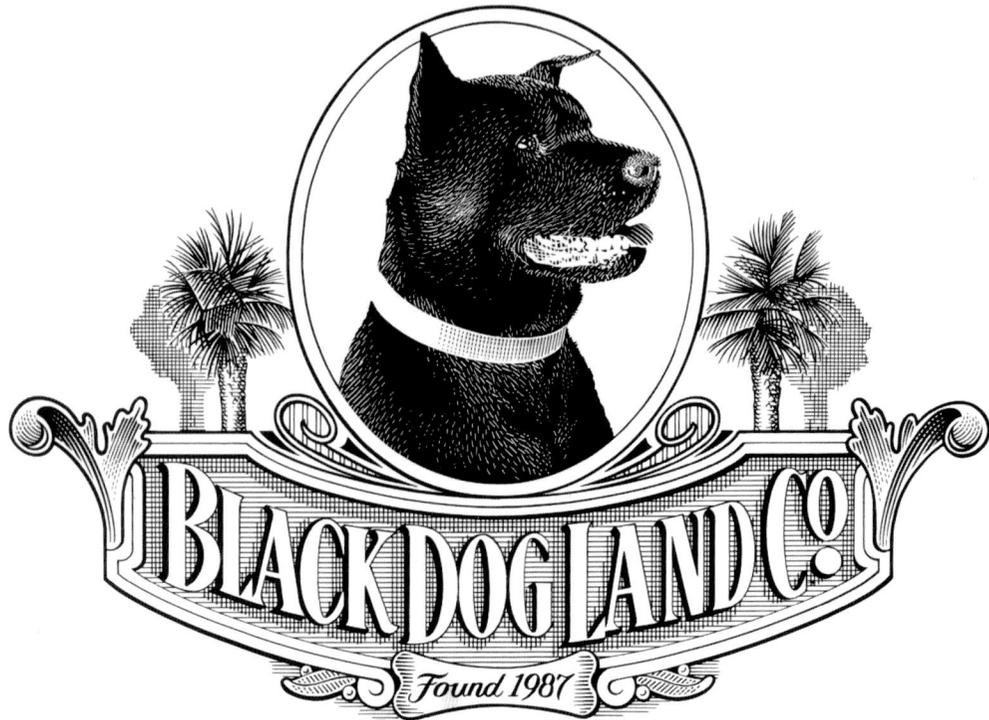

LOGOTYPE
TYPOGRAPHY/DESIGN *Robin Shepherd and Tom Schifanella, Jacksonville, Florida* **LETTERERS** *Bob Cooper and Mike Barnhart,*
Atlanta, Georgia, and Jacksonville, Florida **STUDIO** *Robin Shepherd Studios* **CLIENT** *Black Dog Land Company*
PRINCIPAL TYPE *Handlettering* **DIMENSIONS** *4 × 5¾ in. (10.2 × 14.6 cm)*

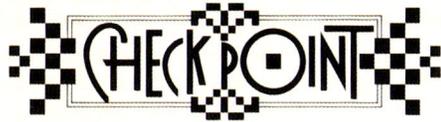

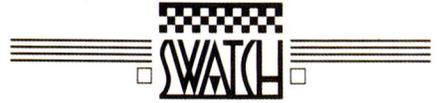

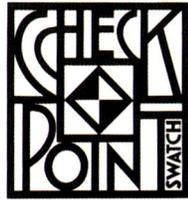

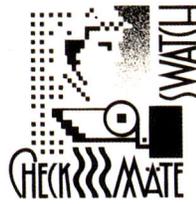

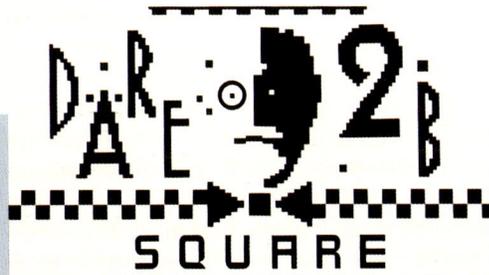

APPAREL DESIGN CAMPAIGN
TYPOGRAPHY/DESIGN *Jeanne Greco and Maruchi Santana, New York, New York* **LETTERER** *Jeanne Greco*
STUDIO *Parham-Santana Inc.* **CLIENT** *Swatch USA* **PRINCIPAL TYPE** *Handlettering* **DIMENSIONS** *Various*

DANIEL PELAVIN

THE CAREER OF DANIEL PELAVIN, OR, HOW TO RISE TO THE TOP IN ONLY 30 YEARS.

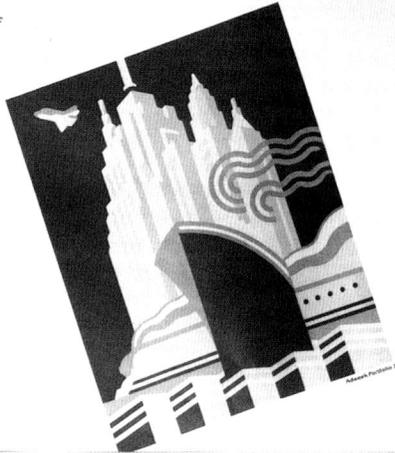

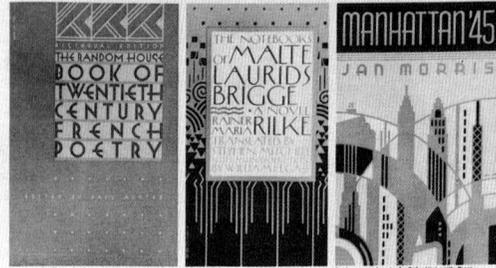

Book cover for Vintage books | Book cover for Vintage books | Book cover and poster for Oxford University Press

Two things graphics students must accept from the start: You can draw like Michelangelo but never become a great illustrator; you can make clever, handsome designs, but not succeed in graphic communication. If your work doesn't illuminate, demonstrate, tell, sell or explain an idea or a product, you're in the wrong business.

There are, of course, any number of people in the field who love the "graphics" but deplore the "communication." Daniel Pelavin is not among them. He is one of those refreshing artists who thoroughly enjoys, as he puts it, "interpreting ideas for people to people." And he has found a most distinctive, successful way of doing it. He reduces ideas to the most fundamental symbols. His images are crisp, clear and immediately understood; hardly a word is required to amplify their meaning. But to tell the truth, his abbreviated, deceptively simple style was 30 years in the making.

If you take only a hasty glance at his work, you're likely to sum it up with a hasty, "Ah, yes, Art Deco." But if you study it for a while, you'll see that his style evolved from a lifetime of visual experiences. You'll guess (and be right) that he was a child who drew cars, boats, planes,

buildings and machines obsessively. (His adult cars, boats, planes, etc., have lost none of their vigor and conviction.) You'll also deduce correctly that he found a kinship with the energetic, rhythmic zigzags and streamlined patterns of Art Deco design. You'll see the influence of Stuart Davis' abstractions, of Roy Lichtenstein's parodies of comic book culture, and all the other bold "pop art" iconography of the '60s, as well as the impeccable hard edge mentality of the '70s. Pelavin has been wide open to all the visual and technological developments around him. He observes, sorts out, filters and incorporates whatever ideas advance his work.

To arrive at a distinctive personal style such as his is a good thing for an illustrator. The fact that it came naturally to him, and is not an affectation, is even better. His work rings with conviction and integrity. There are no false notes—no tricks. Although he admits he is often hired because his style evokes a specific period or theme, his geometric forms and sans serif type are suitable for a wide range of moods and meanings. Furthermore, his finished art is so mechanically flawless, it can be enlarged, reduced, manipulated and reproduced with

Corporate illustration (1985)

There was a time when illustration was more than just a substitute for photography. When the magic of an image, transformed by the hand of an artist, inspired people to say "a picture is worth a thousand words." There still is.
Daniel Pelavin
46 Commerce Street
New York City 10014
(212) 929 · 2706

Book cover for Vintage books and Black Book ad (1986)

absolute fidelity to the original work.
Aside from his singular drawing and lettering styles, Pelavin is full of surprises when it comes to color. He uses unpredictable hues in unexpected combinations; it's all part of his deliberate effort to interrupt the reader, engage the eye and help deliver the message.

When Daniel Pelavin came to New York in 1979 he was 31 years old, but his entire life had been building for his career in graphic design. He had

already worked in a studio and learned all the basic graphic skills—retouching, lettering, airbrushing, comping. He had done illustration and design projects, earned an MFA at Cranbrook Academy of Art in Michigan, and taught Advertising Design at a community college.

With incredible courage, he set up shop in New York as a freelancer. He did not want a studio job where he might be locked into a single specialty. Needless to say, he has been amply rewarded for

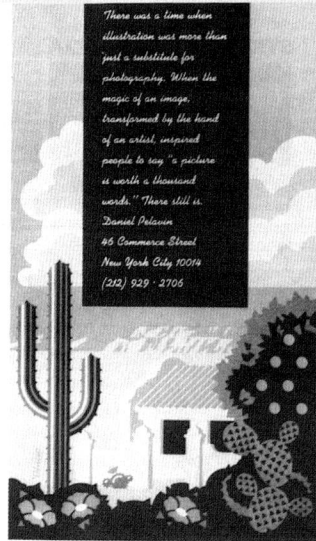

his spunk. His illustration and design work have appeared in publications of Time, Inc., Condé Nast, Ziff-Davis, Hearst, McGraw-Hill, McCall's, CBS and The New York Times. He has also won recognition from the American Institute of Graphic Arts, the Society of Publication Designers, The Art Directors Club of New York, the San Francisco Society of Communication Arts, Mead Paper Company and Print and Communication Arts magazines.

Truly a man of his times, Pelavin has recently

involved himself in computer graphics projects with IBM and the Visual Language Workshop at the Massachusetts Institute of Technology. It is difficult to believe that this totally committed graphic artist almost enrolled in law school after college. Far afield as that may sound, with his orderly logical mind we presume he would have been just as successful with writs and torts as he is with the T-square and typography.
Marion Muller

Animals throughout were designed as hangtags for Barneman's children's clothing

MAGAZINE
TYPOGRAPHY/DESIGN *B. Martin Pedersen, New York, New York* **TYPOGRAPHIC SUPPLIER** *Characters Typographic Services, Inc.*
STUDIO *International Typeface Corporation* **CLIENT** *U & lc* **PRINCIPAL TYPES** *ITC Benguiat Gothic and ITC Avant Garde Gothic*
DIMENSIONS *11 × 14½ in. (27.9 × 36.8 cm)*

LOVE AFFAIR

"If Gillott ever stops making my No. 290 and 291 pens, I'll have to find another career," says Ray Morrone.

"Not likely," say we.

Raymond Morrone of San José, California, has been addicted to penmanship since childhood, and though he made a detour into engineering and spent most of his professional life as a typographer, he has finally settled into the work he loves best—Spencerian writing.

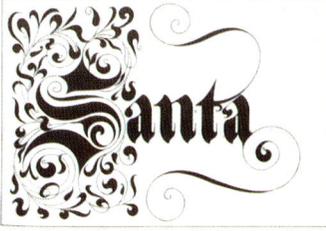

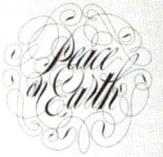

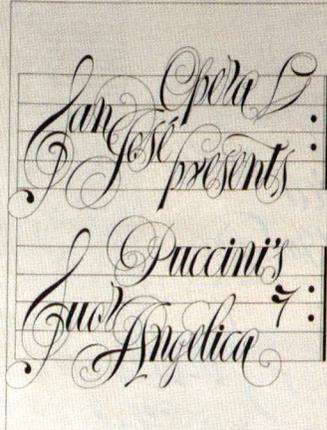

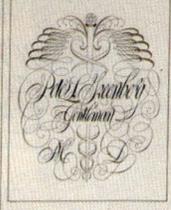

Just for the record, Platt Rogers Spencer, the 19th-century American who originated the hand, was not the only inspiration in Morrone's life. He is a long-time student of the 18th-century English calligrapher, George Bickham.

While he is an appreciator of all forms of calligraphy, he chooses to concentrate on Spencerian, which he executes with the finest of pens and a

loving hand. You have to really love the work to do it, because your concentration must be absolute and the time consumed would be punishing if your heart and your mind were elsewhere. A three-word sentence, for instance, might take a full week to complete, counting sketches, revisions and final inking.

Morrone, of course, does not work for kicks alone. He has

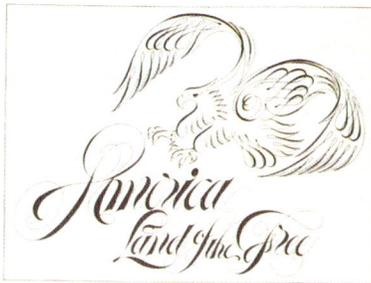

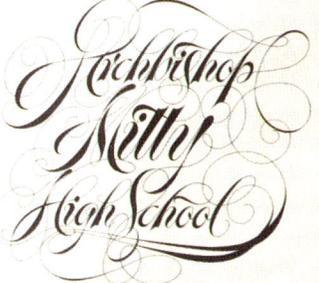

completed numerous commercial assignments, including a series of Academy Award winners and an announcement for the Opera San José.

His favorite piece of work? The valentine on our cover, which was a three-month labor of love. —Marion Muller

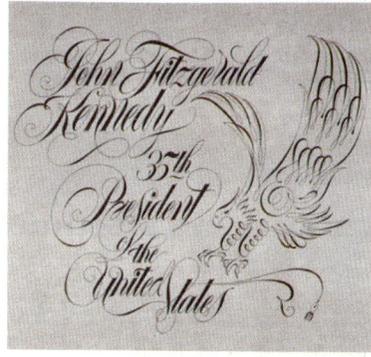

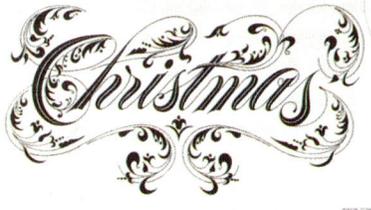

MAGAZINE
TYPOGRAPHY/DESIGN *Mo Lebowitz, North Bellmore, New York* **CALLIGRAPHER** *Raymond Morrone, San José, California*
TYPOGRAPHIC SUPPLIER *Characters Typographic Services, Inc.* **STUDIO** *International Typeface Corporation* **CLIENT** *U & lc*
PRINCIPAL TYPE *ITC Franklin Gothic* **DIMENSIONS** *11 × 14½ in. (27.9 × 36.8 cm)*

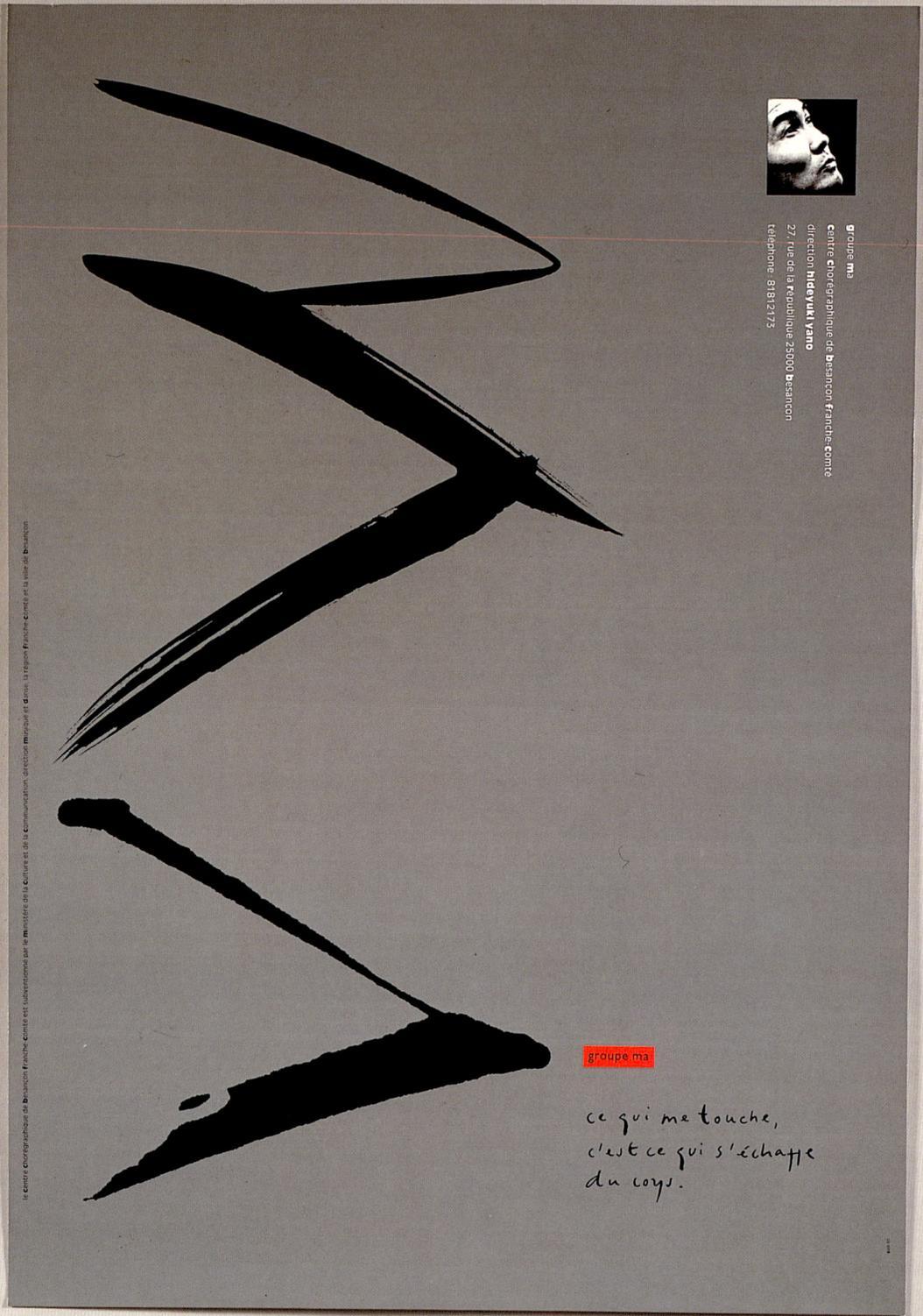

POSTER
TYPOGRAPHY/DESIGN *Zask, Paris, France* **CALLIGRAPHER** *Zask* **CLIENT** *Group Ma—Centre Choreographique de Besançon Franche-Comté* **PRINCIPAL TYPE** *Antique Olive* **DIMENSIONS** *23⅝ × 33⅞ in. (60 × 86 cm)*

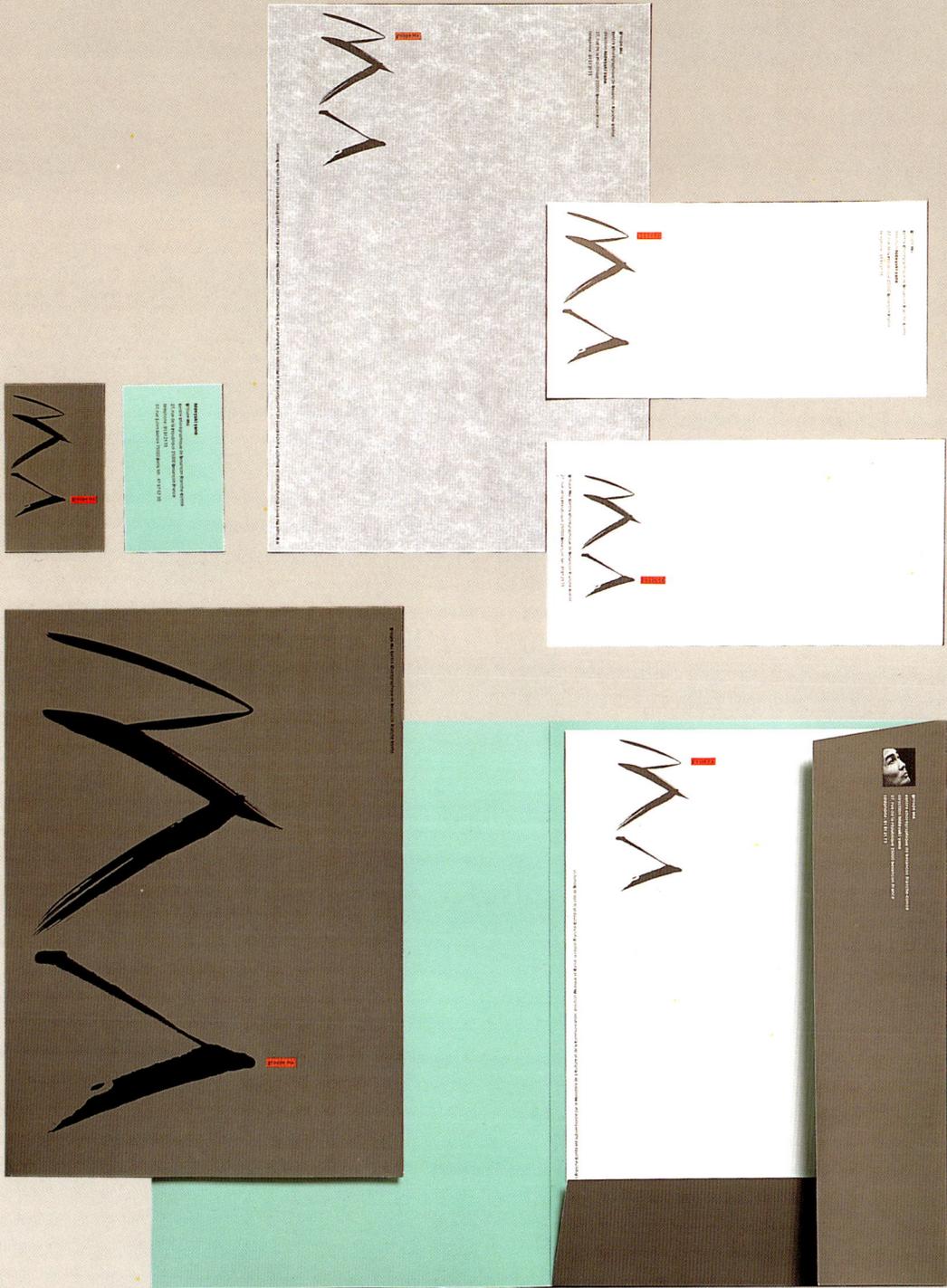

STATIONERY
TYPOGRAPHY/DESIGN *Zask, Paris, France* **CALLIGRAPHER** *Zask* **CLIENT** *Group Ma—Centre Choreographique de Besançon Franche-Comté* **PRINCIPAL TYPE** *Antique Olive* **DIMENSIONS** *8⅛ × 11¾ in. (21 × 29.8 cm)*

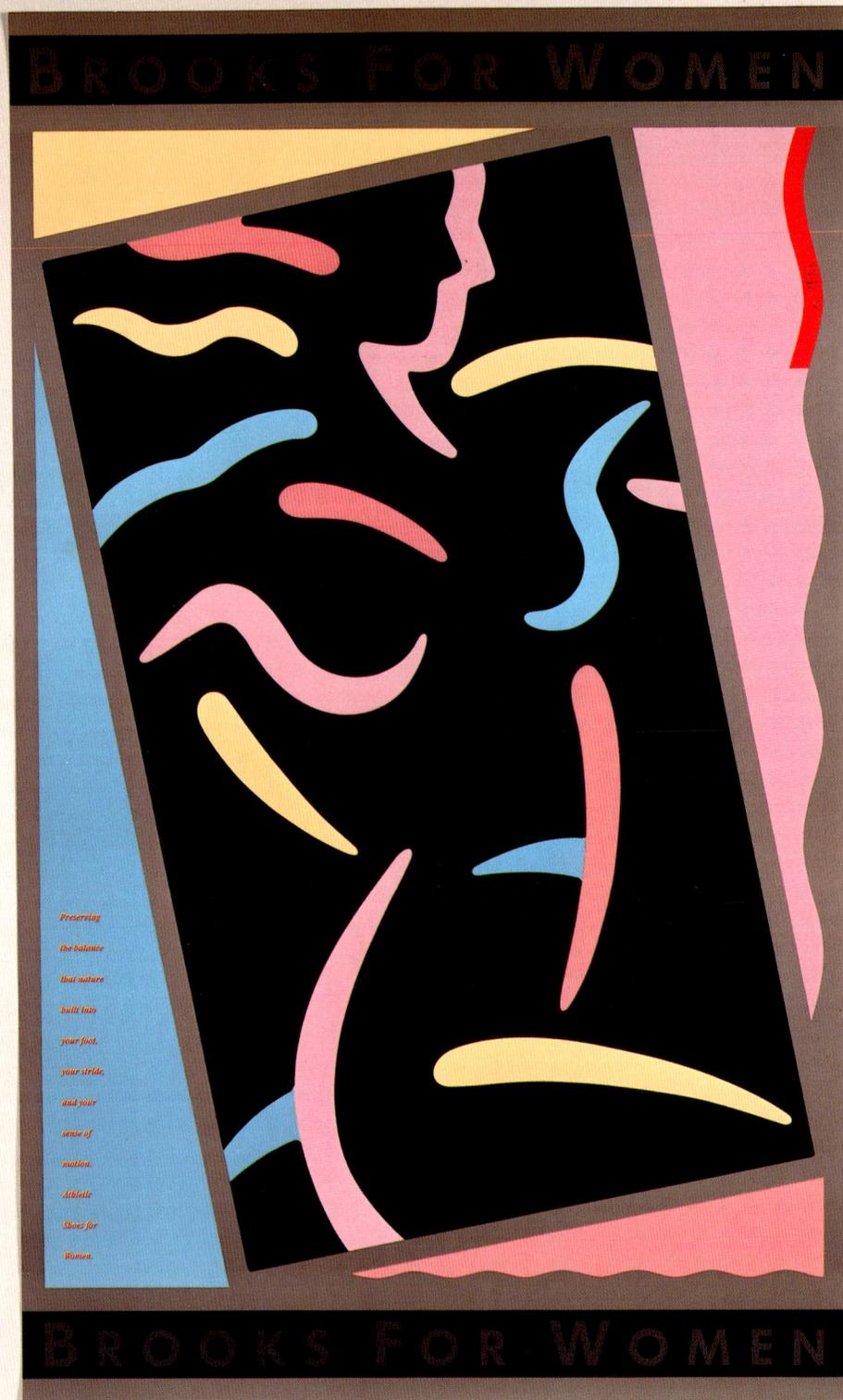

POSTER
TYPOGRAPHY/DESIGN *Charles S. Anderson, Minneapolis, Minnesota* **TYPOGRAPHIC SUPPLIER** *Typeshooters*
STUDIO *The Duffy Design Group* **CLIENT** *Brooks Shoes* **PRINCIPAL TYPE** *Futura* **DIMENSIONS** *21 × 36 in. (53.3 × 91.4 cm)*

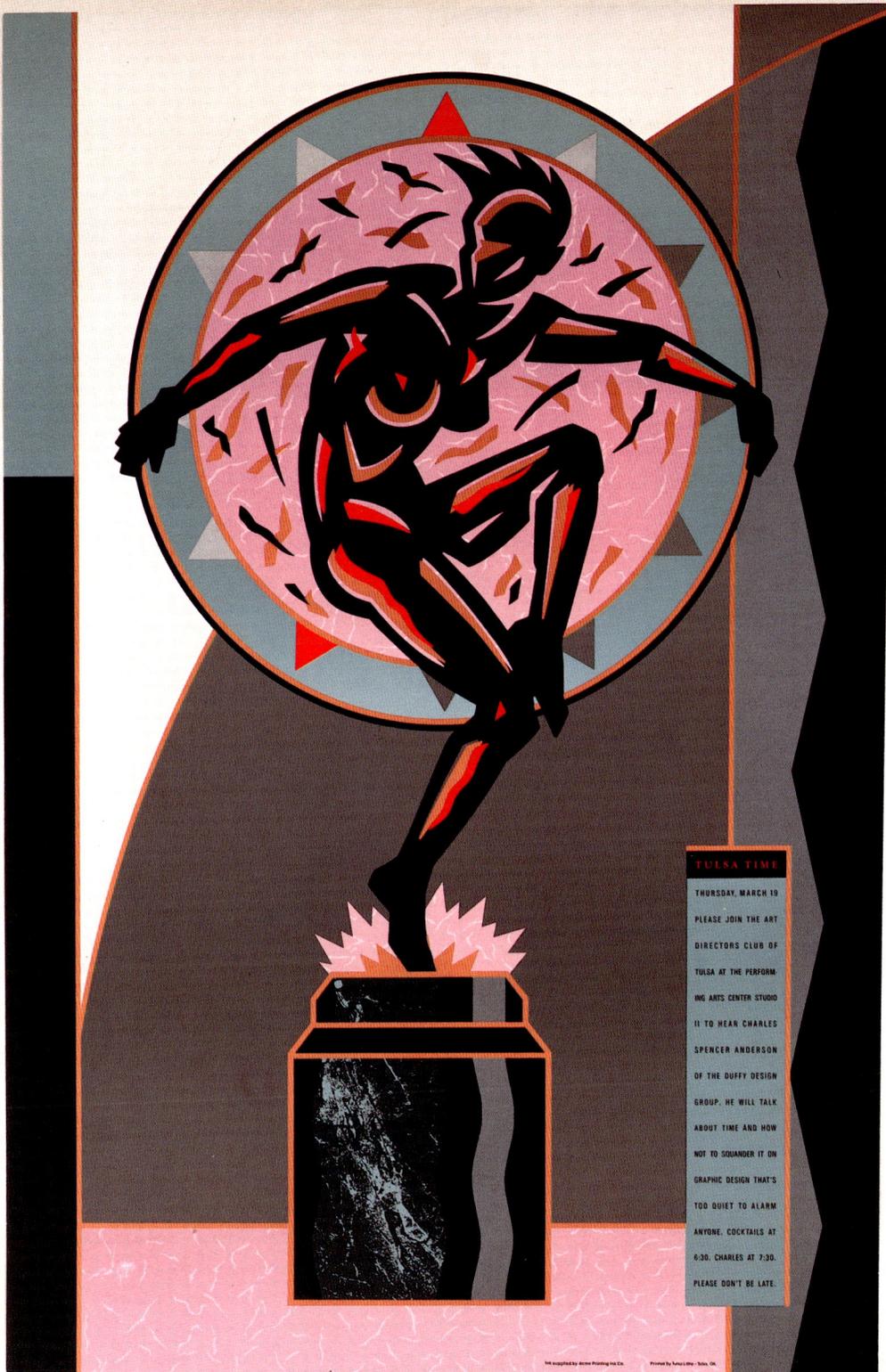

POSTER
TYPOGRAPHY/DESIGN *Charles S. Anderson, Minneapolis, Minnesota* **LETTERER** *Charles S. Anderson* **TYPOGRAPHIC**
SUPPLIER *Typeshooters* **STUDIO** *The Duffy Design Group* **CLIENT** *Art Directors Club of Tulsa* **PRINCIPAL TYPE** *Univers*
DIMENSIONS *17 × 25½ in. (43.2 × 64.8 cm)*

MICHELLE DURAND-ADAMS
President

MIDAMERICA
STUDENT LOAN CO.
P.O. BOX 22070
DES MOINES, IOWA 50322
PHONE: 515 • 223 • 7446

MIDAMERICA
STUDENT LOAN CO.
P.O. BOX 22070
DES MOINES, IOWA 50322
PHONE: 515 • 223 • 7446

CORPORATE IDENTITY
TYPOGRAPHY/DESIGN *Sayles Graphic Design, Inc., Des Moines, Iowa* **LETTERER** *John Sayles* **TYPOGRAPHIC**
SUPPLIER *Push-Pen Studios* **STUDIO** *Sayles Graphic Design, Inc.* **CLIENT** *MidAmerica Student Loan Co.*
PRINCIPAL TYPE *Garamond* **DIMENSIONS** *8½ × 11 in. (21.6 × 27.9 cm)*

STATIONERY
TYPOGRAPHY/DESIGN *Haley Johnson, Minneapolis, Minnesota* **LETTERER** *Lynn Schulte, Minneapolis, Minnesota*
TYPOGRAPHIC SUPPLIER *Typeshooters* **STUDIO** *The Duffy Design Group* **CLIENT** *Calhoun Beach Club* **PRINCIPAL TYPE** *Futura*
DIMENSIONS *8½ × 11 in. (21.6 × 27.9 cm)*

LOGOTYPE
TYPOGRAPHY/DESIGN *John Ball, San Diego, California* **ILLUSTRATOR** *James Staunton, San Diego, California* **TYPOGRAPHIC**
SUPPLIER *Archives* **AGENCY** *Huntington Public Relations* **STUDIO** *Mires Design* **CLIENT** *South Coast Vintners Association*
PRINCIPAL TYPES *Agency Gothic and Dolmen Black*

BROCHURE
TYPOGRAPHY/DESIGN *Jennifer Morla, San Francisco, California* **TYPOGRAPHIC SUPPLIERS** *Andresen Typographics and Spartan Typographers* **STUDIO** *Morla Design, Inc.* **CLIENT** *Bradmill USA, Ltd.* **PRINCIPAL TYPES** *Kabel Ultra and Bold* **DIMENSIONS** *11 × 16 in. (27.9 × 40.6 cm)*

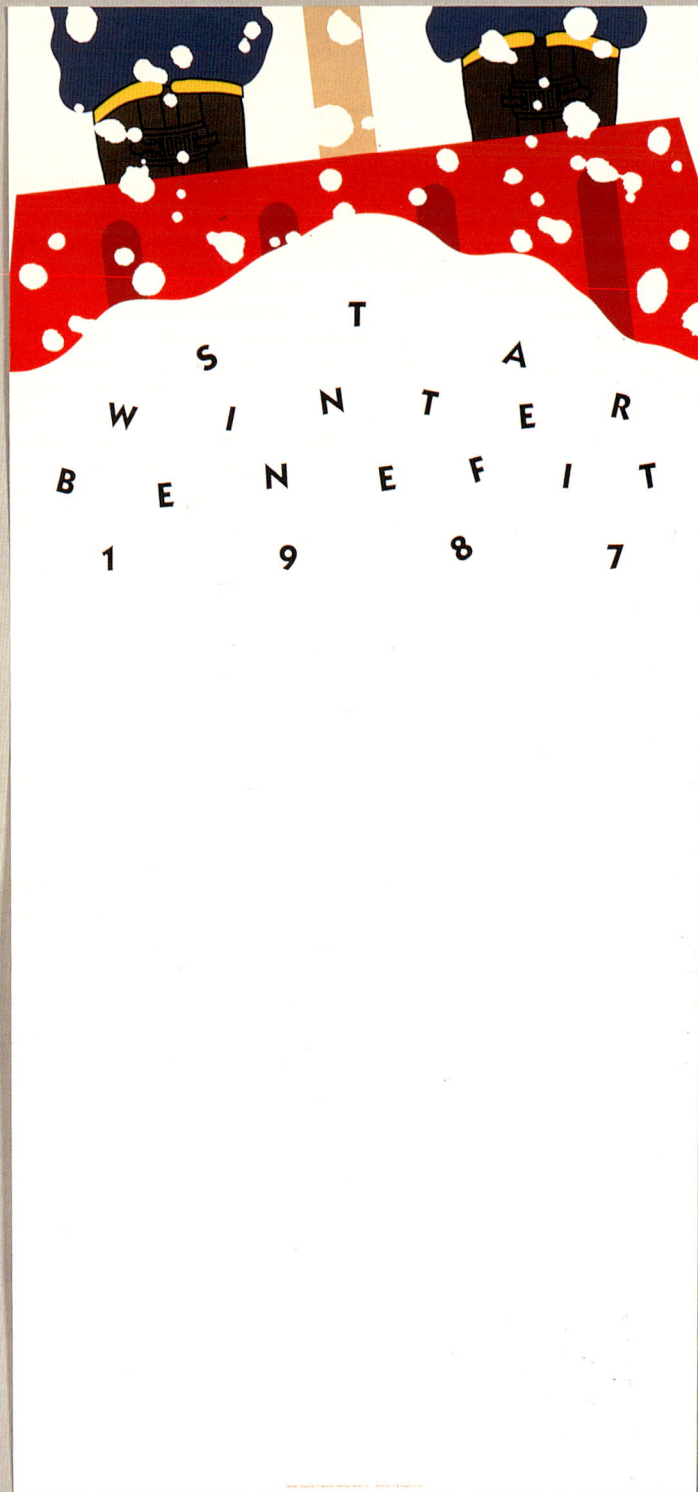

POSTER
TYPOGRAPHY/DESIGN *Stephen Frykholm, Zeeland, Michigan* **TYPOGRAPHIC SUPPLIER** *Type House, Inc.* **STUDIO** *Stephen Frykholm*
CLIENT *STA Chicago* **PRINCIPAL TYPE** *Kabel* **DIMENSIONS** *15½ × 33 in. (39.5 × 83.5 cm)*

BOOK
TYPOGRAPHY/DESIGN *Pat and Greg Samata, Dundee, Illinois* **TYPOGRAPHIC SUPPLIER** *Paul Thompson* **STUDIO** *Samata Associates*
CLIENT *Samata Associates* **PRINCIPAL TYPE** *Garamond Italic* **DIMENSIONS** *7⅛ × 8 in. (18.1 × 20.3 cm)*

A LEGACY AS IMPORTANT AS ALL OUTDOORS

HENNEPIN PARKS FOUNDATION

BROCHURE
TYPOGRAPHY/DESIGN *John C. Reger and Dan Olson, Minnetonka, Minnesota* **TYPOGRAPHIC SUPPLIER** *Typeshooters*
STUDIO *Design Center* **CLIENT** *Hennepin Parks Foundation* **PRINCIPAL TYPE** *Century Light*
DIMENSIONS *7⅜ × 10 in. (18.8 × 25.4 cm)*

The cover and title page show:

&

An
Ampersand
by Frederic
Goudy

A TYPOGRAPHICAL TWELVE DAYS OF CHRISTMAS

An Ampersand
by Frederic Goudy

A Typographical Twelve Days
of Christmas

EVE Press

BOOK
TYPOGRAPHY/DESIGN *Elsi Vassdal Ellis, Bellingham, Washington* **TYPOGRAPHIC SUPPLIER** *EVE Press* **STUDIO** *EVE Press*
CLIENT *EVE Press* **PRINCIPAL TYPE** *Galliard Roman* **DIMENSIONS** *5½ × 4⅞ in. (14 × 12.5 cm)*

POSTER
TYPOGRAPHY/DESIGN *Albert Treskin, San Francisco, California* **LETTERER** *Albert Treskin* **TYPOGRAPHIC**
SUPPLIER *De-Line-O-Type* **CLIENT** *San Luis Obispo Mozart Festival* **PRINCIPAL TYPES** *Torino, Garamond Old Style Italic, and Handlettering* **DIMENSIONS** *18 × 18 in. (45.7 × 45.7 cm)*

Delta Dental

Plan of

California

1 9 8 6

Annual

Report

They're all ages, all colors, and from almost every culture around the globe. They come from large corporations, small companies, and government. • For over thirty years Delta Dental Plan of California has been evaluating and meeting the needs of this diverse group of people. Californians. We understand diversity and the need to be flexible as the market expands and changes. • As we add new and groups to our list of subscribers, we are continuing a business process that began in 1955 with the refinement of our first dental program, one which was designed specifically for children. Today, whether we're covering employees, their children or as individuals, we respond to the market with quality dental plans structured to meet specific group requirements.

Every child discovers the diversity of her world. If she has explored the diversity of our market and responded with good care and attention for subscribers of all ages and backgrounds.

ANNUAL REPORT
TYPOGRAPHY/DESIGN *Conrad and Karen Jorgensen, San Francisco, California* **TYPOGRAPHIC SUPPLIER** *Eurotype*
STUDIO *Jorgensen Design Associates* **CLIENT** *Delta Dental Plan of California* **PRINCIPAL TYPE** *Bodoni Old Face (Berthold)*
DIMENSIONS *7⅞ × 11¾ in. (20 × 29.9 cm)*

What ever happened to Mary Jo Kopechne's five girlfriends who had the good fortune *not* to drive off with Ted Kennedy? See page 37. Why has there never been a best-seller or a movie or even a television docudrama about Chappaquiddick? See page 40. In the age of Everythingscam and Whatevergate,

CHAPPAQUIDDICK

how, after 18 years, can the Chappaquiddick cover-up remain so airtight? Good question. And why won't anybody publish an impressive new investigative book that for once gets a Kennedy cousin and Chappaquiddick witness *on the record* about the incident? Read this article.

The Unsold Story

BY TAD FRIEND

EARLY IN THE MORNING of July 19, 1969, after attending an intimate party of male political cronies and female political aides, Senator Edward Kennedy drove his Oldsmobile off Chappaquiddick Island's Dyke Bridge and into Poucha Pond. His passenger, Mary Jo Kopechne, drowned.

This is not exactly news. Most of us recall that after a considerable public rumpus, Senator Kennedy took the extraordinary step of going 'on television to explain—altogether unconvincingly—this latest Kennedy tragedy.

Kennedy pleaded guilty to leaving the scene of an accident after causing personal injury and later promised to consider resigning his Senate seat (*Nahhhh*, he evidently decided, instead going on to win reelection three times).

After receiving a two-month suspended sentence, he clammed up. And so did everyone else in a position to fill in some of the blanks—the five women at the party who did not drown in Ted Kennedy's car, the five men at the party who did not swim away from a submerged Oldsmobile and then lie about it. So the inquiries have blundered along without Kennedy's help, or the help of his loyal friends at the party. And so, naturally, strange Chappaquiddick theories abound: Kennedy was driving; Kennedy wasn't driving; Kennedy murdered Kopechne because she was pregnant with his child, and jumped out of the moving car in the nick of time; and so on.

What is news—or should be—is that Joe Gargan, a cousin of Kennedy's who spent much of that fatal evening with the senator, finally did unburden himself of his Chappaquid-

MAGAZINE SPREAD
TYPOGRAPHY/DESIGN *Alexander Isley, New York, New York* **TYPOGRAPHIC SUPPLIER** *Trufont Typographers, Inc.*
CLIENT *Spy magazine* **PRINCIPAL TYPES** *Alternate Gothic No. 1 and Garamond No. 3*
DIMENSIONS *10⅞ × 16 in. (27.6 × 41 cm)*

For many people, life is a series of high-stakes business deals, ferociously pursued - including courtship and marriage. Yes, this is 1987; loveless marriage is chic again. And even though we, like you, find the whole business appalling and sad and sordid and vulgar, once we started, we couldn't stop listening to NELL SCOVELL explain

How to Marry a

Gayfryd Steinberg grew up in a rented house in Vancouver, British Columbia, the daughter of a telephone company clerk. Today she lives with her husband, the overfed conglomerateur Saul Steinberg, in an art-clogged Park Avenue triplex that used to belong to John D. Rockefeller Jr. The apartment measures roughly 28,000 square feet, larger than Tiffany's three sales floors combined. Paintings by Titian, Rubens and Frans Hals hang in the public rooms. A lesser artist such as Renoir is placed in Gayfryd Steinberg's powder room.

Barbara "Basia" Piasecka Johnson emigrated from Poland in 1968 with $100 and sufficient cleaning skills to get a chambermaid's job in the home of J. Seward Johnson, the late nutty Johnson & Johnson heir and marine biology buff. Three years later she had stopped doing windows, married her boss and begun overseeing construction of Jasna Polana ("Bright Meadow"), a $30 million Palladian mansion of wretched excess on 140 acres in Princeton, New Jersey. The grounds include a 72-foot-long swimming pool surrounded by Greek and Roman antiquities

illionaire

GOLD-
diggers
of 1987

KEY

1. Alexis Mass Carson 2. Johnny Carson 3. Gloria Steinem 4. Mortimer Zuckerman 5. Gayfryd Steinberg 6. Saul Steinberg 7. Harry Helmsley 8. Leona Helmsley

SEPTEMBER 1987 **SPY** 63

MAGAZINE SPREAD
TYPOGRAPHY/DESIGN *Alexander Isley, New York, New York* **TYPOGRAPHIC SUPPLIERS** *Trufont Typographers, Inc., and TGA Communications* **CLIENT** *Spy magazine* **PRINCIPAL TYPES** *Alternate Gothic No. 1, Commercial Script, and Garamond Old Style* **DIMENSIONS** *10⅞ × 16 in. (27.6 × 41 cm)*

Die

WOHNUNG

u n v e r l e t z l i c h

Die Wohnung ist unverletzlich.
Durchsuchungen dürfen nur durch den Richter, bei Gefahr
im Verzuge auch durch die in den Gesetzen vorgesehenen
anderen Organe angeordnet und nur in der dort vor-
geschriebenen Form durchgeführt werden.
Eingriffe und Beschränkungen dürfen im übrigen nur zur
Abwehr einer gemeinen Gefahr oder einer Lebensgefahr
für einzelne Personen, auf Grund eines Gesetzes auch zur
Verhütung dringender Gefahren für die öffentliche Sicher-
heit und Ordnung, insbesondere zur Behebung der Raum-
not, zur Bekämpfung von Seuchengefahr oder zum Schutze
gefährdeter Jugendlicher vorgenommen werden.

ist

POSTER
TYPOGRAPHY/DESIGN *Detlef Behr, Frankfurt am Main, West Germany* **TYPOGRAPHIC SUPPLIER** *typeshop gmbh*
CLIENT *Fachhochschule Aachen* **PRINCIPAL TYPES** *Garamond Medium and Futura Book*
DIMENSIONS *11¾ × 16½ in. (29.7 × 42 cm)*

POSTER
TYPOGRAPHY/DESIGN *Takaaki Bando, Tokushima, Japan* **TYPOGRAPHIC SUPPLIER** *I Shashoku* **STUDIO** *Takaaki Bando Design*
CLIENT *Takaaki Bando* **PRINCIPAL TYPE** *Univers 55* **DIMENSIONS** *40⅛ × 24⅞ in. (102.1 × 63.1 cm)*

POSTER
TYPOGRAPHY/DESIGN *Takaaki Bando, Tokushima, Japan* **TYPOGRAPHIC SUPPLIER** *I Shashoku* **STUDIO** *Takaaki Bando Design*
CLIENT *Takaaki Bando* **PRINCIPAL TYPE** *Univers 55* **DIMENSIONS** *40⅛ × 24⅞ in. (102.1 × 63.1 cm)*

POSTER
TYPOGRAPHY/DESIGN *Takaaki Bando, Tokushima, Japan* **TYPOGRAPHIC SUPPLIER** *I Shashoku* **STUDIO** *Takaaki Bando Design*
CLIENT *Takaaki Bando* **PRINCIPAL TYPE** *Univers 55* **DIMENSIONS** *40⅛ × 24⅞ in. (102 × 63.2 cm)*

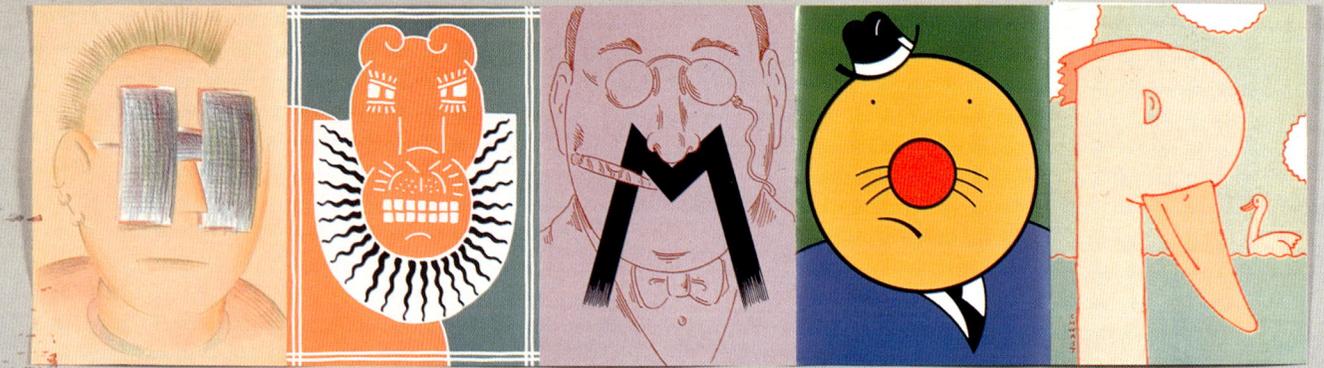

ANNOUNCEMENT
TYPOGRAPHY/DESIGN *Robert Anthony, New York, New York* **LETTERER** *Seymour Chwast, New York, New York*
TYPOGRAPHIC SUPPLIER *Typogram* **STUDIO** *Robert Anthony, Inc.* **CLIENT** *Madison Square Press* **PRINCIPAL TYPE** *LoType*
DIMENSIONS *42⅛ × 9⅝ in. (107 × 24.5 cm)*

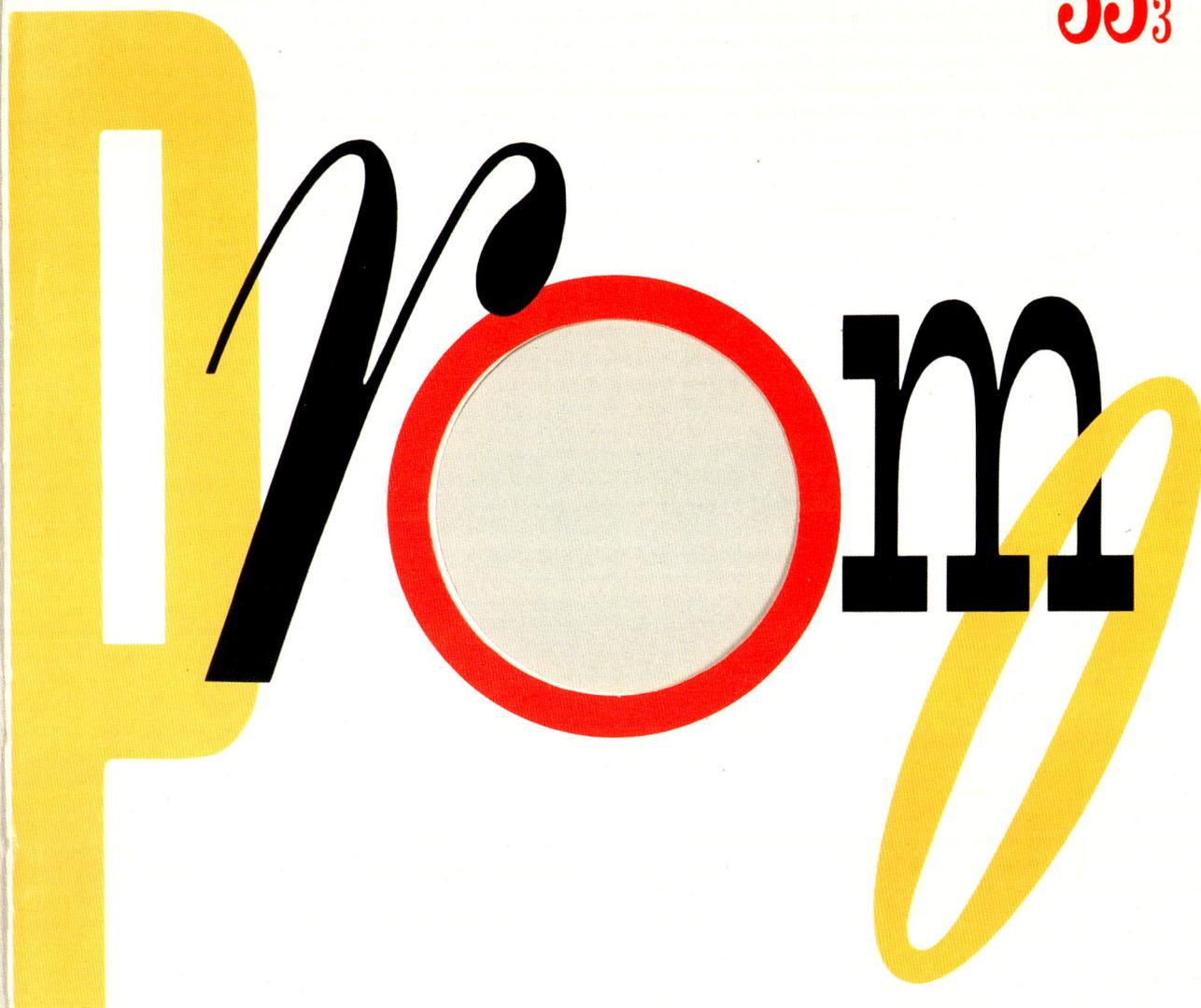

PROMOTIONAL RECORD SLEEVE
TYPOGRAPHY/DESIGN *Kav DeLuxe, Los Feliz, California* **TYPOGRAPHIC SUPPLIER** *Skil-Set Typographers*
AGENCY *Warner Bros. Records* **CLIENT** *Warner Bros. Records Promotion Department* **PRINCIPAL TYPES** *Binderstyle,*
Torino Italic, and Hellenic Wide **DIMENSIONS** *12³⁄₈ × 12³⁄₈ in. (31.5 × 31.5 cm)*

POSTER
TYPOGRAPHY/DESIGN *Scott Ray, Dallas, Texas* **TYPOGRAPHIC SUPPLIER** *Robert J. Hilton Co., Inc.* **STUDIO** *Peterson & Company*
CLIENT *Peterson & Company* **PRINCIPAL TYPE** *Futura Book* **DIMENSIONS** *17¼ × 33 in. (43.8 × 83.8 cm)*

BROCHURE
TYPOGRAPHY/DESIGN *Charles S. Anderson and Joe Duffy, Minneapolis, Minnesota* **LETTERER** *Charles S. Anderson* **TYPOGRAPHIC**
SUPPLIER *Typeshooters* **STUDIO** *The Duffy Design Group* **CLIENT** *Rolling Stone magazine* **PRINCIPAL TYPE** *Garamond Book*
DIMENSIONS *6½ × 6¾ in. (16.5 × 17.2 cm)*

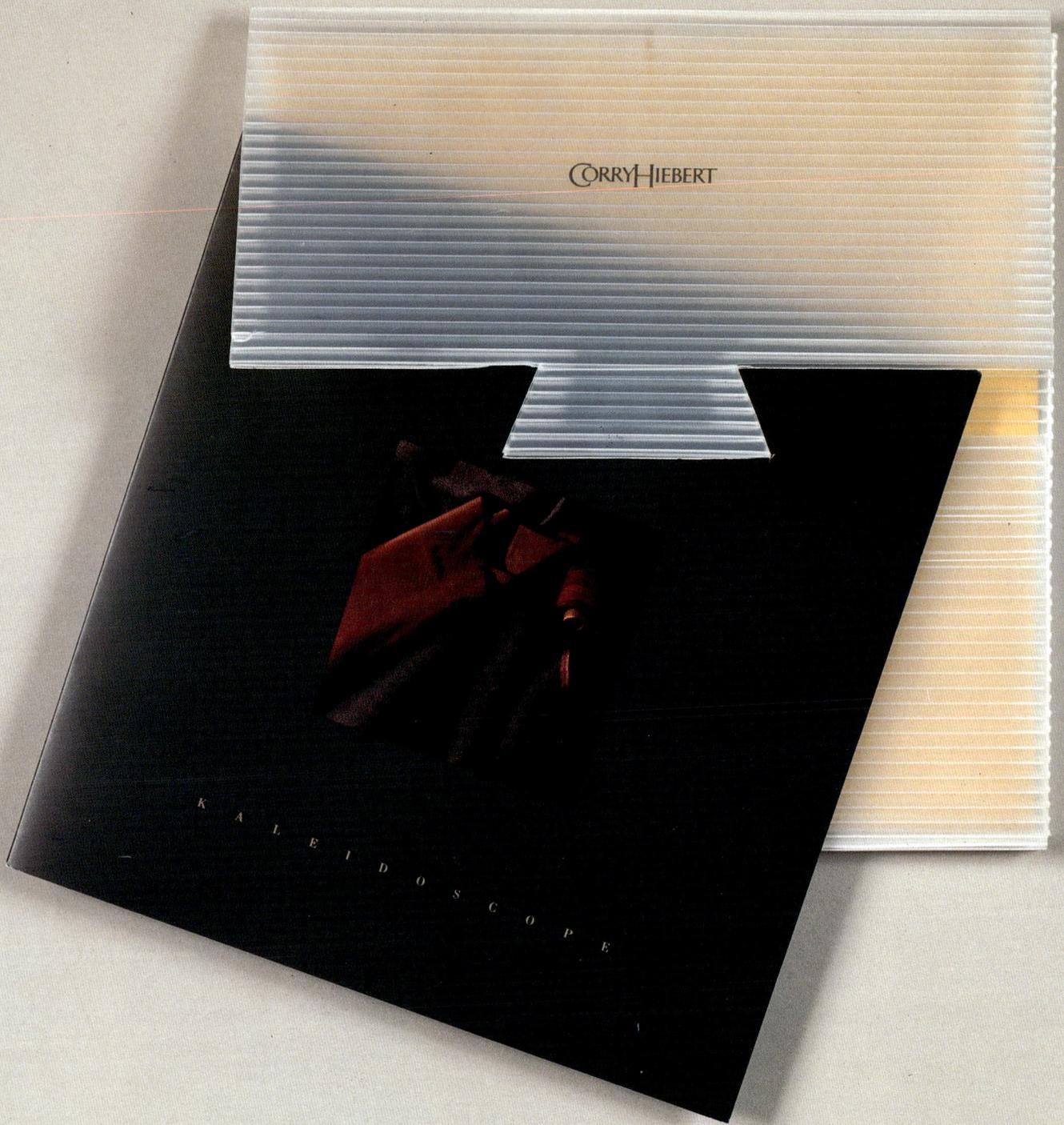

BROCHURE
TYPOGRAPHY/DESIGN *Steve Gibbs, Dallas, Texas* **TYPOGRAPHIC SUPPLIER** *Characters* **STUDIO** *Gibbs Design, Inc.*
CLIENT *Corry Hiebert* **PRINCIPAL TYPE** *Garamond* **DIMENSIONS** *9 × 9 in. (22.9 × 22.9 cm)*

CATALOG
TYPOGRAPHY/DESIGN *Kevin Cahill, Meredith Davis, and Robert Meganck, Richmond, Virginia* **CALLIGRAPHER** *Sue Coe, New York, New York* **TYPOGRAPHIC SUPPLIER** *Riddick Advertising Art* **STUDIO** *Communication Design, Inc.* **CLIENT** *Anderson Gallery*
PRINCIPAL TYPE *Franklin Gothic Condensed* **DIMENSIONS** *11 × 16 in. (27.9 × 40.6 cm)*

KINGDOUGLAS

PHOTOGRAPHY

LOGOTYPE
TYPOGRAPHY/DESIGN *Willie Baronet, Dallas, Texas* **ART DIRECTOR** *Ron Sullivan, Dallas, Texas*
TYPOGRAPHIC SUPPLIER *Southwestern Typographics, Inc.* **STUDIO** *Sullivan Perkins* **CLIENT** *King Douglas Photography*
PRINCIPAL TYPE *Permanent Massiv (modified slightly)*

POSTER
TYPOGRAPHY/DESIGN *Judy Dolim, Dallas, Texas* **CALLIGRAPHER** *Judy Dolim* **TYPOGRAPHIC SUPPLIER** *Production Department, Inc.*
STUDIO *Sibley/Peteet Design* **CLIENT** *USA Film Festival* **PRINCIPAL TYPE** *Bodoni* **DIMENSIONS** *23 × 28 in. (58.4 × 71.2 cm)*

POSTER
TYPOGRAPHY/DESIGN *Don Weller, Park City, Utah* **TYPOGRAPHIC SUPPLIER** *Whipple & Associates* **STUDIO** *The Weller Institute for the Cure of Design, Inc.* **CLIENT** *TDCTJHTBIPC 88 (The Design Conference That Just Happens to Be in Park City 1988)* **PRINCIPAL TYPES** *Goudy Old Style and Goudy Bold* **DIMENSIONS** *19 × 26 in. (48.3 × 66 cm)*

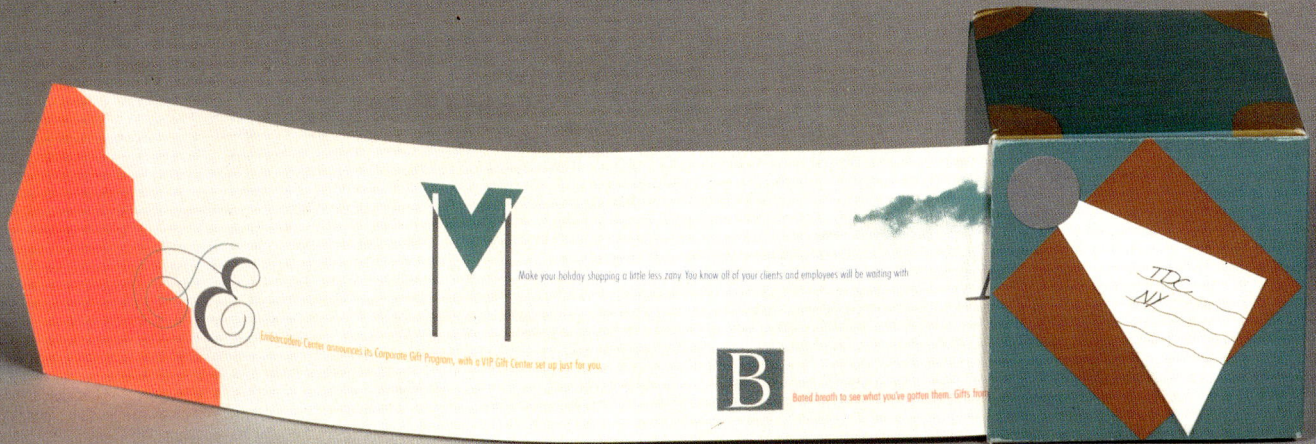

PROMOTION
TYPOGRAPHY/DESIGN *Erik Adigard, San Francisco, California* **ART DIRECTOR** *Bill Cahan, San Francisco, California*
LETTERER *Erik Adigard* **TYPOGRAPHIC SUPPLIER** *Andresen Typographics* **STUDIO** *Cahan & Associates* **CLIENT** *Embarcadero Center*
PRINCIPAL TYPE *Futura Condensed and Handlettering* **DIMENSIONS** *39½ × 3¼ in. (100.3 × 8.3 cm)*

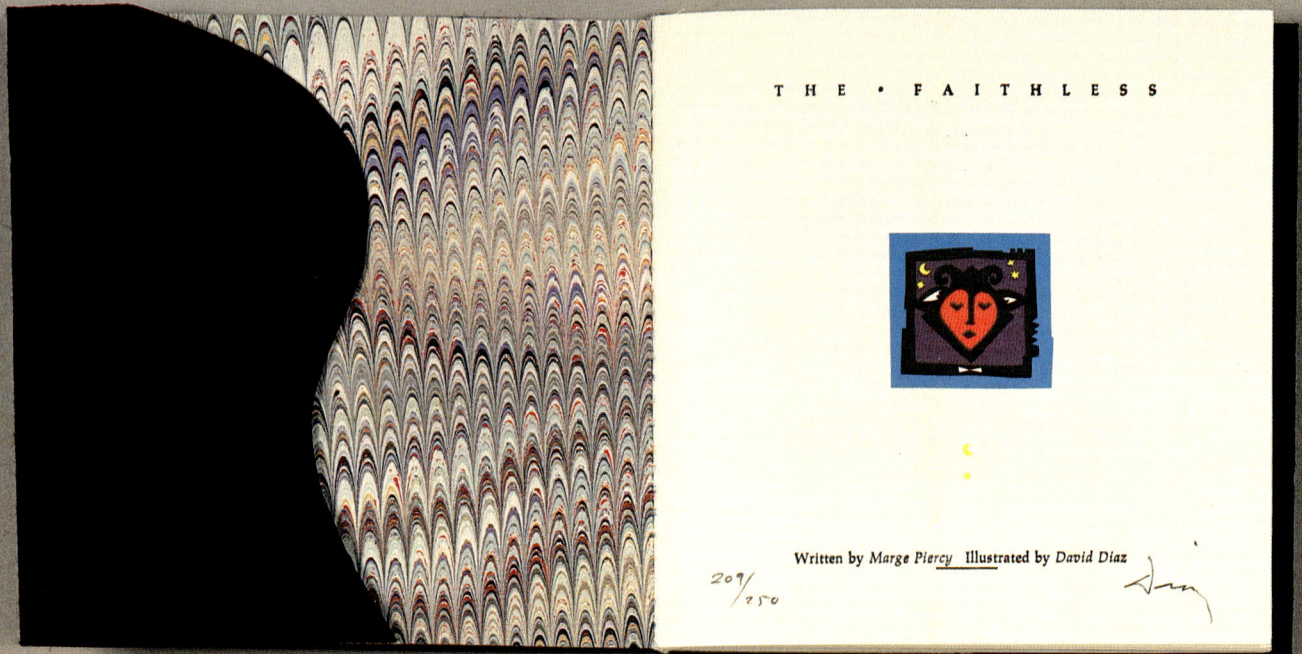

BOOK
TYPOGRAPHY/DESIGN *Cecelia A. Conover and David Diaz, Solana Beach, California, and Carlsbad, California*
TYPOGRAPHIC SUPPLIER *Ed Blount Typesetting* **STUDIO** *Evans & Conover* **CLIENT** *David Diaz Illustration* **PRINCIPAL TYPE** *Aldus*
DIMENSIONS *5 × 5 in. (12.7 × 12.7 cm)*

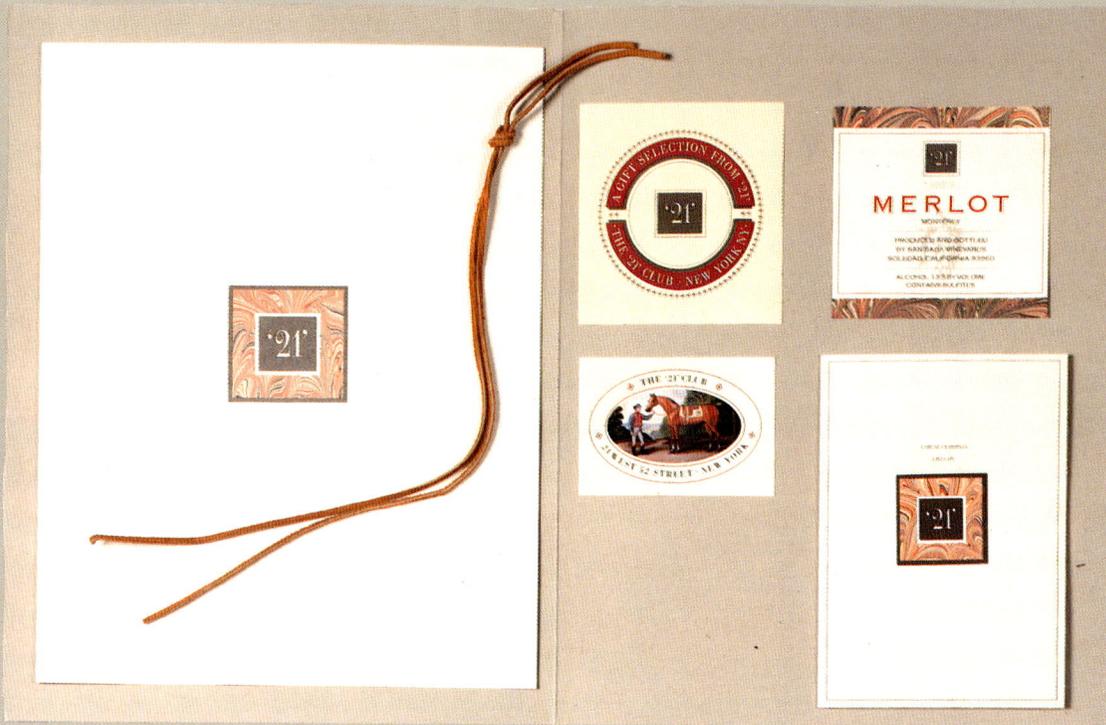

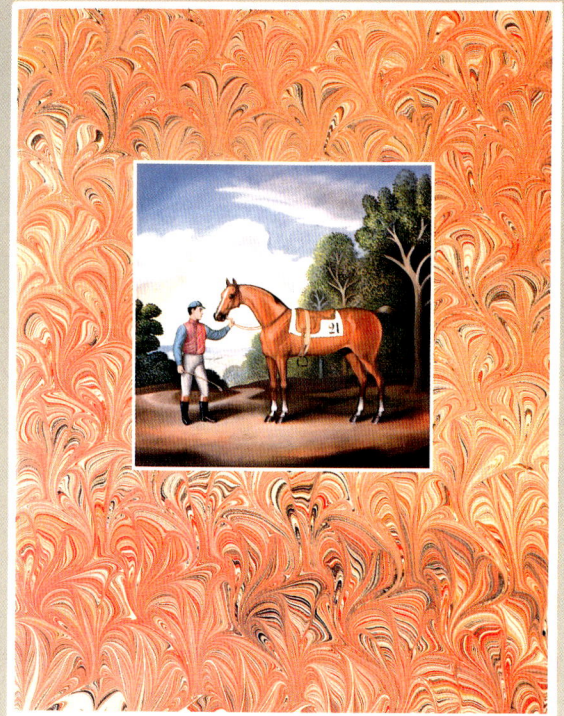

CORPORATE IDENTITY
TYPOGRAPHY/DESIGN *Susan Hochbaum and Peter Harrison, New York, New York* **TYPOGRAPHIC SUPPLIER** *Typogram*
STUDIO *Pentagram Design* **CLIENT** *The '21' Club* **PRINCIPAL TYPES** *Bodoni and Copperplate Gothic* **DIMENSIONS** *Various*

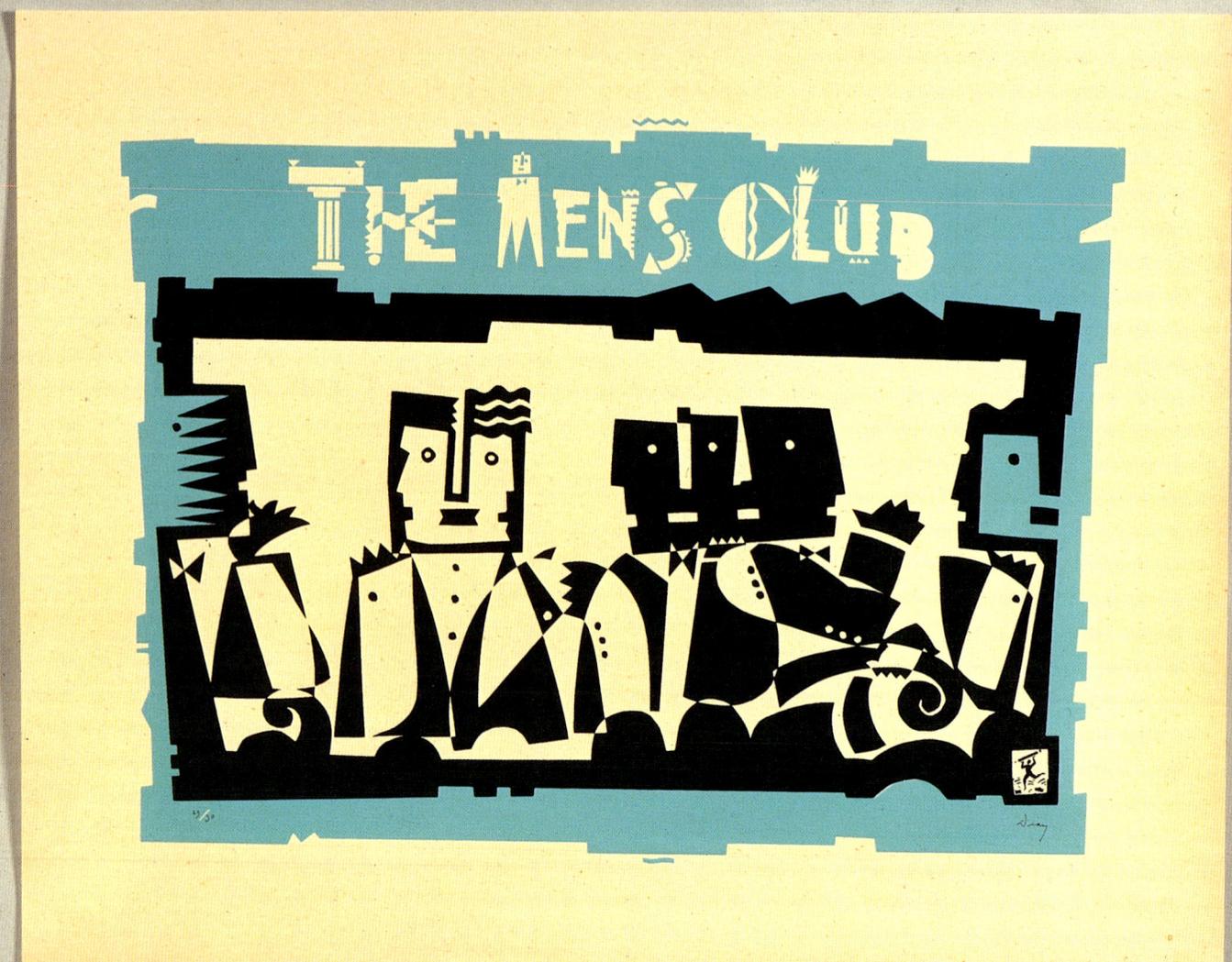

POSTER
TYPOGRAPHY/DESIGN *David Diaz, Carlsbad, California* **LETTERER** *David Diaz* **STUDIO** *David Diaz Illustration*
CLIENT *The Mens Club* **PRINCIPAL TYPE** *Blockhead Bold* **DIMENSIONS** *24 × 20 in. (61 × 50.8 cm)*

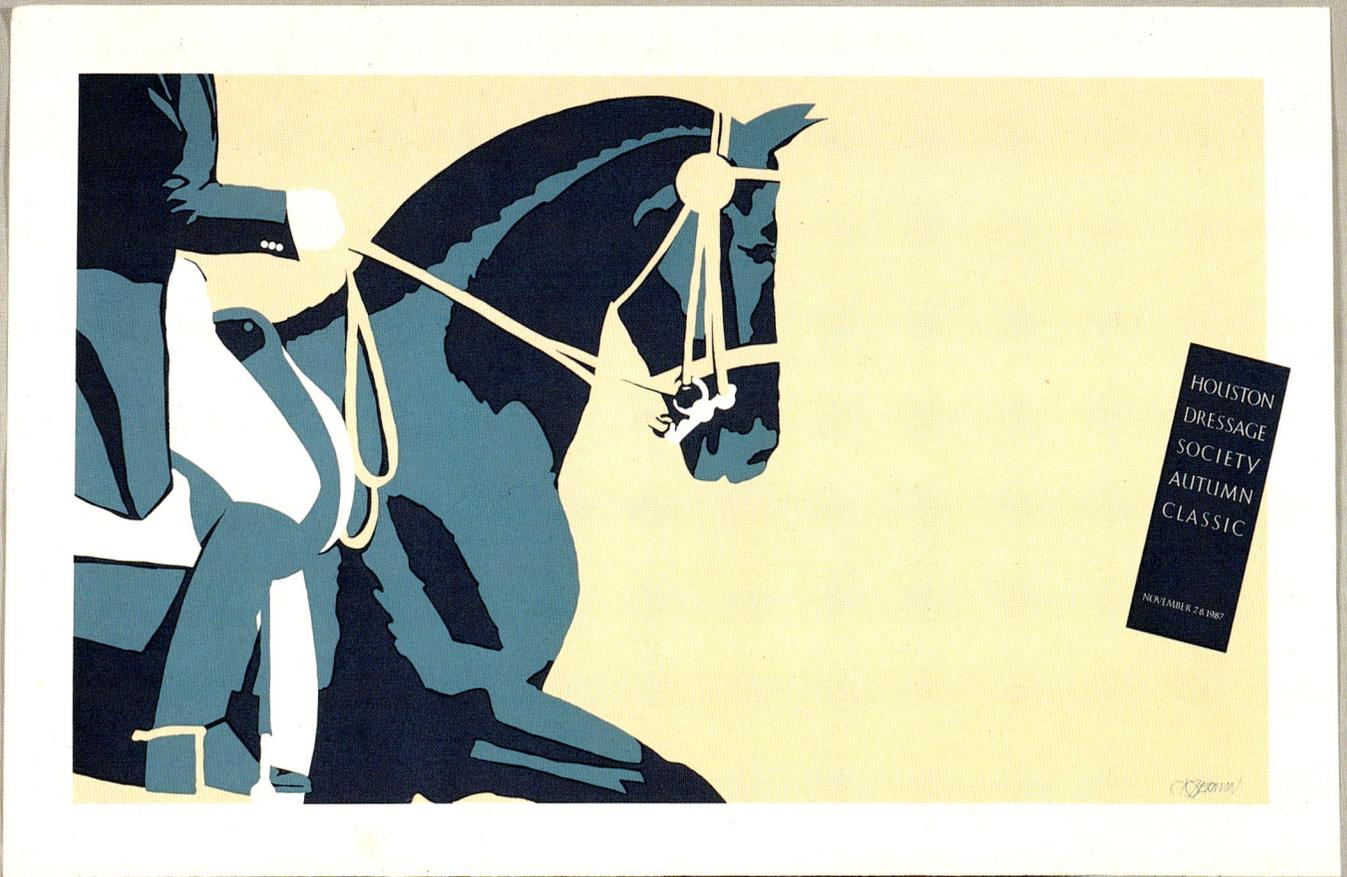

Inside poster:

HOUSTON
DRESSAGE
SOCIETY
AUTUMN
CLASSIC

NOVEMBER 7 8 1987

POSTER
TYPOGRAPHY/DESIGN *C. Randall Sherman, Boston, Massachusetts* **TYPOGRAPHIC SUPPLIER** *Phil's Photo*
AGENCY *Cipriani Advertising, Inc.* **CLIENT** *Houston Dressage Society* **PRINCIPAL TYPE** *Bauer Text Initials*
DIMENSIONS *39 × 24¾ in. (99.1 × 62.9 cm)*

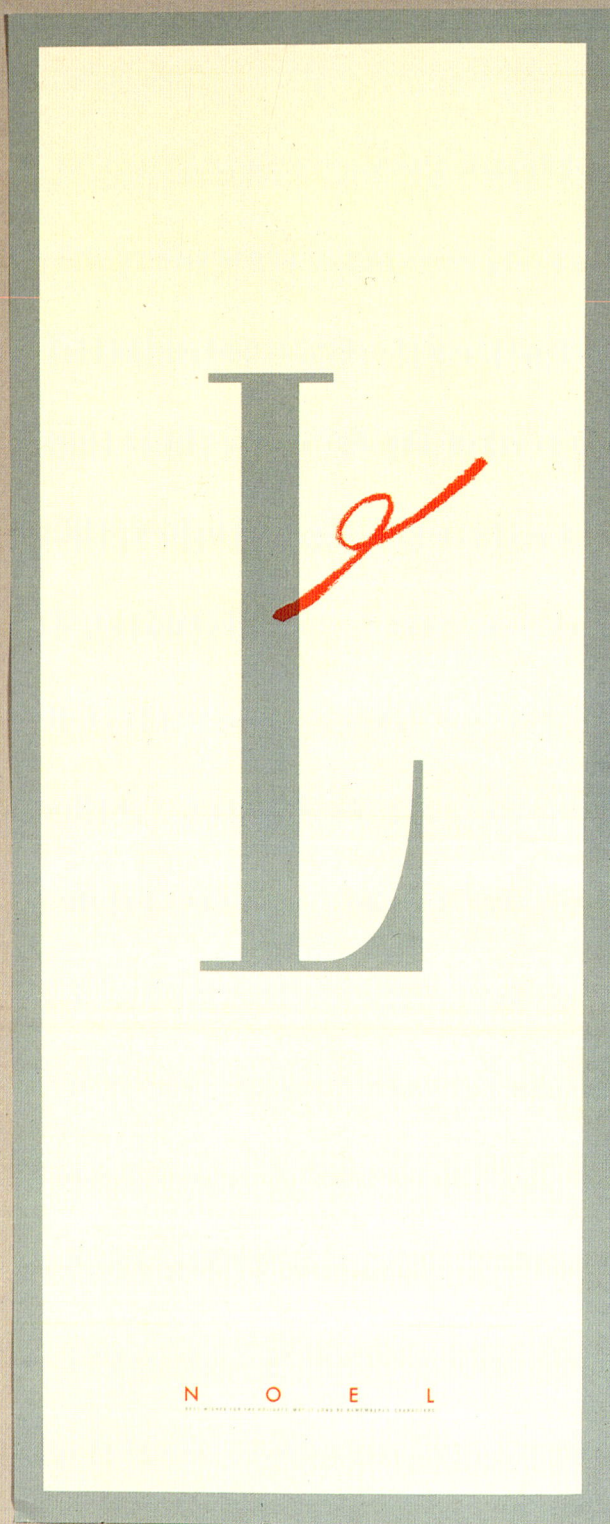

POSTER
TYPOGRAPHY/DESIGN *Scott Paramski, Dallas, Texas* **LETTERER** *Scott Paramski* **TYPOGRAPHIC SUPPLIER** *Characters*
STUDIO *Peterson & Company* **CLIENT** *Characters* **PRINCIPAL TYPES** *Racer and Univers 67 Bold Condensed*
DIMENSIONS *12 × 29½ in. (30.5 × 74.9 cm)*

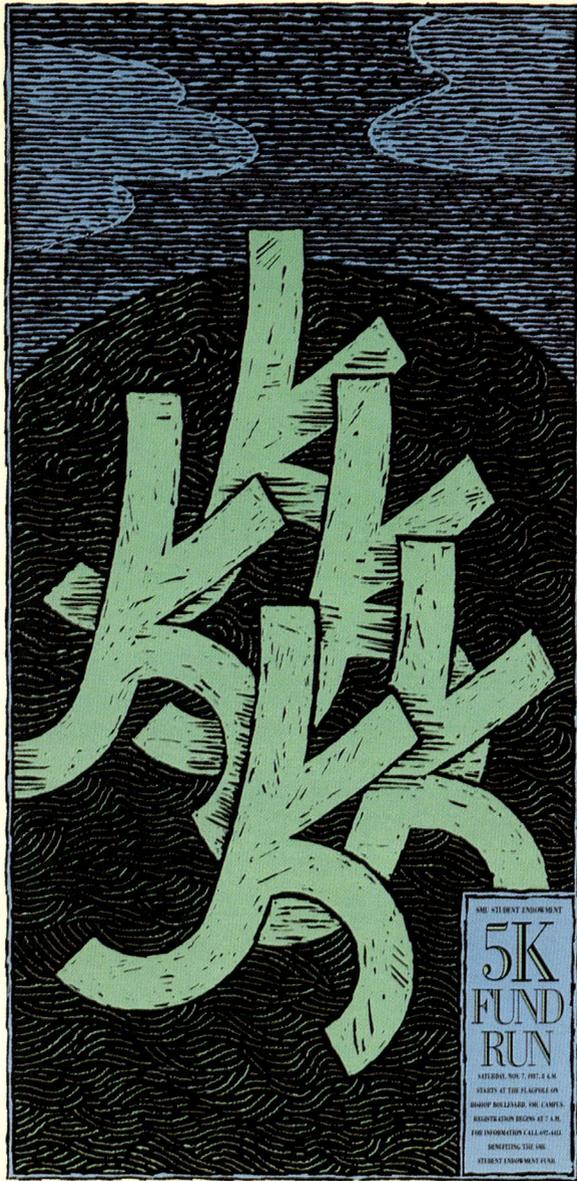

POSTER
TYPOGRAPHY/DESIGN *Bryan L. Peterson, Dallas, Texas* **LETTERER** *Bryan L. Peterson* **TYPOGRAPHIC SUPPLIER** *Typeworks*
STUDIO *Peterson & Company* **CLIENT** *Southern Methodist University* **PRINCIPAL TYPES** *Bodoni Open, Bodoni Bold Condensed, and Handlettering* **DIMENSIONS** *18 × 34 in. (45.7 × 86.4 cm)*

LOGOTYPE
TYPOGRAPHY/DESIGN *Charles S. Anderson and Sara Ledgard, Minneapolis, Minnesota* **LETTERER** *Sara Ledgard* **TYPOGRAPHIC**
SUPPLIER *Typeshooters* **STUDIO** *The Duffy Design Group* **CLIENT** *Typeshooters* **PRINCIPAL TYPES** *Onyx and Helvetica Bold*

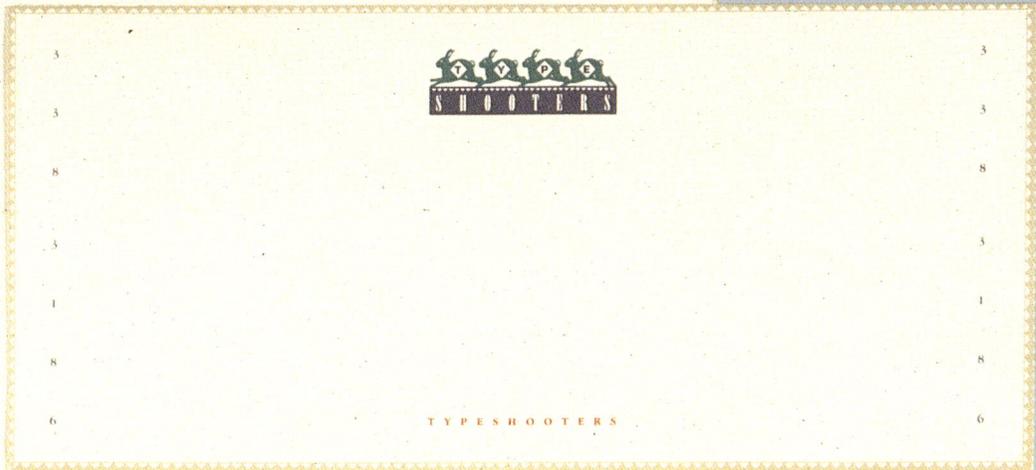

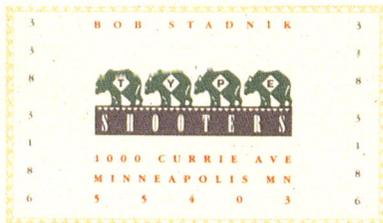

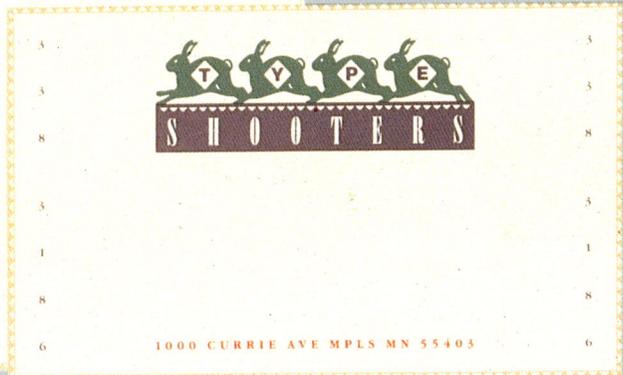

STATIONERY
TYPOGRAPHY/DESIGN Charles S. Anderson and Sara Ledgard, Minneapolis, Minnesota **LETTERER** Sara Ledgard **TYPOGRAPHIC SUPPLIER** Typeshooters **STUDIO** The Duffy Design Group **CLIENT** Typeshooters **PRINCIPAL TYPES** Onyx, Helvetica Bold, and Garamond **DIMENSIONS** 8½ × 11 in. (21.6 × 27.9 cm)

STATIONERY
TYPOGRAPHY/DESIGN *Elmar Schnaare, Düsseldorf, West Germany* **TYPOGRAPHIC SUPPLIER** *Fotosatz Böninghausen GmbH*
STUDIO *Wilma & Elmar Schnaare* **CLIENT** *Cornelia Köster/Mode-Design* **PRINCIPAL TYPE** *Gill Sans Light*
DIMENSIONS *8½ × 11 in. (21.6 × 27.9 cm)*

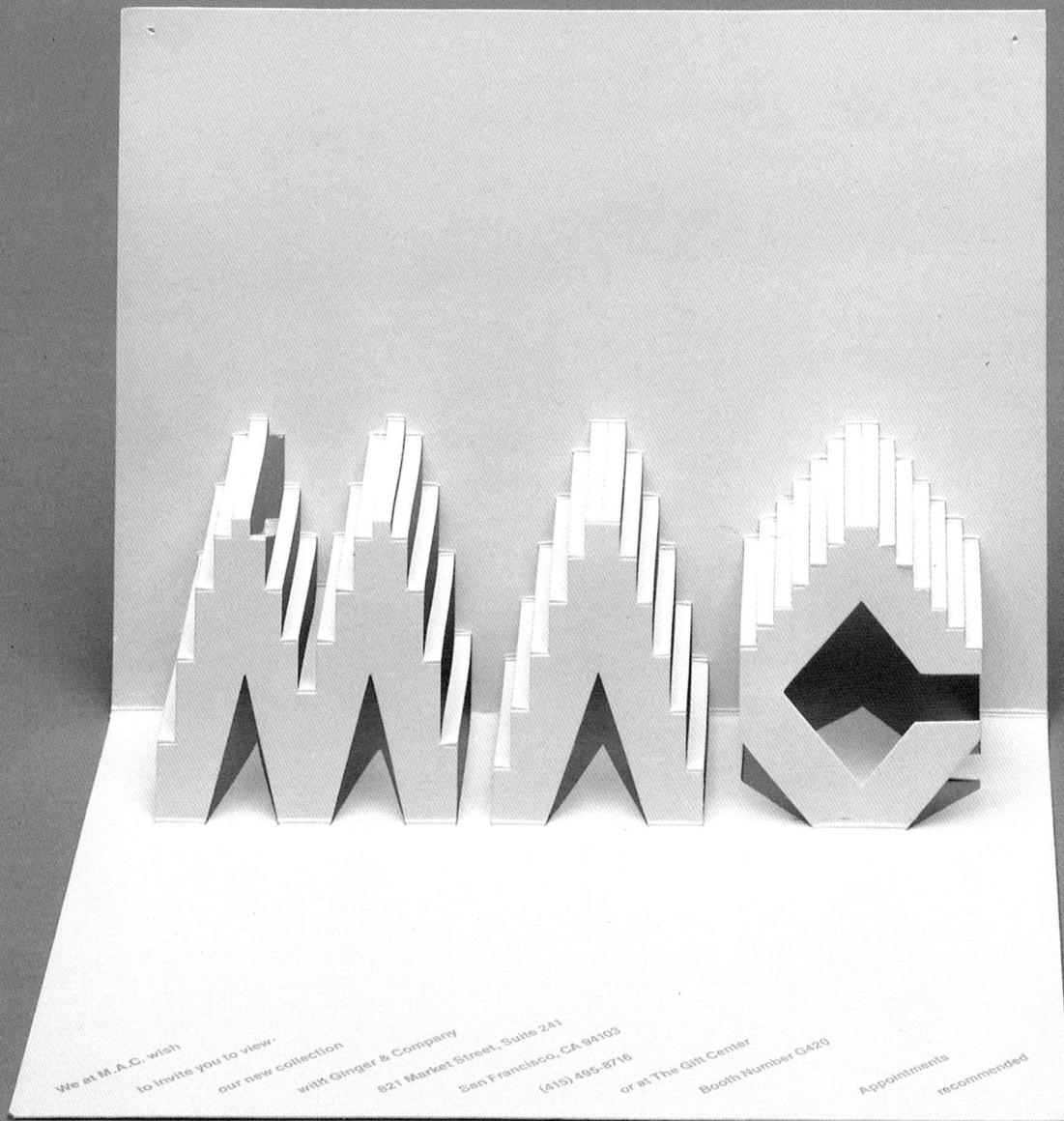

ANNOUNCEMENT
TYPOGRAPHY/DESIGN *Ross Carron, San Francisco, California* **LETTERER** *Ross Carron* **STUDIO** *Ross Carron Design*
CLIENT *M.A.C. (Marin Apparel Company)* **PRINCIPAL TYPE** *Handlettering* **DIMENSIONS** *Folded: 4½ × 6¼ in. (11.4 × 15.9 cm)*

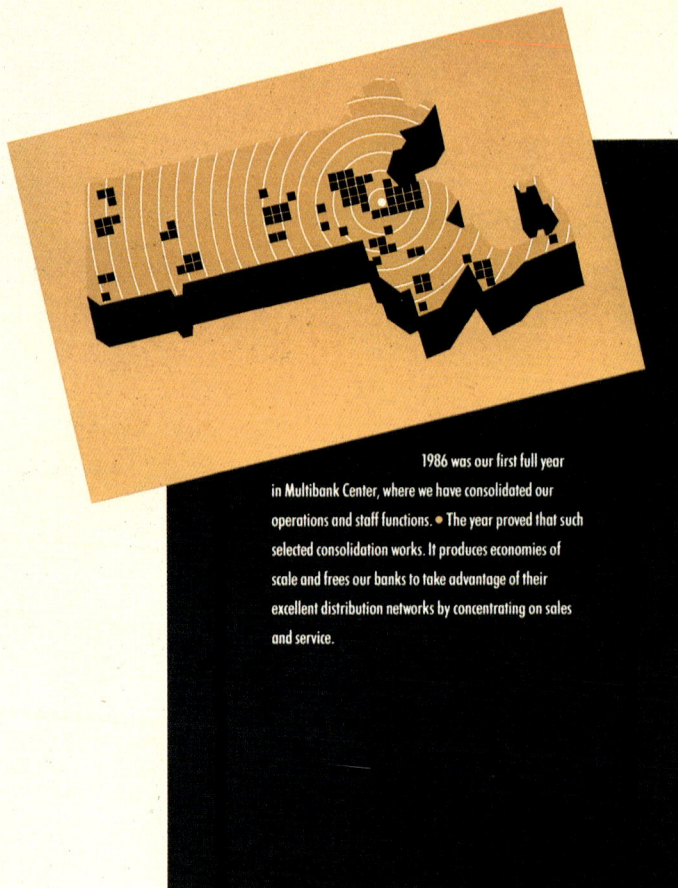

1986 was our first full year in Multibank Center, where we have consolidated our operations and staff functions. ● The year proved that such selected consolidation works. It produces economies of scale and frees our banks to take advantage of their excellent distribution networks by concentrating on sales and service.

ANNUAL REPORT
TYPOGRAPHY/DESIGN *Bob Newman, New York, New York* **TYPOGRAPHIC SUPPLIER** *Typographic House, Inc.*
STUDIO *Newman Design Associates, Inc.* **CLIENT** *Multibank Financial Corp.* **PRINCIPAL TYPES** *Bodoni, Bodoni Book, and Futura Medium Condensed* **DIMENSIONS** *9 × 11½ in. (22.8 × 29.2 cm)*

ANNOUNCEMENT
TYPOGRAPHY/DESIGN *Robin Ayres, Dallas, Texas* **TYPOGRAPHIC SUPPLIER** *Southwestern Typographics, Inc.*
AGENCY *The Richards Group* **STUDIO** *Richards Brock Miller Mitchell & Associates* **CLIENT** *Dallas Society of Visual Communications*
PRINCIPAL TYPE *Aldus* **DIMENSIONS** *17 × 28⅛ in. (43.2 × 71.4 cm)*

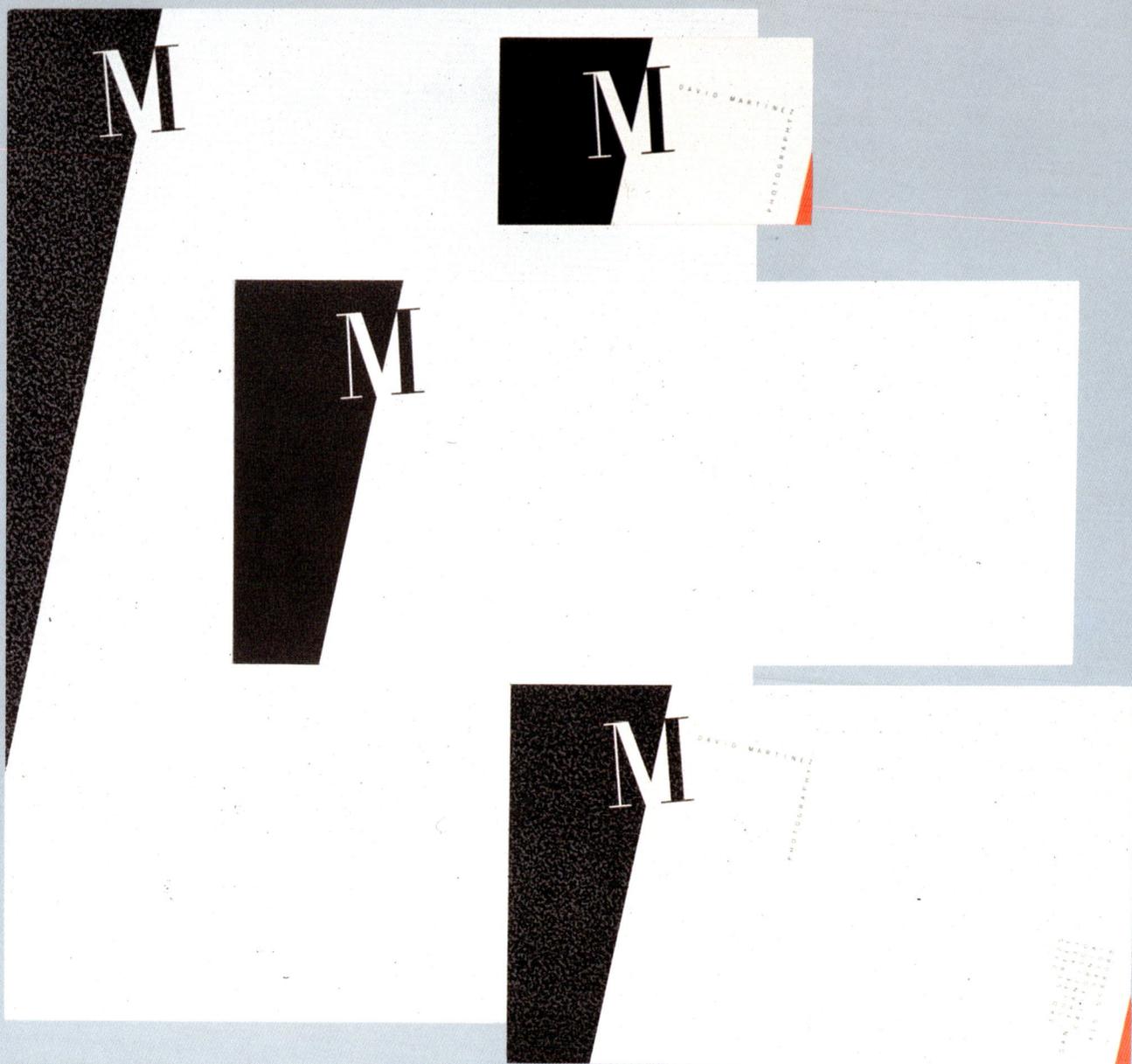

STATIONERY
TYPOGRAPHY/DESIGN *Steven Tolleson, San Francisco, California* **TYPOGRAPHIC SUPPLIER** *Spartan Typographers*
STUDIO *Tolleson Design* **CLIENT** *David Martinez* **PRINCIPAL TYPES** *Bodoni and Trade Gothic Light*
DIMENSIONS *8½ × 11 in. (21.6 × 27.9 cm)*

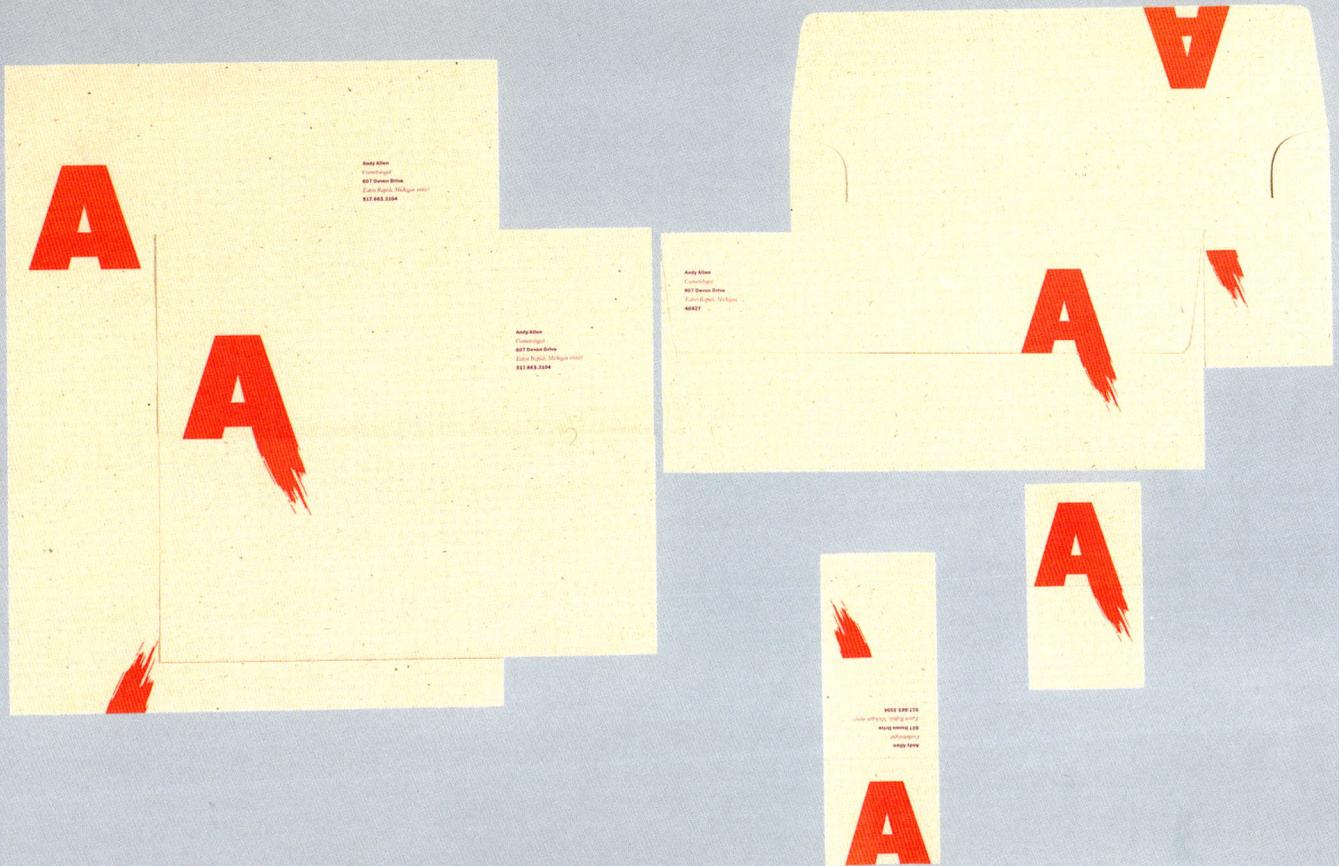

STATIONERY
TYPOGRAPHY/DESIGN *Tim Hartford, Chicago, Illinois* **LETTERER** *Tim Hartford* **TYPOGRAPHIC SUPPLIER** *The Typesmiths, Inc.*
CLIENT *Andy Allen* **PRINCIPAL TYPES** *Franklin Gothic, Bell Medium Italic, and Handlettering*
DIMENSIONS *8½ × 11 in. (21.6 × 27.9 cm)*

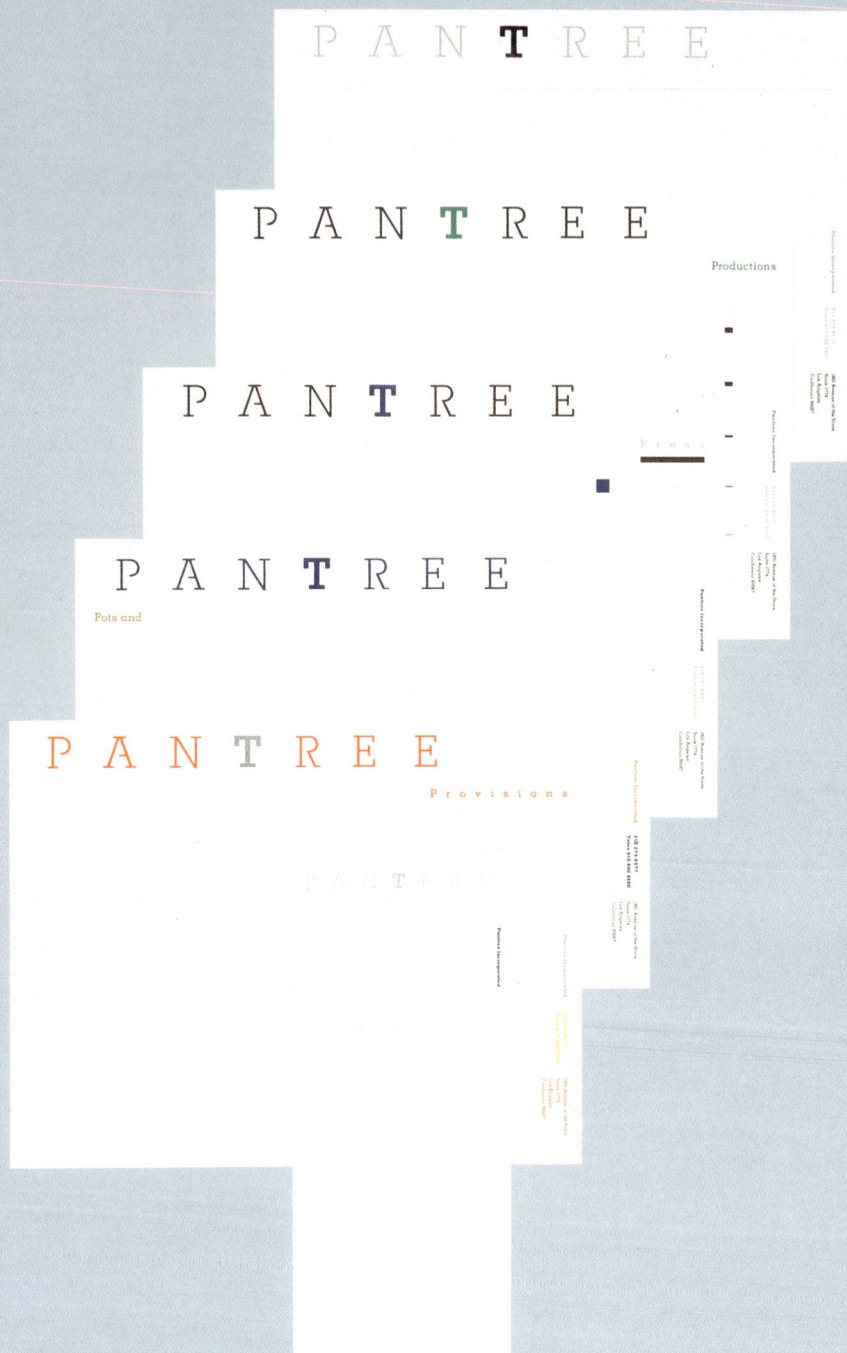

CORPORATE IDENTITY
TYPOGRAPHY/DESIGN *April Greiman, Los Angeles, California* **LETTERER** *Leah Hoffmitz, Los Angeles, California*
TYPOGRAPHIC SUPPLIER *Andresen Typographics* **STUDIO** *April Greiman, Inc.* **CLIENT** *Pantree, Inc.* **PRINCIPAL TYPE** *Stymie*
DIMENSIONS *8½ × 11 in. (21.6 × 27.9 cm)*

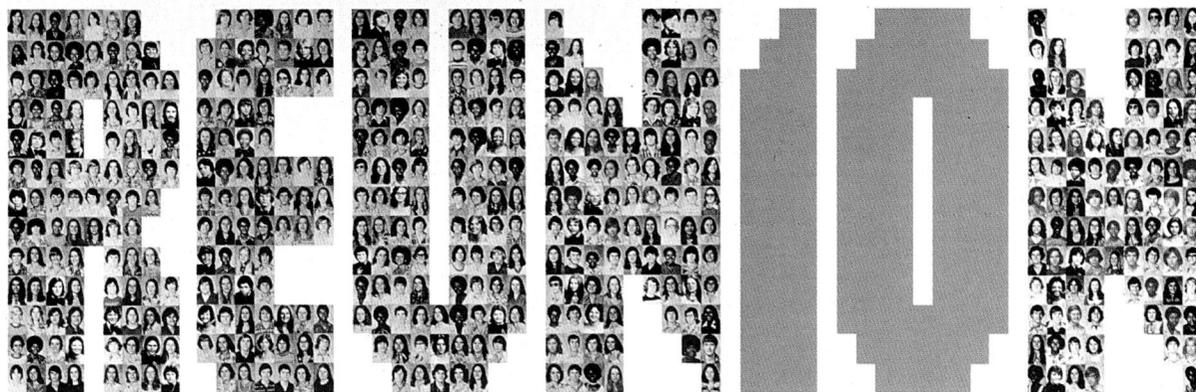

INVITATION
TYPOGRAPHY/DESIGN *Willie Baronet, Dallas, Texas* **ART DIRECTOR** *Ron Sullivan, Dallas, Texas*
TYPOGRAPHIC SUPPLIER *Robert J. Hilton Co., Inc.* **STUDIO** *Sullivan Perkins* **CLIENT** *Lafayette High School Class of 1977*
PRINCIPAL TYPE *Garamond Italic* **DIMENSIONS** *18 × 36 in. (45.7 × 91.4 cm)*

INVITATION
TYPOGRAPHY/DESIGN *Richard G. Hess, Seattle, Washington* **LETTERER** *Richard G. Hess*
TYPOGRAPHIC SUPPLIER *Thomas & Kennedy* **STUDIO** *Richard Hess Graphic Design* **CLIENTS** *Richard G. Hess and Anne Henry*
PRINCIPAL TYPES *Handlettering and Centaurus* **DIMENSIONS** *5 × 4 in. (12.7 × 10.2 cm)*

The friends of Bonnie Legro invite you to a shower in her honor at 320 Morris Ave. in Lutherville, Maryland on Sunday, February 23 at 3 P.M. RSVP soon to Cathy Cason at 301-992-6260. And please join us. Because with you at the shower, it'll be a big splash.

INVITATION
TYPOGRAPHY/DESIGN *Darrel Kolosta, Dallas, Texas* **ART DIRECTOR** *Ron Sullivan, Dallas, Texas*
TYPOGRAPHIC SUPPLIER *Robert J. Hilton Co., Inc.* **STUDIO** *Sullivan Perkins* **CLIENT** *Friends of Bonnie Legro*
PRINCIPAL TYPE *Monty Light* **DIMENSIONS** *20 × 14 in. (50.8 × 35.6 cm)*

YMCA OF METROPOLITAN CHICAGO

ANNUAL REPORT 1987

ANNUAL REPORT
TYPOGRAPHY/DESIGN *Pat and Greg Samata, Dundee, Illinois* **TYPOGRAPHIC SUPPLIER** *Paul Thompson*
STUDIO *Samata Associates* **CLIENT** *YMCA of Metropolitan Chicago* **PRINCIPAL TYPES** *Stymie Light and Futura Extra Bold*
DIMENSIONS *5½ × 11 in. (14 × 27.9 cm)*

POSTER
TYPOGRAPHY/DESIGN *Katherine W. Lorenzetti, Chicago, Illinois* **CALLIGRAPHER** *Katherine W. Lorenzetti* **TYPOGRAPHIC**
SUPPLIER *Master Typographers* **AGENCY** *Burson-Marsteller* **CLIENT** *New City YMCA* **PRINCIPAL TYPES** *Handlettering,*
Romantic Medium Agency, and Helvetica **DIMENSIONS** *21¼ × 35 in. (54 × 89 cm)*

CATALOG COVER
TYPOGRAPHY/DESIGN *Ken Parkhurst, Los Angeles, California* **CALLIGRAPHER** *Ken Parkhurst* **STUDIO** *Ken Parkhurst & Associates, Inc.*
CLIENT *UCLA Extension Department* **PRINCIPAL TYPE** *Handlettering* **DIMENSIONS** *11 × 12¼ in. (27.9 × 31.1 cm)*

XX
A
Twenty-four Page
Book

X
IV
I

Design by Tom Geismar

PAG
E F O
U R T
E E N

BOOK
TYPOGRAPHY/DESIGN *John Luke, Mt. Sinai, New York* **TYPOGRAPHIC SUPPLIER** *Pastore DePamphilis Rampone Inc.*
AGENCY *John Luke Graphic Design* **STUDIO** *The Boardroom* **CLIENT** *John Luke Publishing* **PRINCIPAL TYPES** *Baskerville and*
Bauer Bodoni **DIMENSIONS** *8 × 9 in. (20.3 × 22.9 cm)*

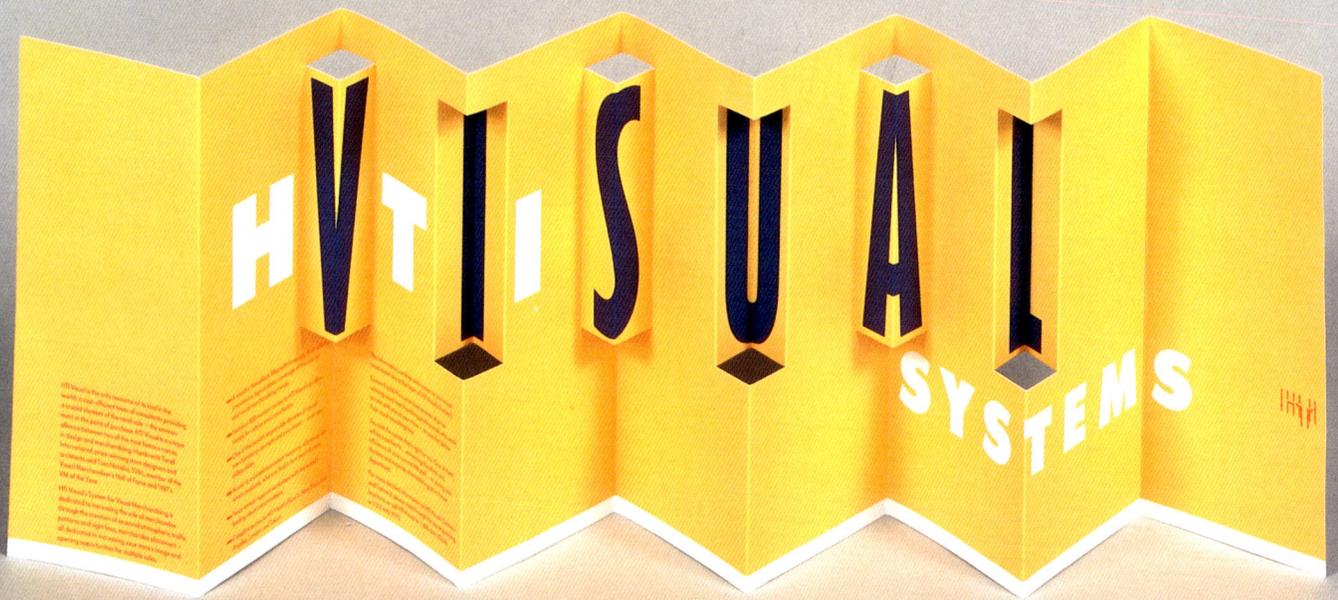

ANNOUNCEMENT
TYPOGRAPHY/DESIGN *Eric A. Pike, New York, New York* **ART DIRECTOR** *Ken Carbone, New York, New York*
TYPOGRAPHIC SUPPLIERS *Typogram and TypoGraphic Innovations* **STUDIO** *Carbone Smolan Associates* **CLIENT** *HTI Visual*
PRINCIPAL TYPES *Gill Sans Extra Bold Condensed and Futura Extra Bold* **DIMENSIONS** *8¾ × 33¾ in. (22.2 × 85.5 cm)*

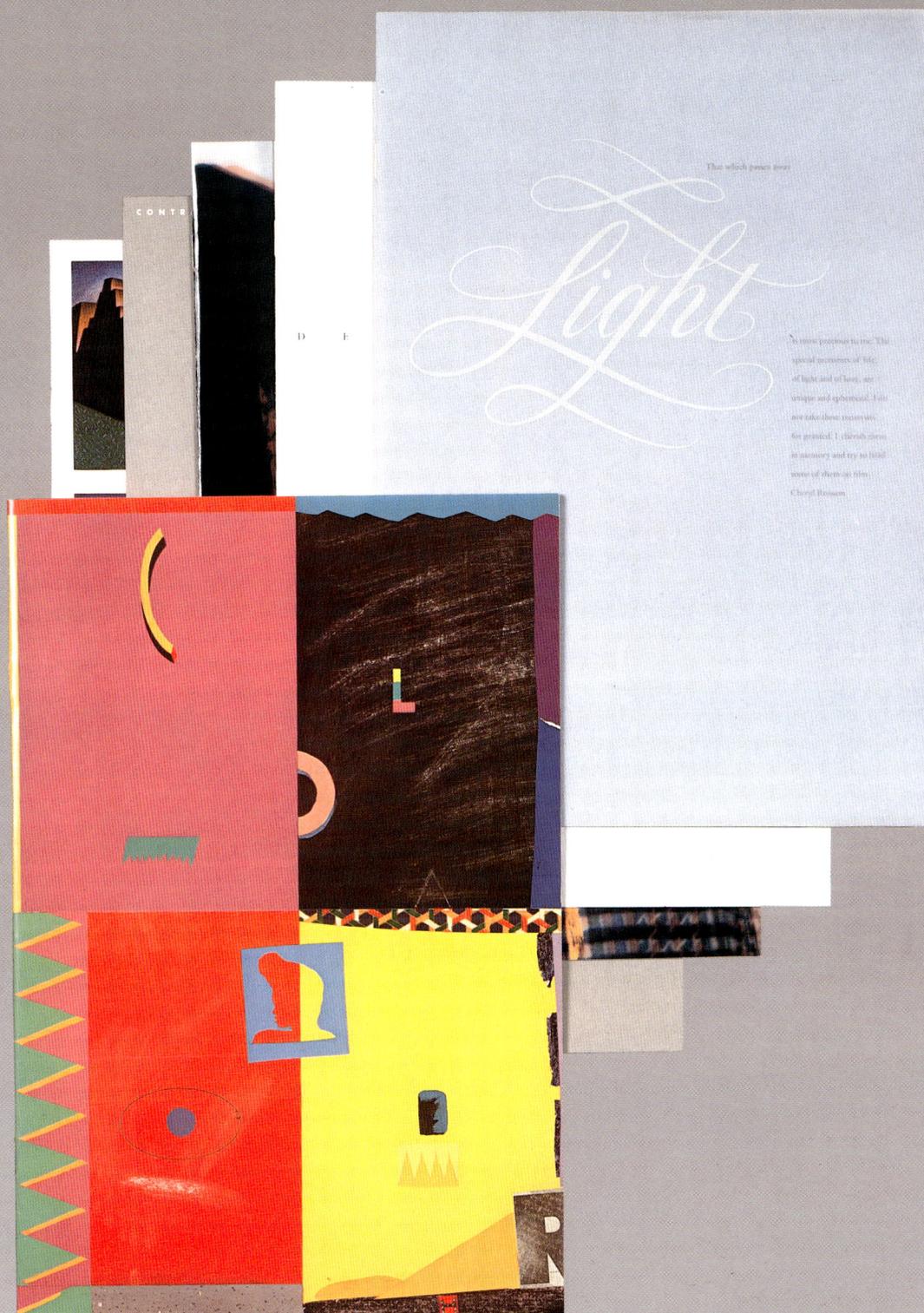

That which passes away

Light

Is most precious to me. The
special moments of life,
of light and of love, are
unique and ephemeral. I do
not take these moments
for granted. I cherish them
in memory and try to hold
some of them on film.
Cheryl Rossum

BROCHURE
TYPOGRAPHY/DESIGN *Steven Tolleson and Susan Gross, San Francisco, California* **TYPOGRAPHIC SUPPLIER** *Spartan Typographers*
STUDIO *Tolleson Design* **CLIENT** *National Press* **PRINCIPAL TYPES** *Futura, Gill Sans, Modern No. 216, Perpetua, Garamond, and Yale*
DIMENSIONS *8 × 11¾ in. (20.3 × 29.8 cm)*

BOOK
TYPOGRAPHY/DESIGN *Greg Samata, Dundee, Illinois* **TYPOGRAPHIC SUPPLIER** *Typographic Resource* **STUDIO** *Samata Associates*
CLIENT *27 Chicago Designers* **PRINCIPAL TYPE** *Galliard* **DIMENSIONS** *12 × 16¾ in. (30.5 × 42.6 cm)*

BROCHURE
TYPOGRAPHY/DESIGN *Kevin B. Kuester and Bob Goebel, Minneapolis, Minnesota* **TYPOGRAPHIC SUPPLIER** *Typeshooters*
STUDIO *Madsen and Kuester, Inc.* **CLIENT** *Heritage Press* **PRINCIPAL TYPE** *Sabon* **DIMENSIONS** *8½ × 11 in. (21.6 × 27.9 cm)*

BROCHURE
TYPOGRAPHY/DESIGN *Laurie Jacobi, Leslee Avchen, and Eric Madsen, Minneapolis, Minnesota*
TYPOGRAPHIC SUPPLIER *Typeshooters* **STUDIO** *Avchen & Jacobi, Inc.* **CLIENT** *Leonard, Street and Deinard*
PRINCIPAL TYPE *Trump Mediaeval* **DIMENSIONS** *4¼ × 10 in. (10.8 × 25.4 cm)*

ANNUAL REPORT
TYPOGRAPHY/DESIGN *Joe Duffy, Sharon Werner, and Charles S. Anderson, Minneapolis, Minnesota* **TYPOGRAPHIC**
SUPPLIERS *Typeshooters and Williamson Financial Typesetters* **STUDIO** *The Duffy Design Group* **CLIENT** *US West*
PRINCIPAL TYPE *Cheltenham Old Style* **DIMENSIONS** *8½ × 11 in. (21.6 × 27.9 cm)*

139

1986

SHADYSIDE

HEALTH,

EDUCATION AND

RESEARCH

CORPORATION

ANNUAL REPORT

ANNUAL REPORT
TYPOGRAPHY/DESIGN *Ralph James Russini, Pittsburgh, Pennsylvania* **ART DIRECTOR** *Dennis P. Moran, Pittsburgh, Pennsylvania*
TYPOGRAPHIC SUPPLIER *Adam, Filippo & Moran, Inc.* **STUDIO** *Adam, Filippo & Moran, Inc.* **CLIENT** *Shadyside Health, Education and Research Corporation* **PRINCIPAL TYPE** *Times Roman* **DIMENSIONS** *8 × 13 in. (20.3 × 33 cm)*

POSTER
TYPOGRAPHY/DESIGN *Julian Waters, Washington, D.C.* **CALLIGRAPHER** *Julian Waters* **AGENCY** *Howard Gralla*
STUDIO *Julian Waters Letterform Design* **CLIENT** *Rochester Institute of Technology* **PRINCIPAL TYPE** *Handlettering*
DIMENSIONS *24 × 36 in. (61 × 91.4 cm)*

Annual Report

To Our Stockholders:

Fiscal 1987, our fourth full year as a company and our second full year of production shipments, marked a momentous period for Network Equipment Technologies, Inc. (N.E.T.) during which we achieved significant growth in sales and earnings.

Our installed client base more than doubled during the year, which enabled us to reach the profitability levels we expected. This helped set the stage for our initial public offering on January 23, 1987. We were pleased with the vote of confidence received from the investment community. And we've been especially gratified by the strong acceptance of N.E.T. by the major corporations that have made a strategic commitment to select our products.

Momentum generated by our sales and earnings performance in fiscal 1987, coupled with our sound financial condition, creates an environment for continued growth this year. Mid-way through calendar 1987, N.E.T. is reaffirming its leadership in the industry segment it created in 1984 when we shipped the first of what has become the product of choice in utility networks: the IDNX® family. Today our product line addresses all of our key market segments, and efforts underway will result in an even broader line in fiscal 1988.

Products introduced in fiscal 1987 included the first two implementations of a new line of network management offerings, the Integrated Network Command System (INCS)™: The INCS/500 system for managing IDNX based networks,

ANNUAL REPORT
TYPOGRAPHY/DESIGN *Steven Tolleson, San Francisco, California* **PHOTOGRAPHER** *David Martinez*
TYPOGRAPHIC SUPPLIER *Spartan Typographers* **STUDIO** *Tolleson Design* **CLIENT** *Network Equipment Technologies, Inc.*
PRINCIPAL TYPE *Palatino* **DIMENSIONS** *8 × 11 in. (20.3 × 27.9 cm)*

DAVID BITHER FOR WARNER COMMUNICATIONS

NORTHROP

LES DALY FOR NORTHROP CORPORATION

SAM YANES FOR POLAROID CORPORATION

JIM SWEENEY FOR CAREMARK, INC.

TIM CARR FOR DOMINO'S PIZZA, INC.

TOM McINTOSH FOR H.J. HEINZ COMPANY

JESS HAY FOR LOMAS & NETTLETON

Reebok

SHARON COHEN FOR REEBOK INTERNATIONAL LTD.

PROMOTION
TYPOGRAPHY/DESIGN *Bennett Robinson, New York, New York* **TYPOGRAPHIC SUPPLIERS** *Typogram and Pastore DePamphilis Rampone, Inc.* **STUDIO** *Corporate Graphics, Inc.* **CLIENT** *Simpson Paper Company*
PRINCIPAL TYPES *Various* **DIMENSIONS** *7½ × 11½ in. (19 × 29.2 cm)*

CARD
TYPOGRAPHY/DESIGN *James Cross, Los Angeles, California* **TYPOGRAPHIC SUPPLIER** *Central Typesetting*
PRINTER *Gardner Lithograph* **STUDIO** *Cross Associates* **CLIENT** *Cross Associates* **PRINCIPAL TYPE** *Bembo*
DIMENSIONS *8½ × 19½ in. (21.6 × 49.5 cm)*

MODERN

Bureau

of

Architecture

and

Urbanism

EXHIBITION: TORONTO MODERN

May 19 - June 5, 1987 Toronto City Hall / Rotunda

An exhibition of significant modern buildings built in metropolitan Toronto from 1945 to 1965

SYMPOSIUM: TORONTO MODERN RECONSIDERED

Saturday, May 30, 1987, 1–4pm

Council Chambers / Toronto City Hall

A panel discussion moderated by Barbara Frum

Participants include: Dr. Kurt Forster, J.Paul Getty Center, California

Donald McKay, University of Waterloo School of Architecture

Colin Vaughan, political commentator

George Baird, architect

George Kapelos, Bureau of Architecture and Urbanism

Toronto Modern has been realized with the support of The Architecture Division of the Canada

Council ■ Heritage Canada Foundation

■ Ontario Heritage Foundation ■ Ontario Ministry of Citizenship and Culture ■ Municipality of Metropolitan

Toronto ■ City of Toronto ■ Toronto Historical Board ■ Ontario Association of Architects ■ Toronto Society of

Architects ■ Association for Preservation Technology ■ Society for the Study of Architecture in Canada ■ Canadian

Institute of Planners ■ Art Gallery at Harbourfront ■ Faculty of Architecture and Landscape Architecture, University of

Toronto ■ University of Waterloo School of Architecture ■ Fliess Gates McGowan Easton Architects ■ M.S. Yolles

and Partners ■ **Exhibition catalogue available from local bookstores and Coach House Press**

The Bureau of Architecture and Urbanism / Directors: Marc Baraness, Ruth Cawker, George Kapelos, Detlef Mertins, Brigitte Shim

TORONTO MODERN ARCHITECTURE

1945 / 1965

CAMPAIGN

TYPOGRAPHY/DESIGN *Tiit Telmet and Joseph Gault, Toronto, Canada* **TYPOGRAPHIC SUPPLIERS** *Primetype, Inc., and Coach House Press* **STUDIO** *Telmet Design Associates* **CLIENT** *Bureau of Architecture & Urbanism (BAU)* **PRINCIPAL TYPES** *Garamond, Helvetica Black, and Helvetica Light* **DIMENSIONS** *Various*

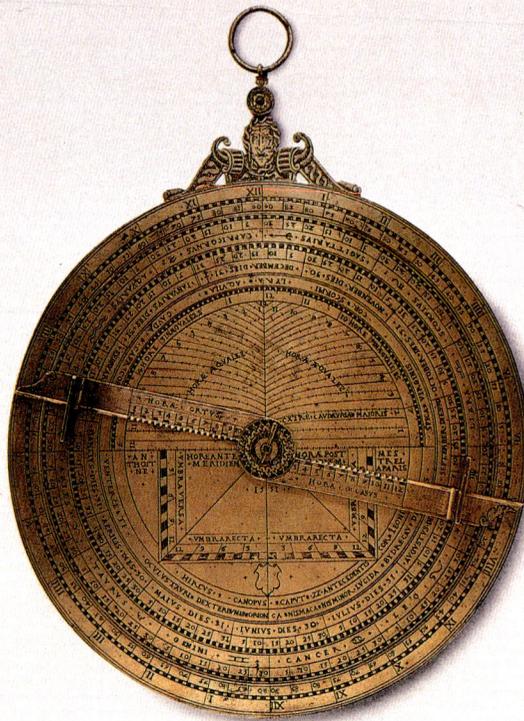

Expeditors

International

Annual

Report

1986

ANNUAL REPORT
TYPOGRAPHY/DESIGN *John Van Dyke, Seattle, Washington* **TYPOGRAPHIC SUPPLIER** *Typehouse* **AGENCY** *Van Dyke Company*
CLIENT *Expeditors International* **PRINCIPAL TYPE** *Garamond Old Style* **DIMENSIONS** *8¼ × 11¾ in. (21 × 29.9 cm)*

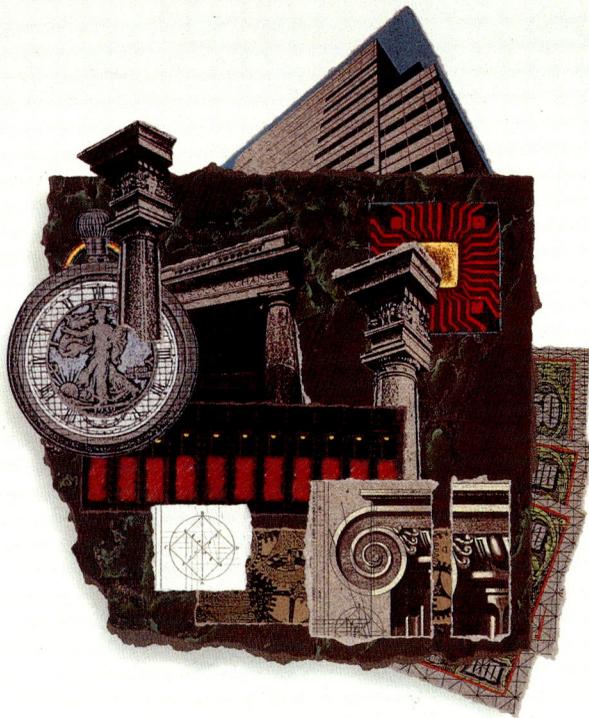

Time, money and the R. R. Donnelley Financial Printing System.

BROCHURE
TYPOGRAPHY/DESIGN *Gordon Hochhalter and Dan La Rocca, Chicago, Illinois* **TYPOGRAPHIC SUPPLIER** *Master Typographers*
AGENCY *R. R. Donnelley & Sons Company* **CLIENT** *R. R. Donnelley Financial* **PRINCIPAL TYPE** *Versatile 53*
DIMENSIONS *9½ × 14 in. (24.1 × 35.6 cm)*

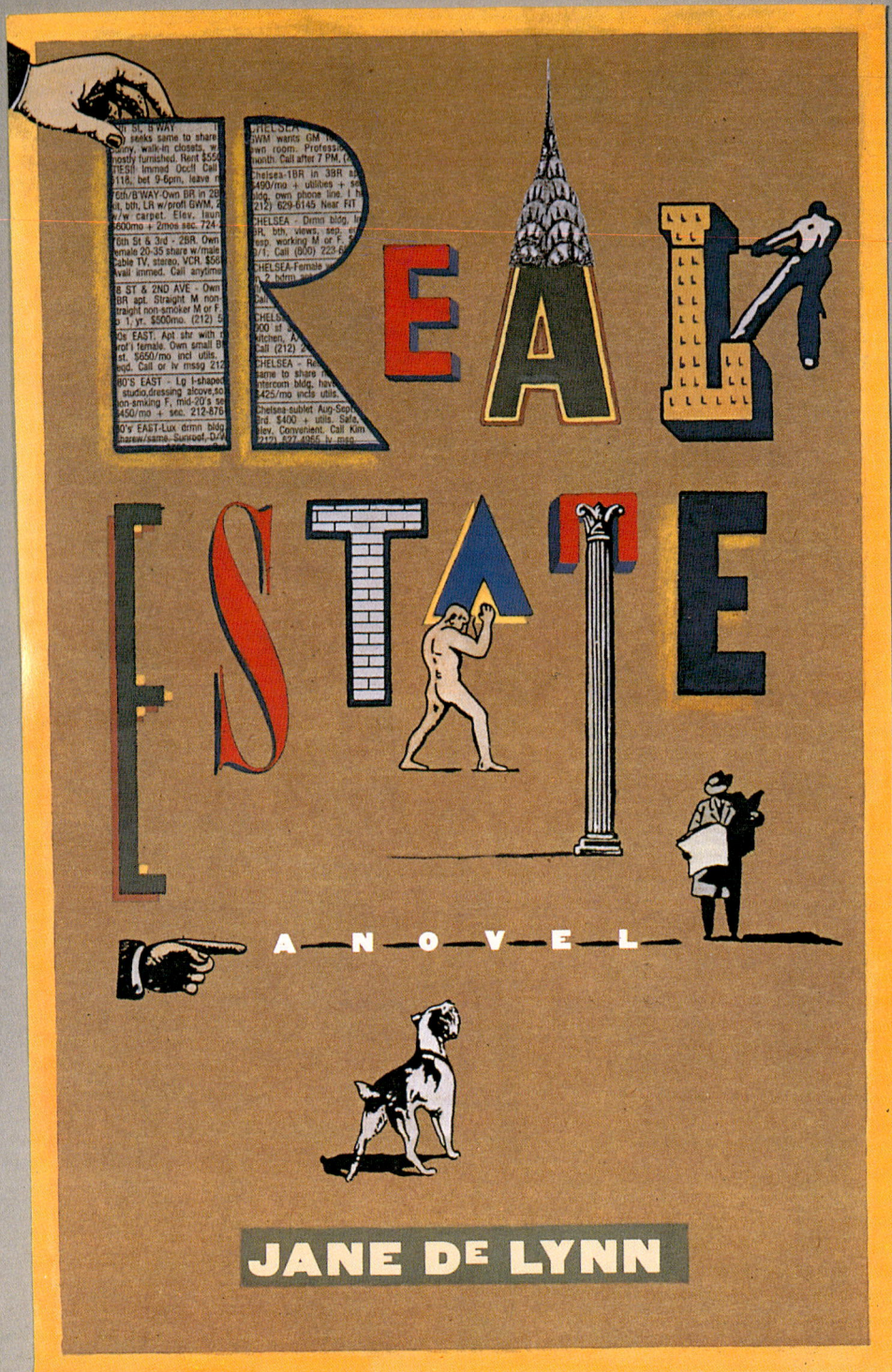

REAL ESTATE

A NOVEL

JANE DE LYNN

BOOK COVER
TYPOGRAPHY/DESIGN *Paula Scher, New York, New York* **LETTERER** *Paula Scher*
TYPOGRAPHIC SUPPLIER *Personal collection of Paula Scher* **STUDIO** *Koppel & Scher* **CLIENT** *Simon and Schuster*
PRINCIPAL TYPE *Handlettering* **DIMENSIONS** *5⅝ × 8⅝ in. (14.3 × 21.9 cm)*

SIGNA

MORE THAN RECENT WORKS

Identity
↓
Intentions

Although people may recognize the value
of managing their visual reputation with

consistency, integrity and style,

sometimes they don't have much money.

Collaboration

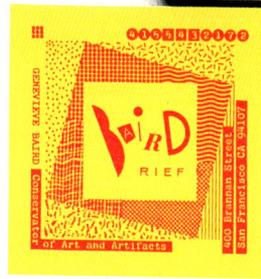

Works

Baird Rief trademark and stationery
for a studio specializing in art conservation and photography

BROCHURE
TYPOGRAPHY/DESIGN *Barry Seifer and Ed McDonald, Ann Arbor, Michigan* **TYPOGRAPHIC SUPPLIER** *Typographic Resource*
STUDIO *Signa Design Group, Inc.* **CLIENT** *Signa Design Group, Inc.* **PRINCIPAL TYPES** *Walbaum and Gill Sans*
DIMENSIONS *8½ × 7½ in. (21.6 × 19.1 cm)*

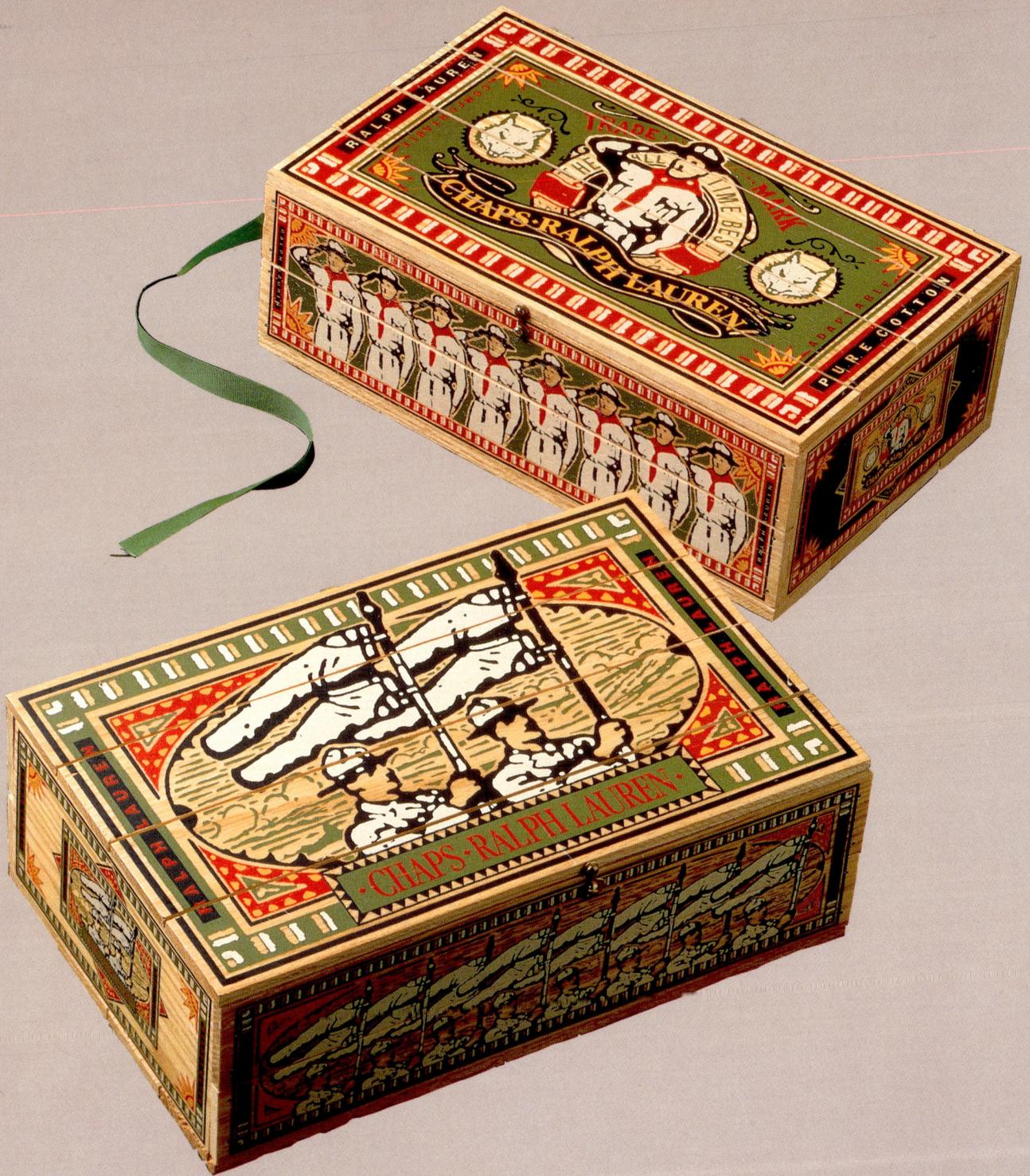

PACKAGING
TYPOGRAPHY/DESIGN *Charles S. Anderson and Sara Ledgard, Minneapolis, Minnesota* **LETTERER** *Charles S. Anderson*
TYPOGRAPHIC SUPPLIER *Typeshooters* **STUDIO** *The Duffy Design Group* **CLIENT** *Chaps–Ralph Lauren*
PRINCIPAL TYPE *Garamond Bold*

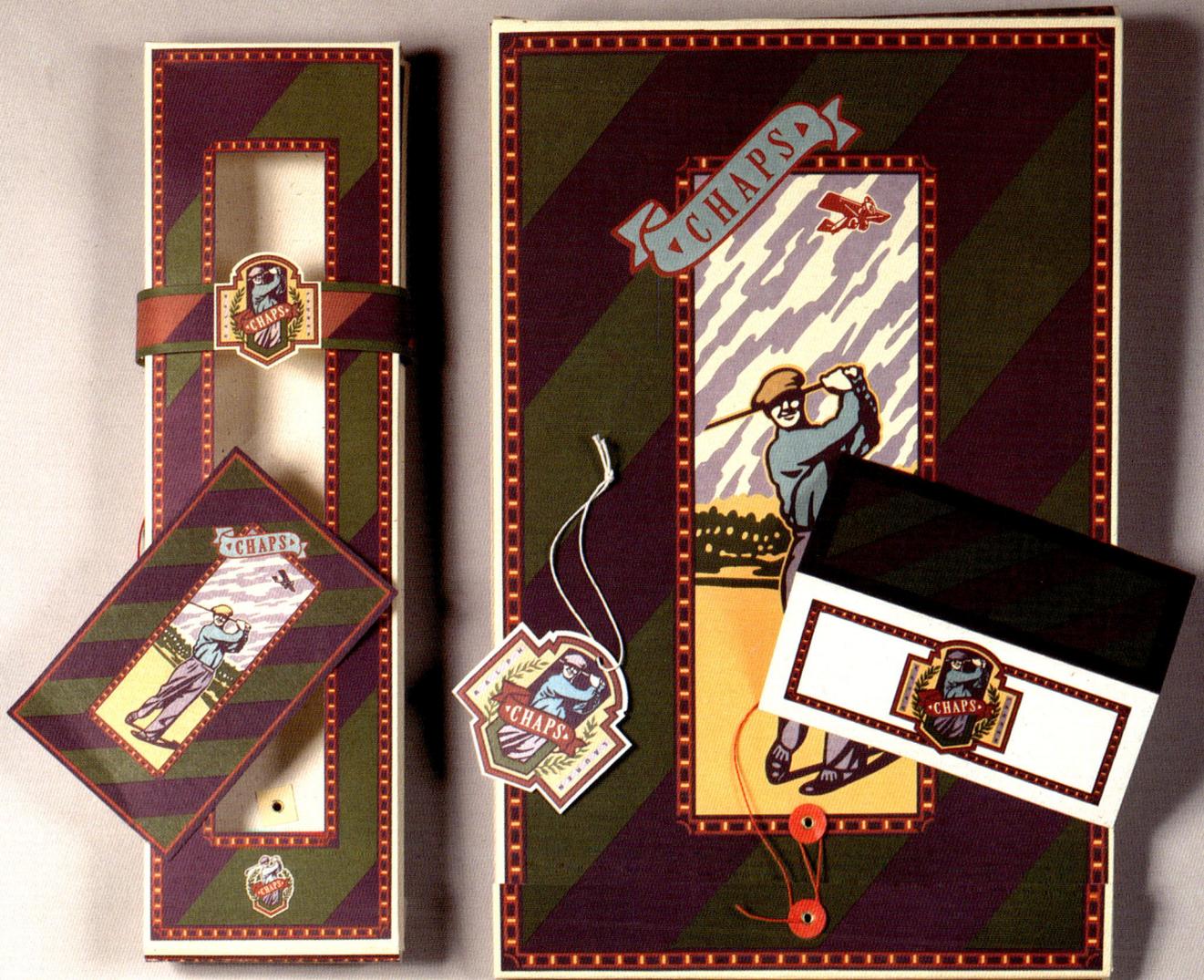

PACKAGING
TYPOGRAPHY/DESIGN *Joe Duffy and Sara Ledgard, Minneapolis, Minnesota* **LETTERER** *Joe Duffy* **TYPOGRAPHIC**
SUPPLIER *Typeshooters* **STUDIO** *The Duffy Design Group* **CLIENT** *Chaps–Ralph Lauren* **PRINCIPAL TYPE** *Garamond Bold*

POSTCARD
TYPOGRAPHY/DESIGN *Robert Valentine, New York, New York* **TYPOGRAPHIC SUPPLIER** *Franklin Typographers, Inc.*
STUDIO *Bloomingdale's—Design* **CLIENT** *Bloomingdale's* **PRINCIPAL TYPE** *Bodoni* **DIMENSIONS** *6 × 8⅞ in. (15.2 × 22.6 cm)*

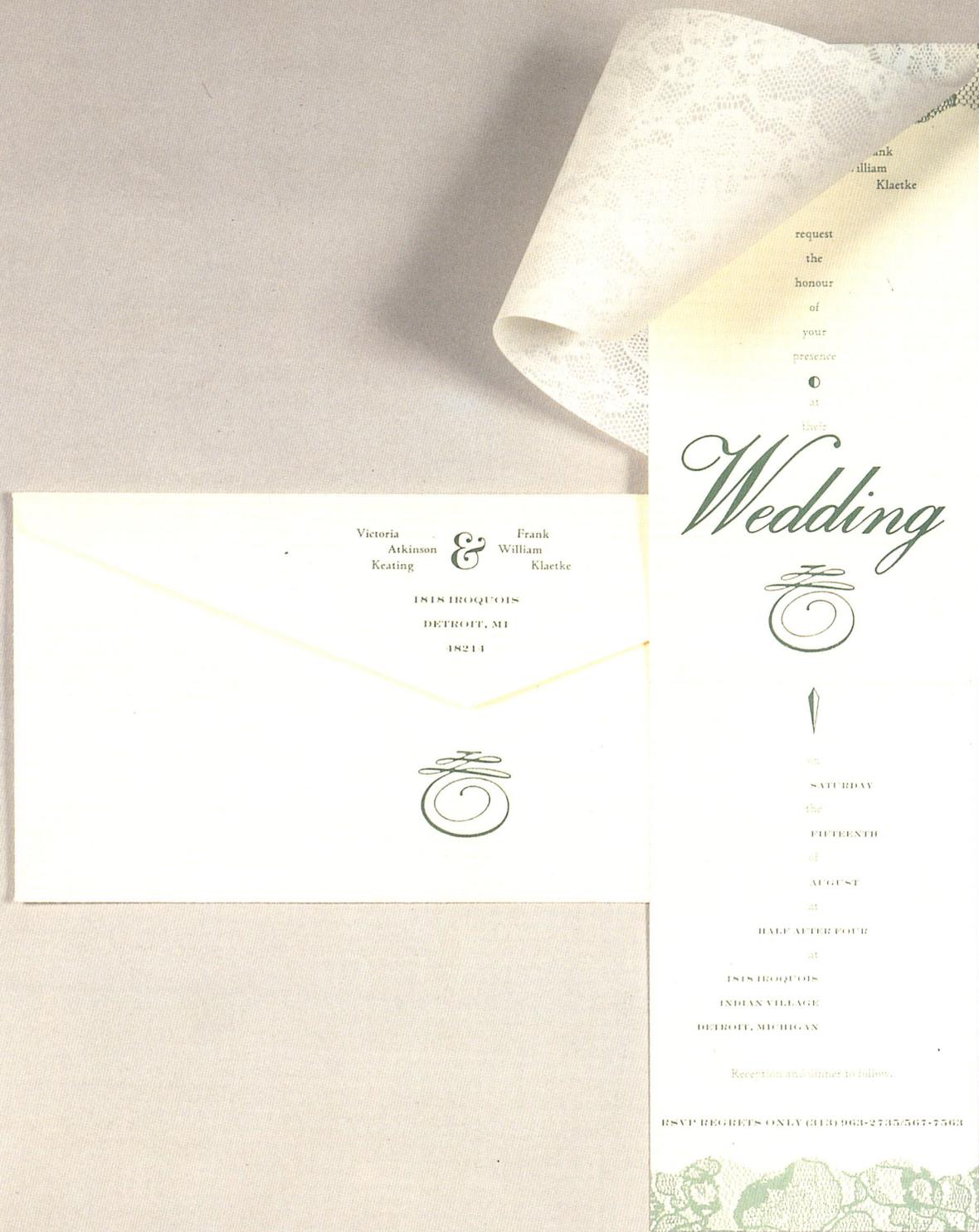

INVITATION
TYPOGRAPHY/DESIGN *Fritz Klaetke, Ann Arbor, Michigan* **TYPOGRAPHIC SUPPLIER** *Total Type* **STUDIO** *Visual Dialogue*
CLIENTS *Frank Klaetke and Vicki Keating* **PRINCIPAL TYPES** *Palace Script, Cloister Open Face, and Engraver's Bold*
DIMENSIONS *Folded: 3½ × 9 in. (8.9 × 23 cm) Flat: 3½ × 12⅛ in. (8.9 × 30.8 cm)*

U.S. BANCORP
AND SUBSIDIARIES
ANNUAL
REPORT TO
SHAREHOLDERS
1986

ANNUAL REPORT
TYPOGRAPHY/DESIGN *John Van Dyke, Seattle, Washington* **TYPOGRAPHIC SUPPLIER** *Paul O. Giesey and Typehouse*
AGENCY *Van Dyke Company* **CLIENT** *U.S. Bancorp* **PRINCIPAL TYPE** *Garamond Old Style* **DIMENSIONS** *8¼ × 11¾ in. (21 × 29.9 cm)*

MODULAIRE

1986

Annual Report

ANNUAL REPORT
TYPOGRAPHY/DESIGN *Steven Tolleson, San Francisco, California* **TYPOGRAPHIC SUPPLIER** *Spartan Typographers*
STUDIO *Tolleson Design* **CLIENT** *Modulaire Industries* **PRINCIPAL TYPE** *Bodoni* **DIMENSIONS** *8¾ × 11¾ in. (22.3 × 29.8 cm)*

BOOK
TYPOGRAPHY/DESIGN *Paul Rand, Weston, Connecticut* **TYPOGRAPHIC SUPPLIER** *Pastore DePamphilis Rampone, Inc.*
STUDIO *Paul Rand Design* **CLIENT** *Next, Inc.* **PRINCIPAL TYPE** *Caslon No. 540* **DIMENSIONS** *8½ × 11⅞ in. (21.6 × 30.2 cm)*

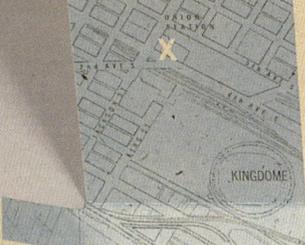
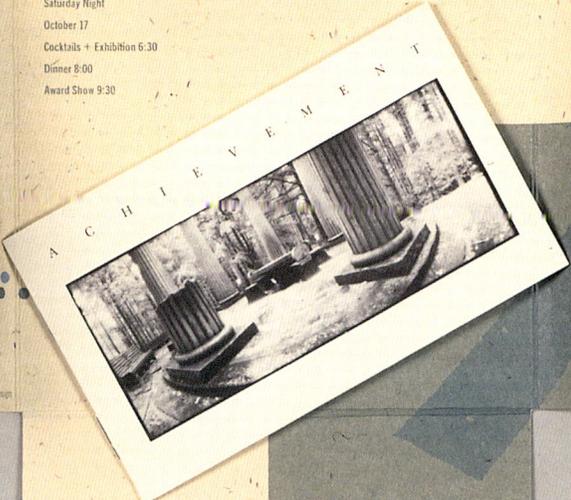

INVITATION
TYPOGRAPHY/DESIGN *Christopher Ozubko and Jo Ann Sire, Seattle, Washington* **PHOTOGRAPHERS** *MP Curtis and Fritz Dent*
WRITER *John Koval* **TYPOGRAPHIC SUPPLIER** *Eclipse Typography* **STUDIO** *OZUBKO Communication & Design*
CLIENT *Seattle Design Association* **PRINCIPAL TYPE** *News Gothic* **DIMENSIONS** *15 × 15 in. (38.1 × 38.1 cm)*

Lotus

1986 Annual Report to Shareholders

ANNUAL REPORT
TYPOGRAPHY/DESIGN *Tom Hughes and Nancy Noel, Cambridge, Massachusetts* **TYPOGRAPHIC SUPPLIER** *Wrightson Typographers*
AGENCY *Lotus Creative Development* **CLIENT** *Lotus* **PRINCIPAL TYPES** *ITC Modern 216 and ITC Century Light*
DIMENSIONS *8¼ × 11¾ in. (21 × 29.9 cm)*

Object Poems
Kos, O'Connor, Labat

CATALOG
TYPOGRAPHY/DESIGN *Douglas Wadden, Seattle, Washington* **EDITOR** *Joseph Newland* **TYPOGRAPHIC SUPPLIER** *Thomas & Kennedy*
STUDIO *Design Collaborative/Seattle* **CLIENT** *Henry Art Gallery/University of Washington* **PRINCIPAL TYPE** *Helvetica*
DIMENSIONS *11 × 17 in. (27.9 × 43.2 cm)*

BROCHURE
TYPOGRAPHY/DESIGN *John Casado, San Francisco, California* **TYPOGRAPHIC SUPPLIER** *Display Lettering and Copy*
AGENCY *G.B. Cox Company* **STUDIO** *Casado, Inc.* **CLIENT** *Haworth, Inc.* **PRINCIPAL TYPE** *Olympus*
DIMENSIONS *11¾ × 18 in. (29.7 × 45.5 cm)*

FOLDER
TYPOGRAPHY/DESIGN *David Quay, London, England* **TYPOGRAPHIC SUPPLIER** *Span Graphics Ltd.* **STUDIO** *David Quay Design*
CLIENT *Esselte Letraset Ltd.* **PRINCIPAL TYPE** *Helvetica Light* **DIMENSIONS** *10¼ × 15¼ in. (26 × 38.7 cm)*

May the spirit of this Christmas be present throughout the New Year
Richards Brock Miller Mitchell and Associates

POSTER
TYPOGRAPHY/DESIGN *Ken Shafer, Dallas, Texas* **LETTERER** *Ken Shafer* **TYPOGRAPHIC SUPPLIERS** *Phil's Photo and Southwestern Typographics, Inc.* **AGENCY** *The Richards Group* **STUDIO** *Richards Brock Miller Mitchell and Associates* **CLIENT** *Richards Brock Miller Mitchell and Associates* **PRINCIPAL TYPE** *Caslon Light No. 223* **DIMENSIONS** *11½ × 33¾ in. (29.2 × 85.7 cm)*

HOLIDAY CARD
TYPOGRAPHY/DESIGN *Susan Schatz and Jeffrey Burgazzoli, New York, New York* **LETTERERS** *Susan Schatz and Jeffrey Burgazzoli*
TYPOGRAPHIC SUPPLIER *Ascenders Typographic Services, Inc.* **STUDIO** *Schatz & Burgazzoli, Inc.* **CLIENT** *Apple Bank for Savings*
PRINCIPAL TYPES *Handlettering and Diotima* **DIMENSIONS** *Folded: 5 × 5 in. (12.6 × 12.6 cm) Flat: 5 × 10 in. (12.6 × 25.4 cm)*

PACKAGING
TYPOGRAPHY/DESIGN *Jack Anderson, Mary Hermes, Cheri Huber, and Julie Tanagi, Seattle, Washington* **CALLIGRAPHER** *John Fortune, Seattle, Washington* **TYPOGRAPHIC SUPPLIER** *The Camera* **STUDIO** *Hornall Anderson Design Works* **CLIENT** *TradeWell*
PRINCIPAL TYPE *Times Roman* **DIMENSIONS** *Various*

Cousin of Buckingham, and sage grave men,
Since you will buckle fortune on my back,
To bear her burden, whe'r I will or no,
I must have patience to endure the load;
But if black scandal or foul-faced reproach
Attend the sequel of your imposition,
Your mere enforcement shall acquittance me
From all the impure blots and stains thereof;
For God doth know, and you may partly see,
How far I am from the desire of this.

MAYOR. God bless your Grace! We see it and will say it.
RICHARD. In saying so you shall but say the truth.
BUCKINGHAM. Then I salute you with this royal title:
Long live King Richard, England's worthy king!

ALL. Amen.
BUCKINGHAM. Tomorrow may it please you to be crowned?
RICHARD. Even when you please, for you will have it so.
BUCKINGHAM. Tomorrow then we will attend your Grace.
And so most joyfully we take our leave.

RICHARD. *[To the Bishops]* Come, let us to our holy work again.
Farewell, my cousin; farewell, gentle friends. *Exeunt.*

LORD MAYOR OF LONDON

BOOK
TYPOGRAPHY/DESIGN *Martin Solomon, New York, New York* **TYPOGRAPHIC SUPPLIER** *Royal Composing Room, Inc.*
STUDIO *Royal Composing Room, Inc.* **CLIENTS** *Royal Composing Room, Inc.; Finch, Pruyn & Company, Inc.; and*
Horowitz/Rae Book Manufacturers, Inc. **PRINCIPAL TYPES** *Gill Sans Light and Galliard Ultra* **DIMENSIONS** *8 × 8¼ in. (20.3 × 21 cm)*

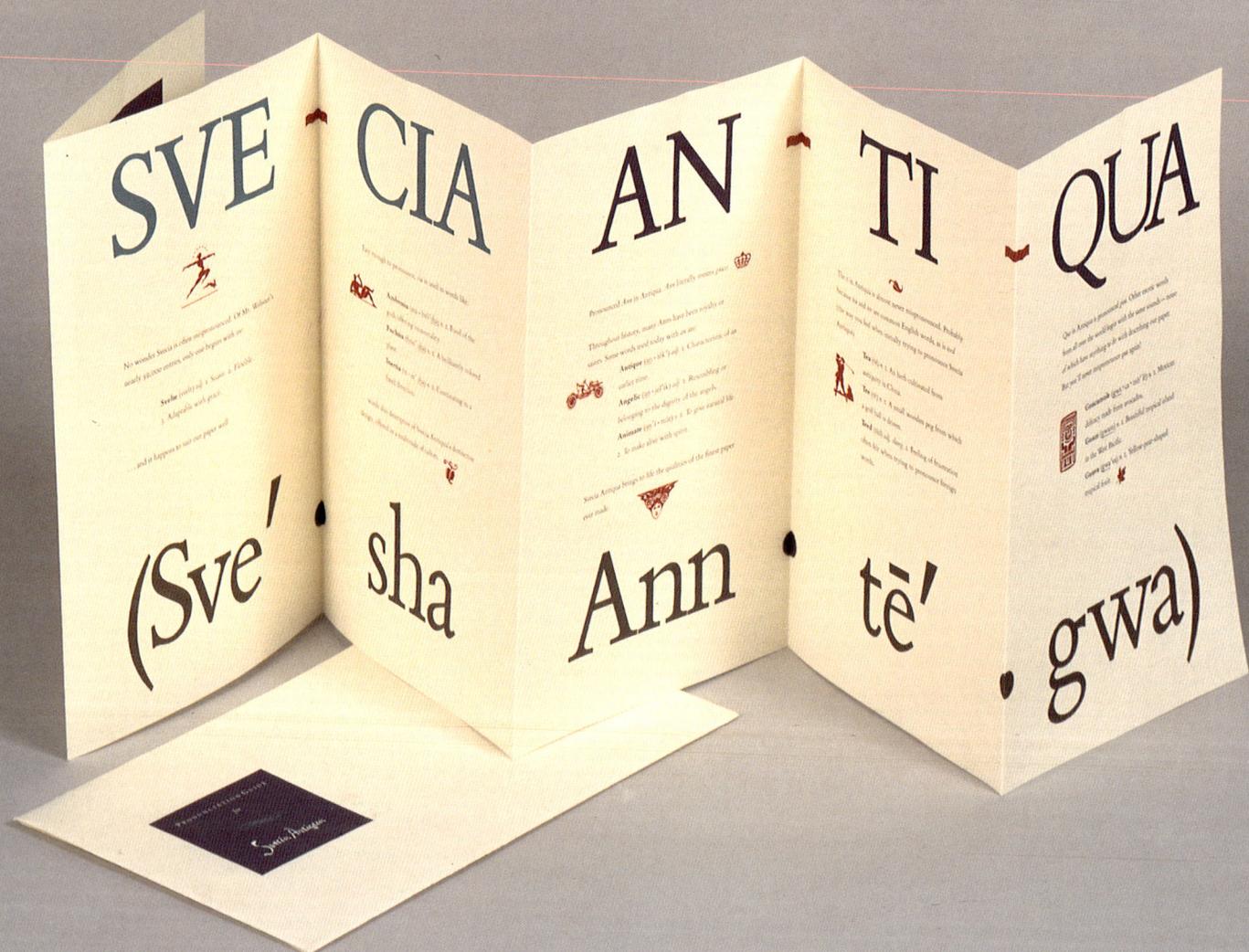

PROMOTION
TYPOGRAPHY/DESIGN *Jane Kobayashi Ritch, Santa Monica, California* **TYPOGRAPHIC SUPPLIER** *Central Typesetting Company*
STUDIO *Morava & Oliver Design Office* **CLIENT** *Svecia Antiqua* **PRINCIPAL TYPE** *Bembo* **DIMENSIONS** *9 × 33 in. (22.7 × 83.8 cm)*

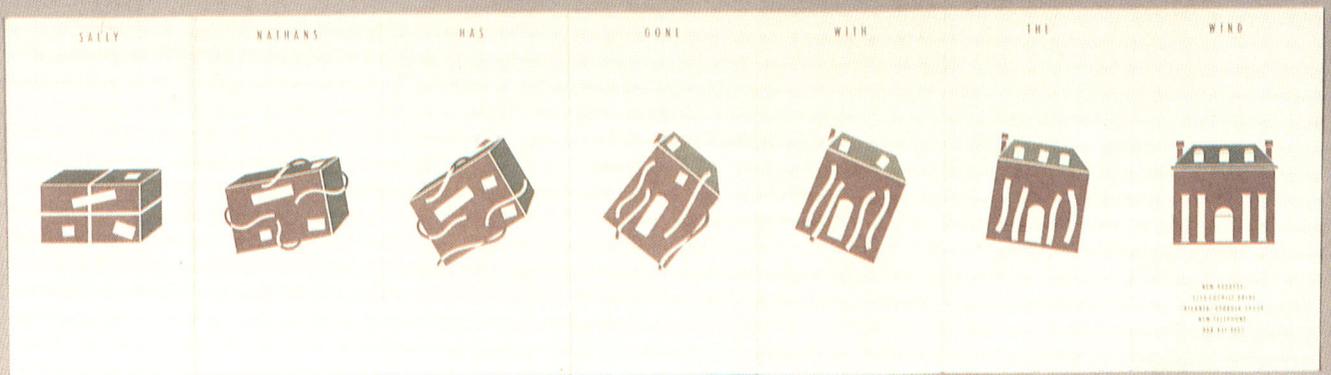

ANNOUNCEMENT
TYPOGRAPHY/DESIGN *Robert P. Kellerman, New York, New York* **TYPOGRAPHIC SUPPLIER** *C.T. Typografix, Inc.*
STUDIO *John Waters Associates, Inc.* **CLIENT** *Sally Nathans* **PRINCIPAL TYPE** *Gill Sans Medium Extra Condensed*
DIMENSIONS *3⅜ × 6⅜ in. (9 × 16.2 cm)*

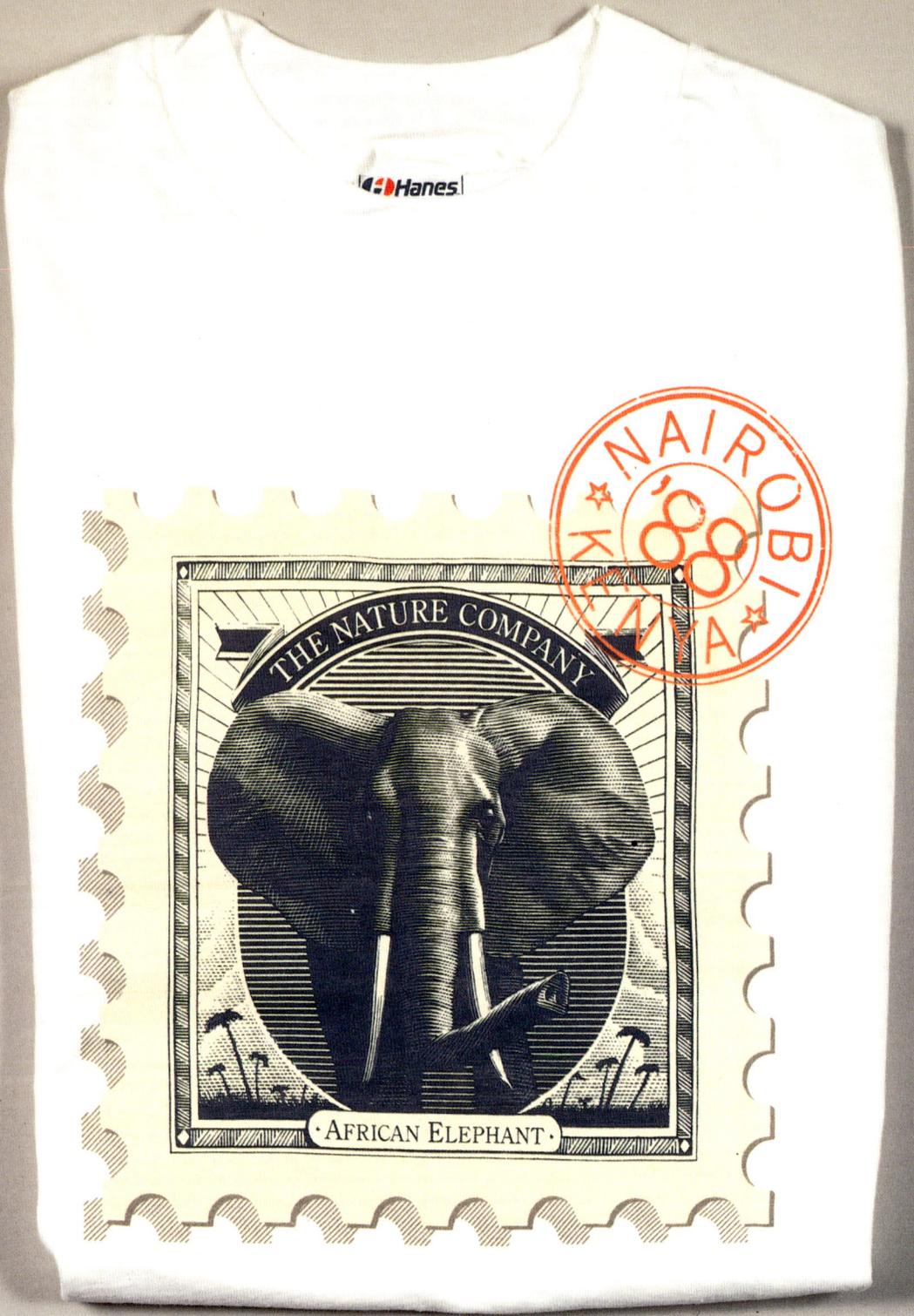

PRODUCT DESIGN
TYPOGRAPHY/DESIGN *Kit Hinrichs, San Francisco, California* **TYPOGRAPHIC SUPPLIER** *Eurotype* **STUDIO** *Pentagram Design*
CLIENT *The Nature Company* **PRINCIPAL TYPES** *Century Old Style and News Gothic*

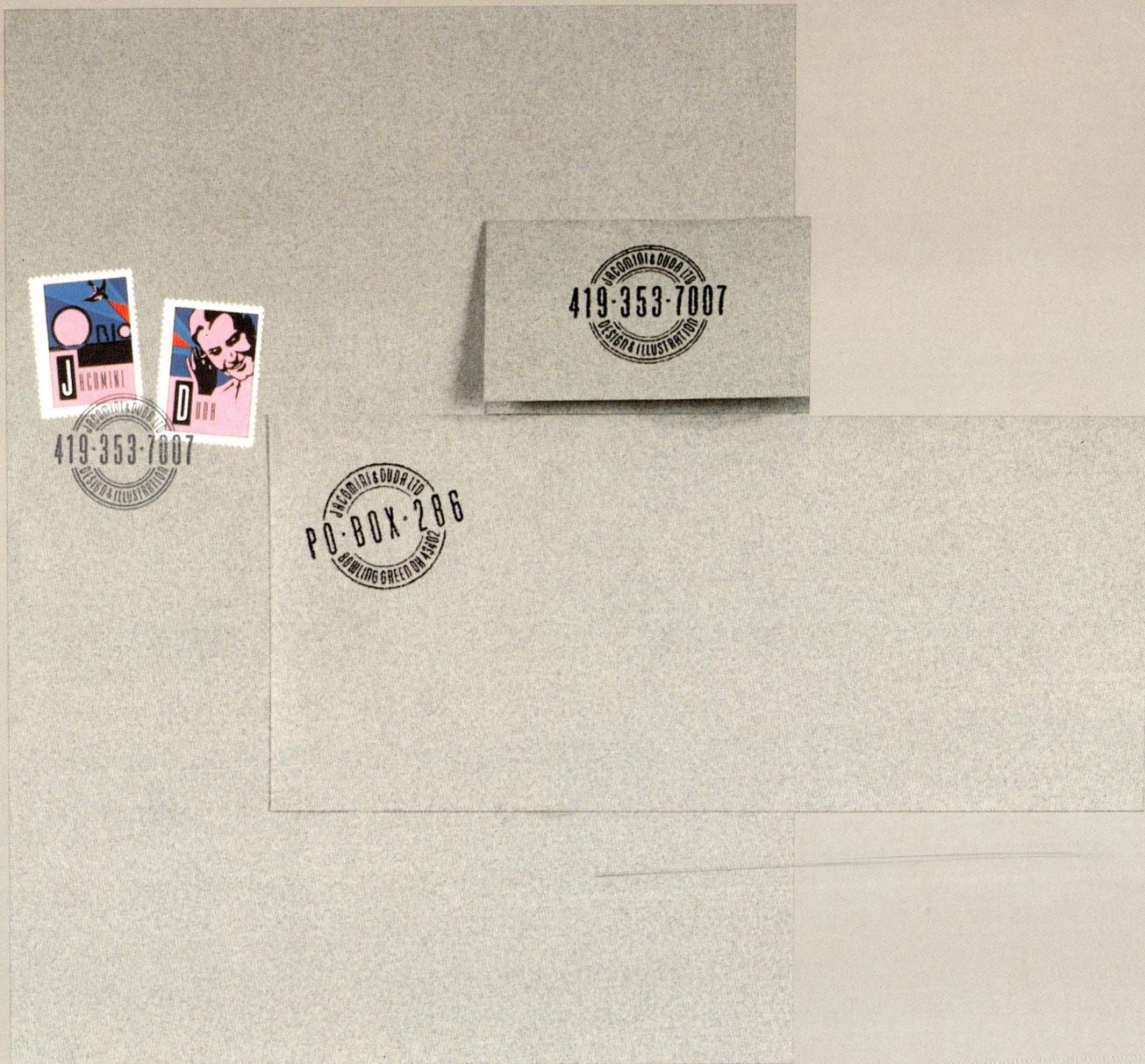

STATIONERY
TYPOGRAPHY/DESIGN *Ronald Jacomini and Tony Duda, Bowling Green, Ohio* **TYPOGRAPHIC SUPPLIER** *Type House, Inc.*
STUDIO *Jacomini & Duda, Ltd.* **CLIENT** *Jacomini & Duda, Ltd.* **PRINCIPAL TYPE** *Title Gothic Condensed, Empire, Onyx, and Spire*
DIMENSIONS *8½ × 11 in. (21.6 × 27.9 cm)*

ANNUAL REPORT
TYPOGRAPHY/DESIGN *Willie Baronet, Dallas, Texas* **ART DIRECTOR** *Ron Sullivan, Dallas, Texas*
TYPOGRAPHIC SUPPLIER *Robert J. Hilton Co., Inc.* **STUDIO** *Sullivan Perkins* **CLIENT** *Intertrans Corporation*
PRINCIPAL TYPE *Quorum Light* **DIMENSIONS** *8½ × 11 in. (21.6 × 27.9 cm)*

REDSETTER LIMITED

With Compliments

17-19
WHITWORTH STREET WEST
MANCHESTER M1 5WG TEL 061 228 3549
FAX 061 228 6197

Les Bird

17-19
WHITWORTH STREET WEST
MANCHESTER M1 5WG
TEL 061 228 3549
FAX 061 228 6197

17-19
WHITWORTH STREET WEST
MANCHESTER M1 5WG TEL 061 228 3549
FAX 061 228 6197
Company Registered in England No. 2121640
VAT Registration No. 450 6507 30

STATIONERY
TYPOGRAPHY/DESIGN *Jim Williams, Manchester, England* **TYPOGRAPHIC SUPPLIER** *The Quick Brown Fox Company*
DESIGN GROUP *The Chase* **CLIENT** *Redsetter Limited* **PRINCIPAL TYPE** *Bodoni* **DIMENSIONS** *11¾ × 8¼ in. (29.7 × 21 cm)*

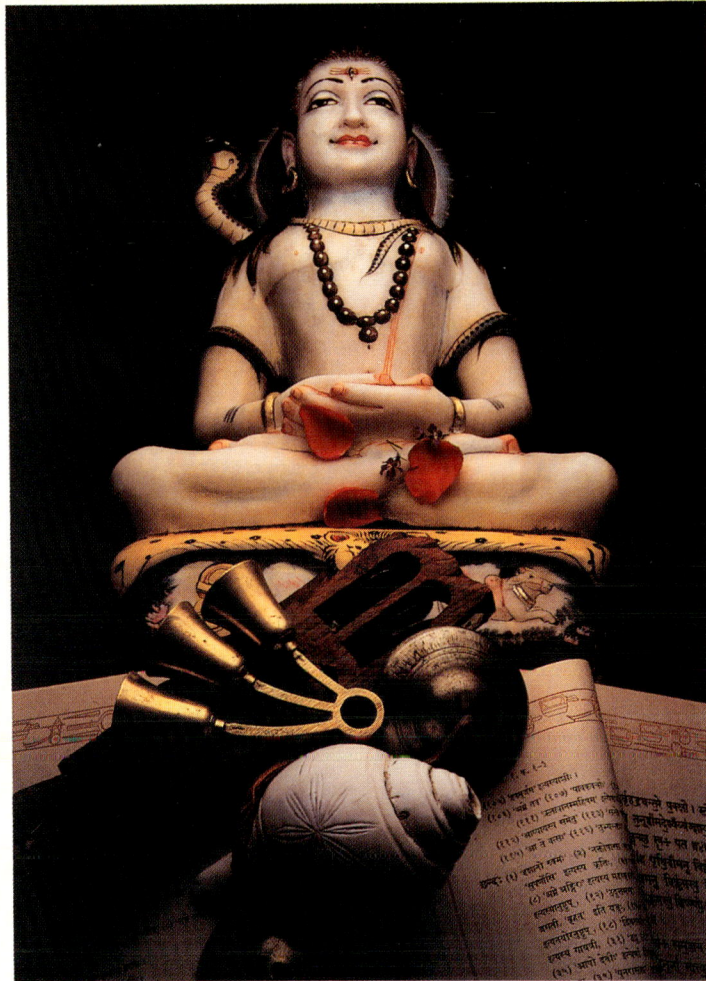

BROCHURE
TYPOGRAPHY/DESIGN *Kevin B. Kuester, Minneapolis, Minnesota* **TYPOGRAPHIC SUPPLIER** *Typeshooters*
STUDIO *Madsen and Kuester, Inc.* **CLIENT** *Potlatch Corporation* **PRINCIPAL TYPE** *Cheltenham*
DIMENSIONS *10 × 14 in. (25.4 × 35.6 cm)*

GEORGE HARRISON
Gets Back

The mystical ex-Beatle rides 'Cloud Nine' back into the material world

BY ANTHONY DeCURTIS

PHOTOGRAPHS BY WILLIAM COUPON

MAGAZINE SPREAD
TYPOGRAPHY/DESIGN *Fred Woodward, New York, New York* **TYPOGRAPHIC SUPPLIER** *Rolling Stone magazine (in-house)*
CLIENT *Rolling Stone magazine* **PRINCIPAL TYPE** *Cochin Black* **DIMENSIONS** *20 × 12 in. (50.8 × 30.5 cm)*

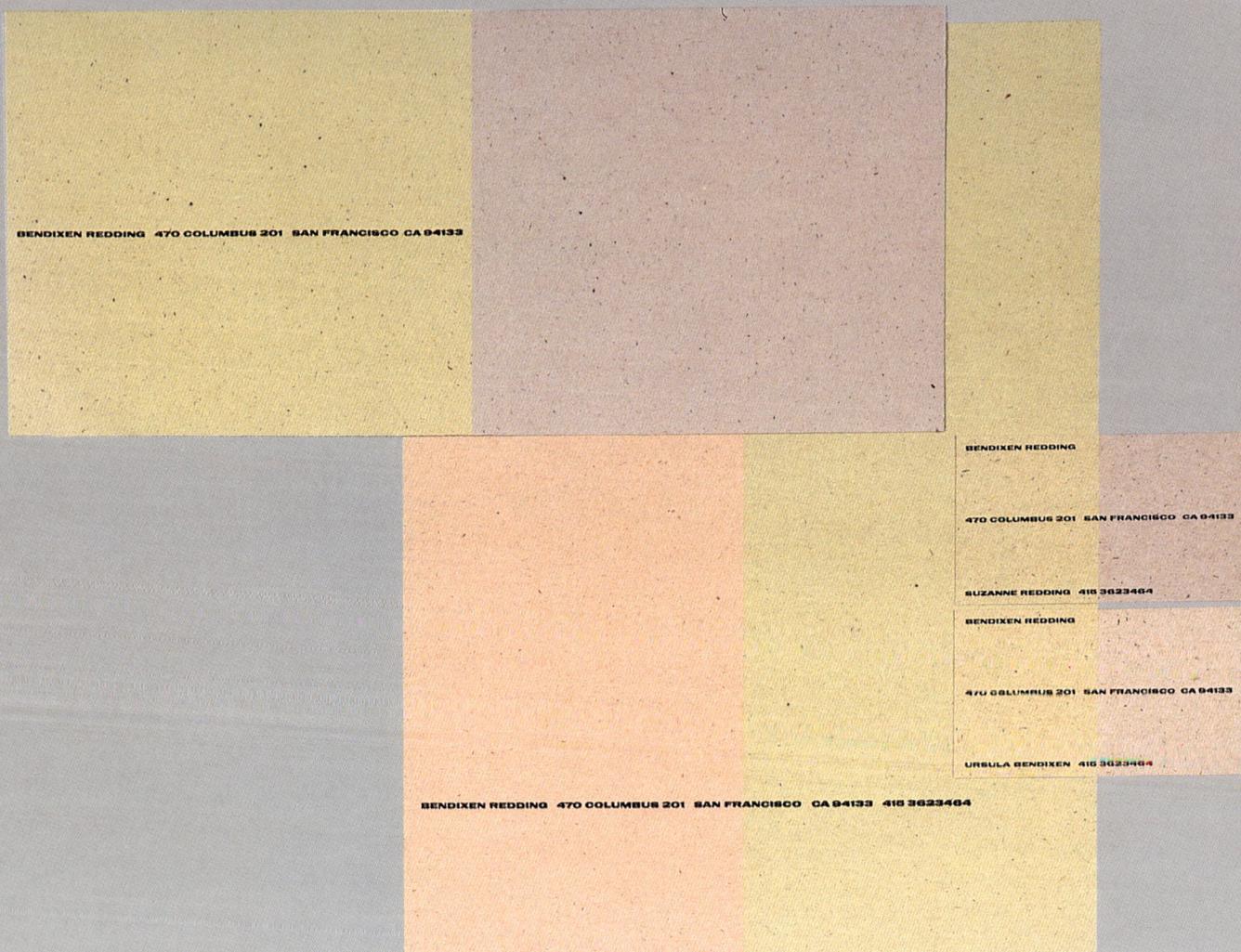

STATIONERY
TYPOGRAPHY/DESIGN *Ursula Bendixen and Suzanne Redding, San Francisco, California* **TYPOGRAPHIC SUPPLIER** *MasterType*
STUDIO *Bendixen Redding* **CLIENT** *Bendixen Redding* **PRINCIPAL TYPE** *Gibbons* **DIMENSIONS** *8½ × 11 in. (21.6 × 27.9 cm)*

I M C

International

Minerals

&

Chemical

Corporation

Annual

Report

1987

ANNUAL REPORT
TYPOGRAPHY/DESIGN *Pat and Greg Samata, Dundee, Illinois* **TYPOGRAPHIC SUPPLIER** *Typographic Resource*
STUDIO *Samata Associates* **CLIENT** *International Minerals & Chemical Corporation* **PRINCIPAL TYPE** *Garamond*
DIMENSIONS *8¼ × 11½ in. (28.6 × 29.2 cm)*

STATIONERY
TYPOGRAPHY/DESIGN *Laura and Christopher Hough, Norwalk, Connecticut* **TYPOGRAPHIC SUPPLIER** *Typographic Art, Inc.*
STUDIO *Laura Hough Design* **CLIENT** *Laura Hough Design* **PRINCIPAL TYPE** *Sabon* **DIMENSIONS** *8½ × 11 in. (21.6 × 27.9 cm)*

ANNUAL

L REPORTS ARE

BROCHURE
TYPOGRAPHY/DESIGN *John Waters and Dana Gonsalves, New York, New York* **TYPOGRAPHIC SUPPLIER** *Typogram*
STUDIO *John Waters Associates, Inc.* **CLIENT** *John Waters Associates, Inc.* **PRINCIPAL TYPE** *Franklin Gothic Condensed*
DIMENSIONS *8⅝ × 12 in. (21.9 × 30.5 cm)*

STATIONERY
TYPOGRAPHY/DESIGN *Christiane Beylier, Paris, France* **TYPOGRAPHIC SUPPLIER** *FACE Photosetting* **STUDIO** *Christiane Beylier*
CLIENT *Christiane Beylier* **PRINCIPAL TYPES** *Futura Light and Futura Extra Bold* **DIMENSIONS** *8¼ × 11¾ in. (21 × 29.7 cm)*

STATIONERY
TYPOGRAPHY/DESIGN *Jennifer Morla, San Francisco, California* **TYPOGRAPHIC SUPPLIER** *Spartan Typographers*
STUDIO *Morla Design, Inc.* **CLIENT** *Morla Design, Inc.* **PRINCIPAL TYPE** *Futura* **DIMENSIONS** *8½ × 11 in. (21.6 × 27.9 cm)*

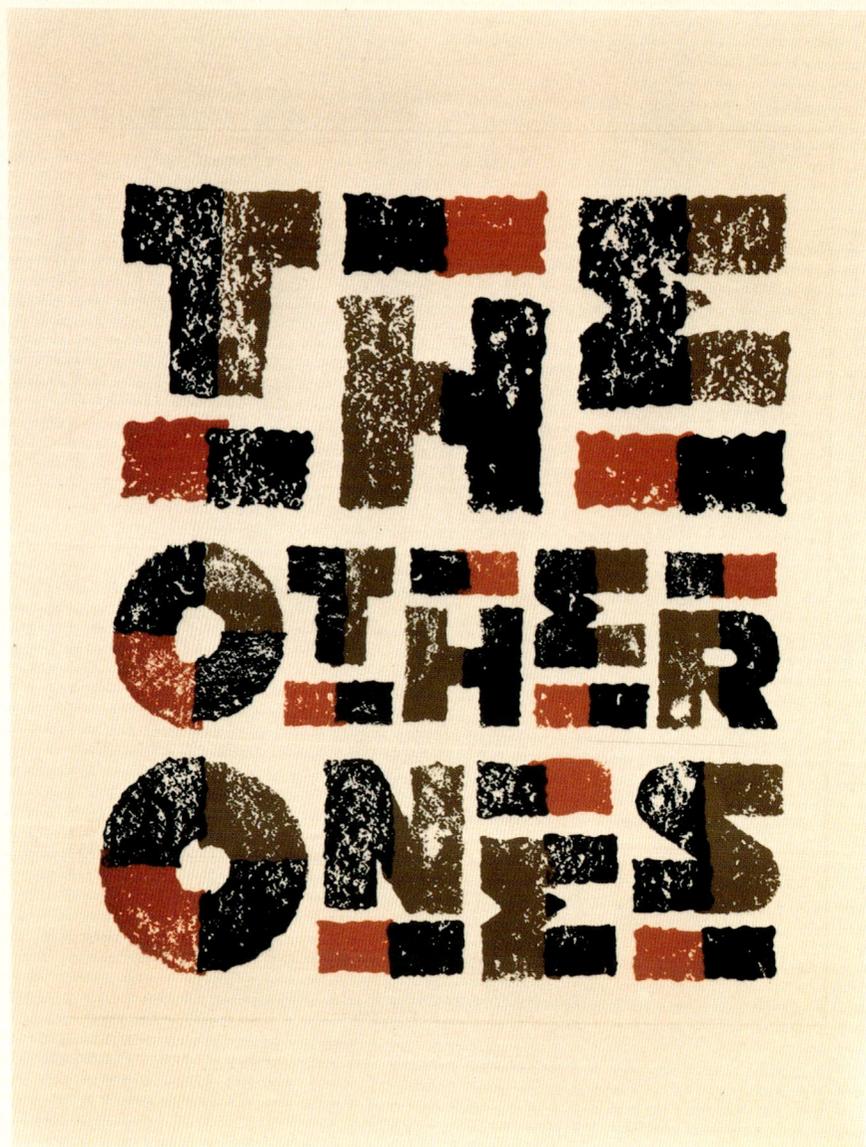

LOGOTYPE
TYPOGRAPHY/DESIGN *Margo Chase, Los Angeles, California* **LETTERER** *Margo Chase* **STUDIO** *Margo Chase Design*
CLIENT *Virgin Records America, Inc.* **PRINCIPAL TYPE** *Handlettering*

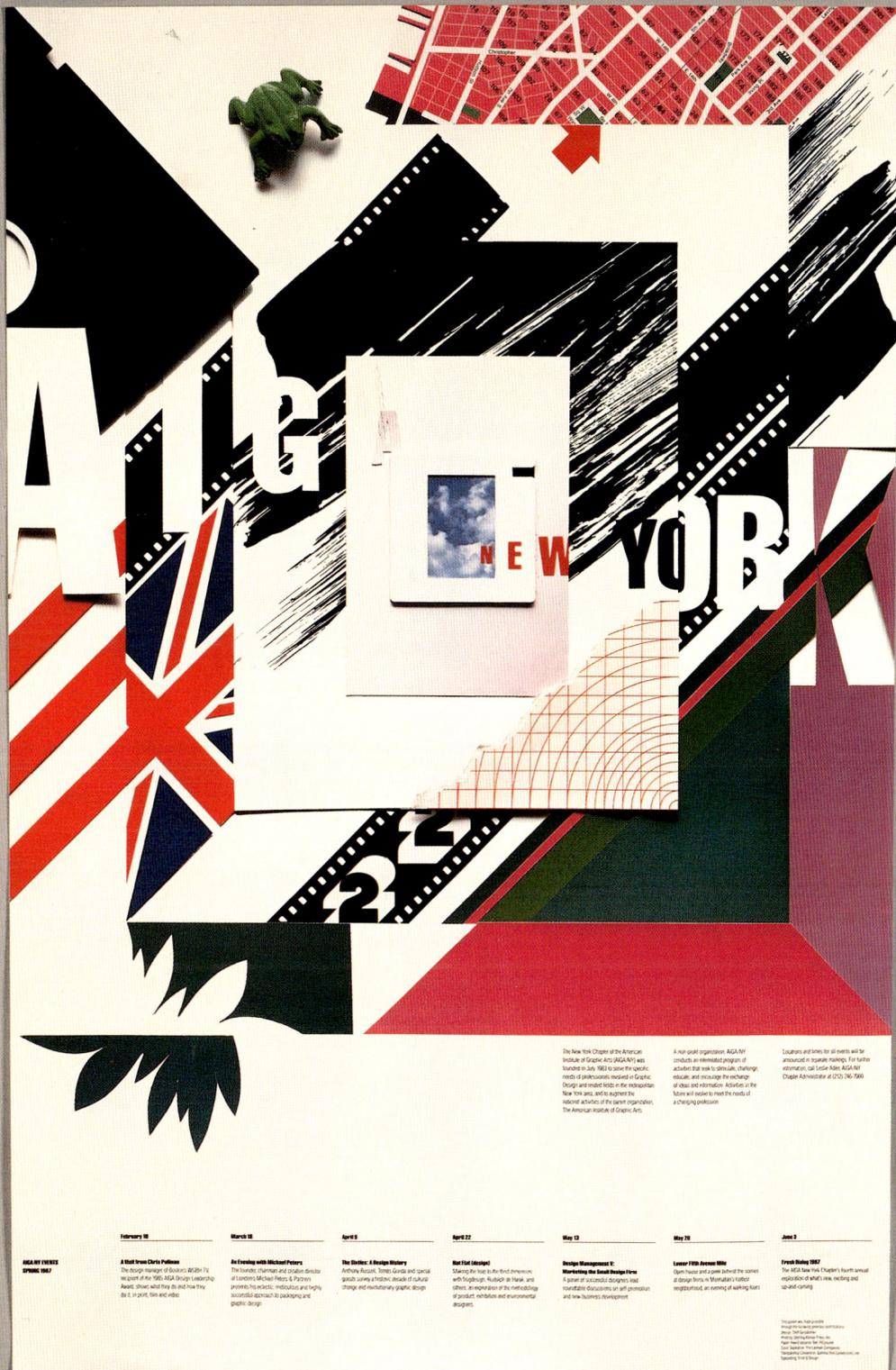

POSTER
TYPOGRAPHY/DESIGN *Steff Geissbuhler, New York, New York* **TYPOGRAPHIC SUPPLIER** *Print & Design*
STUDIO *Chermayeff & Geismar Associates* **CLIENT** *American Institute of Graphic Arts (AIGA)/New York*
PRINCIPAL TYPE *Helvetica Condensed* **DIMENSIONS** *24 × 36 in. (61 × 91 cm)*

Beckenstein Enterprises

FOLDER
TYPOGRAPHY/DESIGN *Arthur Beckenstein, New York, New York* **TYPOGRAPHIC SUPPLIER** *Typographic Images*
STUDIO *Arthur Beckenstein* **CLIENT** *Beckenstein Enterprises* **PRINCIPAL TYPE** *Helvetica* **DIMENSIONS** *9 × 12 in. (22.9 × 30.5 cm)*

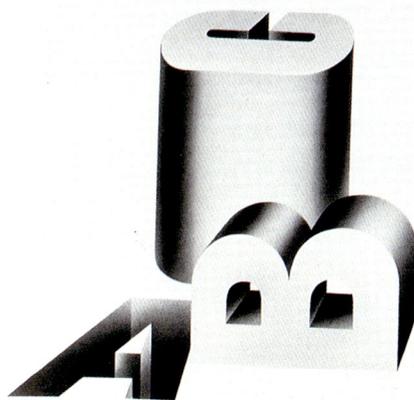

BOOK
TYPOGRAPHY/DESIGN *Alan Fletcher and Debbie Martindale, London, England* **TYPOGRAPHIC SUPPLIER** *APT Photoset Limited*
STUDIO *Pentagram Design* **CLIENT** *Pentagram Design* **PRINCIPAL TYPE** *Baskerville* **DIMENSIONS** *98½ × 98½ in. (250 × 250 cm)*

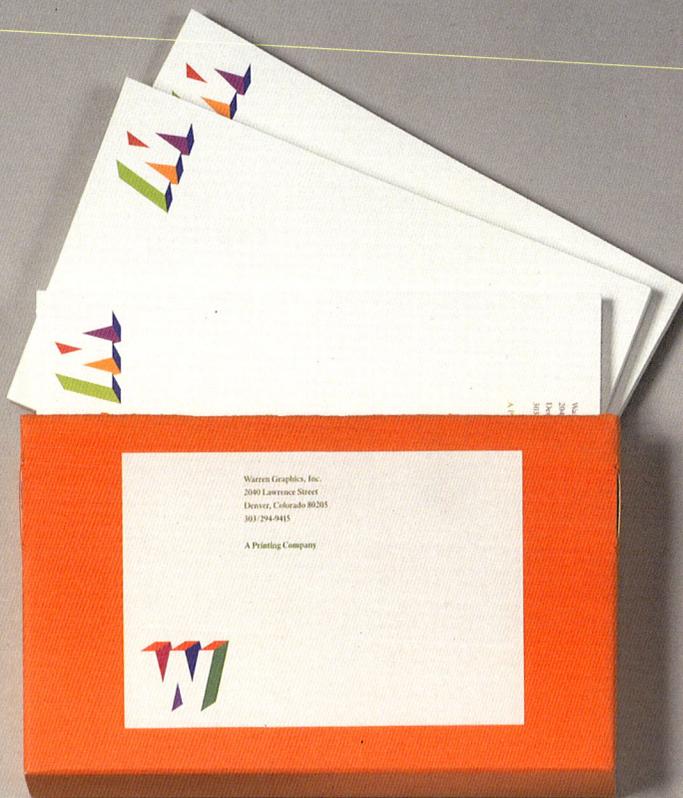

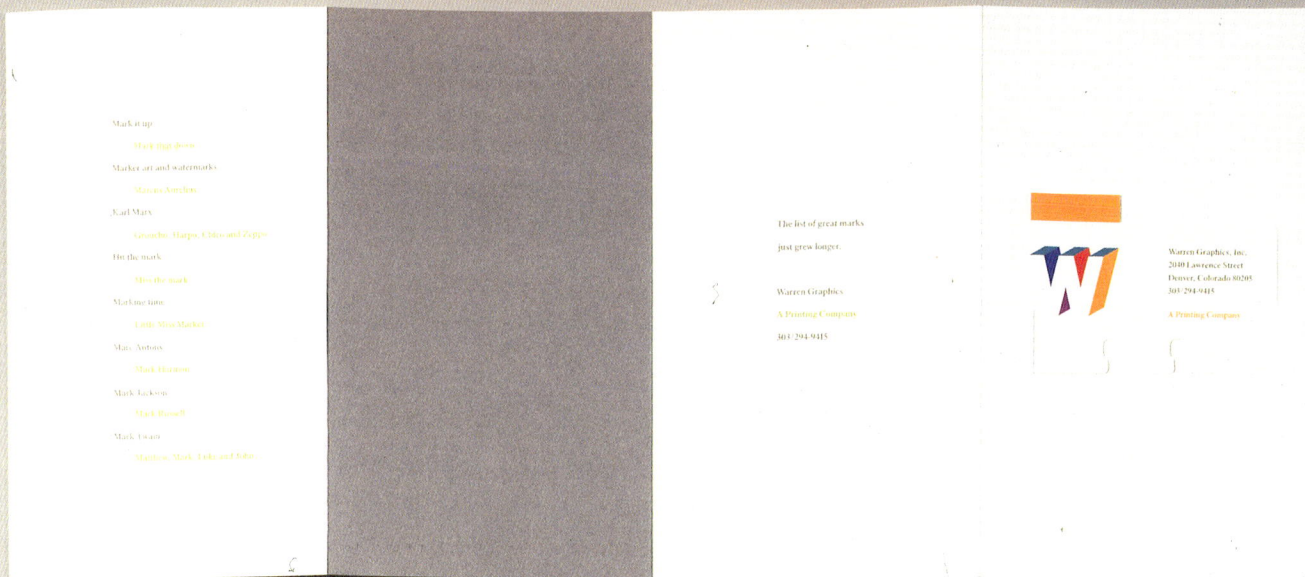

CORPORATE IDENTITY
TYPOGRAPHY/DESIGN *Monique Davis, Denver, Colorado* **TYPOGRAPHIC SUPPLIER** *EB Typecrafters* **STUDIO** *Weber Design*
CLIENT *Warren Graphics, Inc.* **PRINCIPAL TYPE** *Times Roman Semi-Bold* **DIMENSIONS** *27¼ × 13¼ in. (69.2 × 33.7 cm)*

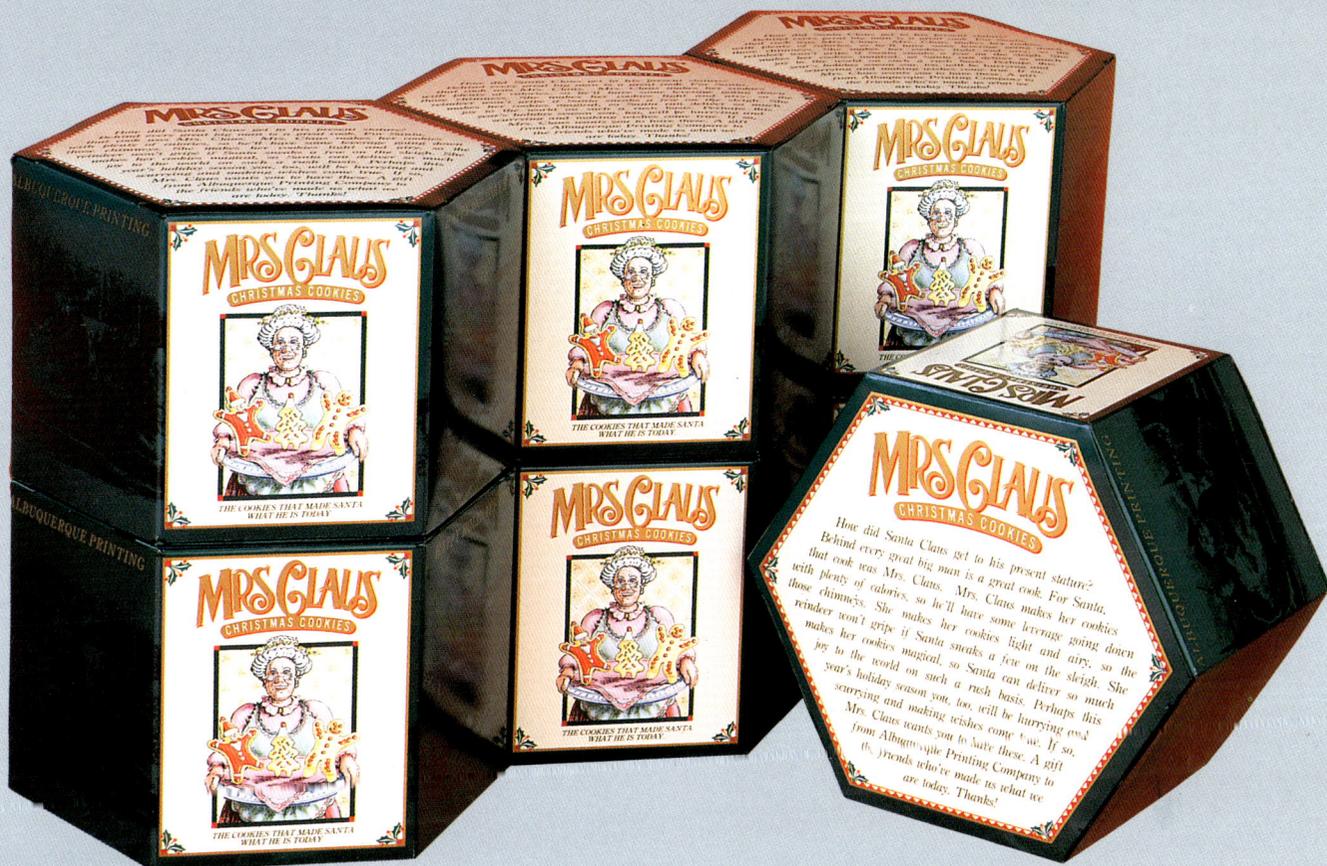

PACKAGING
TYPOGRAPHY/DESIGN *Dan Flynn, Albuquerque, New Mexico* **LETTERER** *Dan Flynn* **TYPOGRAPHIC**
SUPPLIER *Albuquerque Printing Art Department* **STUDIO** *Flynn Graphic Design* **CLIENT** *Albuquerque Printing Company*
PRINCIPAL TYPE *Handlettering* **DIMENSIONS** *2¾ × 3⅜ × 4¾ in. (7 × 8.7 × 12.1 cm)*

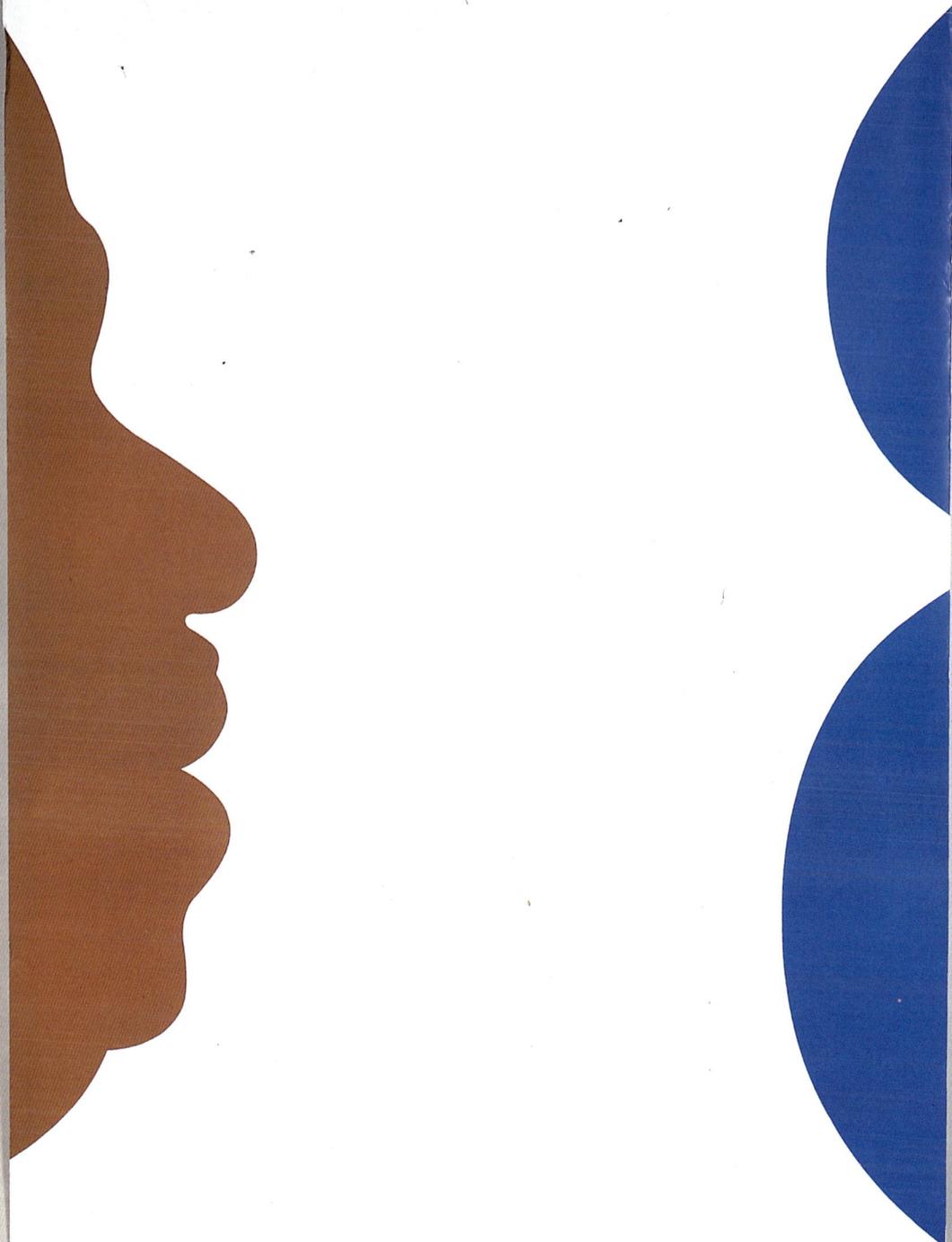

Sonntag 18. Januar '87, 19.00 Uhr Kurtheater Baden **The Great Basie Eight** Vorverkauf: SKA, Baden

Clark Terry, Buddy Tate, Billy Mitchell, Al Grey, Nat Pierce, Freddie Green, Eddie Jones, Oliver Jackson

POSTER
TYPOGRAPHY/DESIGN *Niklaus Troxler, Willisau, Switzerland* **CALLIGRAPHER** *Niklaus Troxler* **STUDIO** *Grafik-Studio Niklaus Troxler*
CLIENT *Jazz in Baden* **PRINCIPAL TYPES** *Helvetica Light and Helvetica Bold* **DIMENSIONS** *35½ × 50¼ in. (90.2 × 127.6 cm)*

CORPORATE IDENTITY MANUAL
TYPOGRAPHY/DESIGN *Henry Steiner, Hong Kong* **TYPOGRAPHIC SUPPLIER** *Core Bookwork Company*
STUDIO *Graphic Communication Ltd.* **CLIENT** *IBM Asia/Pacific Group—Line Operations* **PRINCIPAL TYPE** *Didot*
DIMENSIONS *8¼ × 11¾ in. (21 × 30 cm)*

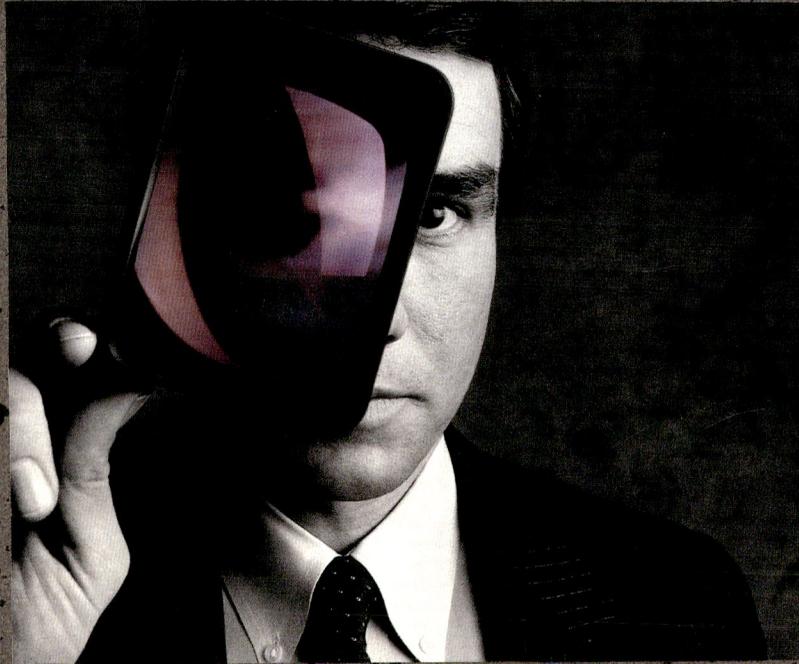

ANNUAL REPORT
TYPOGRAPHY/DESIGN *Greg Samata, Dundee, Illinois* **TYPOGRAPHIC SUPPLIER** *Typographic Resource* **STUDIO** *Samata Associates*
CLIENT *Kemper Reinsurance Company* **PRINCIPAL TYPE** *Garamond* **DIMENSIONS** *7¾ × 11½ in. (19.7 × 29.2 cm)*

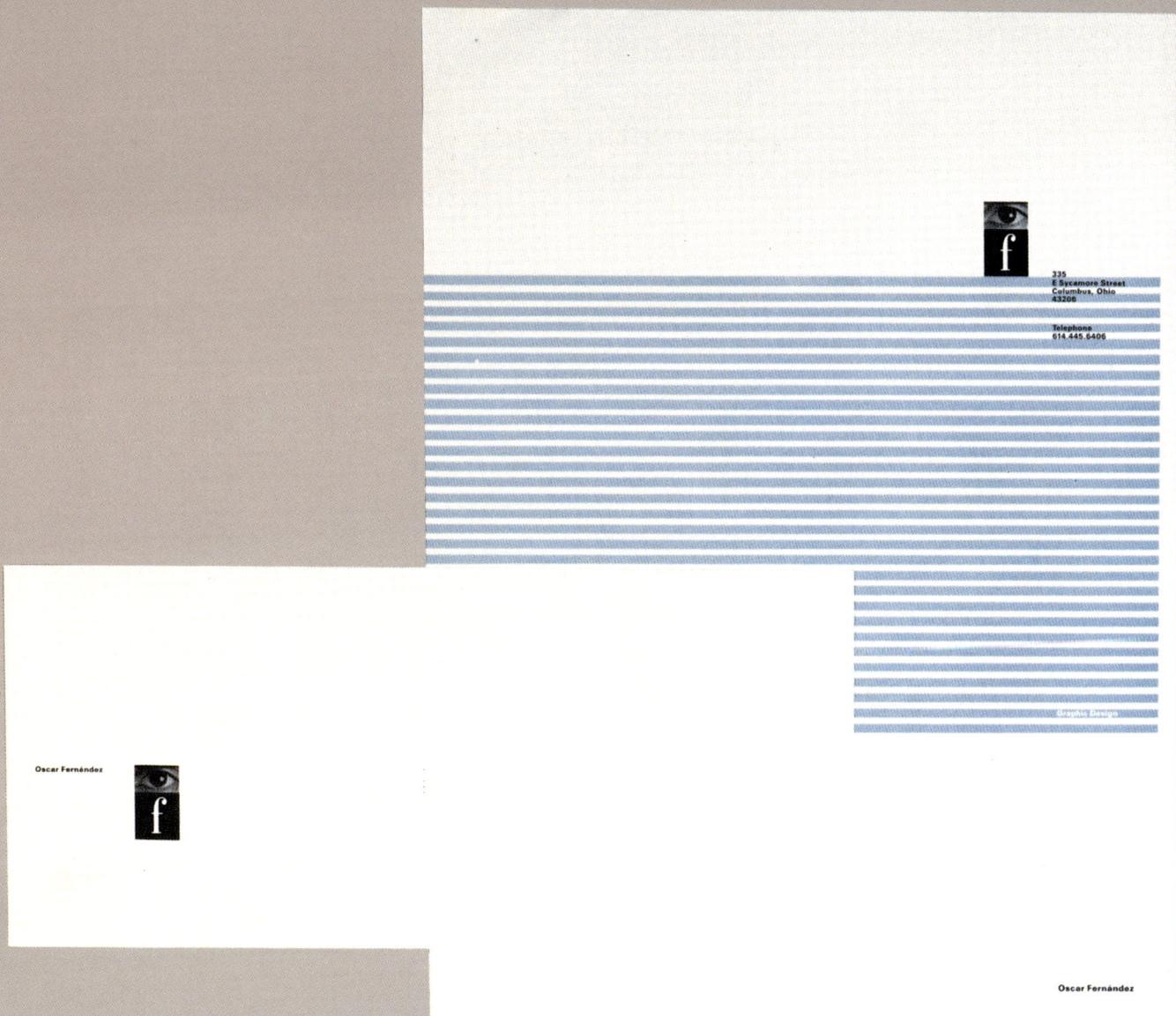

335
E Sycamore Street
Columbus, Ohio
43206

Telephone
614.445.6406

Graphic Design

Oscar Fernández

Oscar Fernández

STATIONERY
TYPOGRAPHY/DESIGN *Oscar Fernández, Columbus, Ohio* **TYPOGRAPHIC SUPPLIER** *Dwight Yaeger Typographers*
STUDIO *Fernández Design* **CLIENT** *Fernández Design* **PRINCIPAL TYPE** *Univers 75* **DIMENSIONS** *8½ × 11 in. (21.6 × 27.9 cm)*

LOGOTYPE
TYPOGRAPHY/DESIGN *Pat Hansen, Seattle, Washington* **LETTERER** *Jesse Doquilo and Pat Hansen*
TYPOGRAPHIC SUPPLIER *Typehouse* **STUDIO** *Pat Hansen Design* **CLIENT** *Chocolate & Co.*
PRINCIPAL TYPES *Futura Bold Condensed and Handlettering*

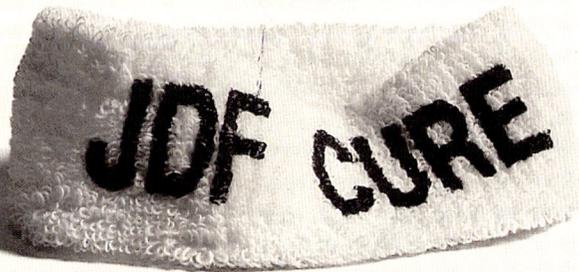

ANNUAL REPORT
TYPOGRAPHY/DESIGN *Hershell George, New York, New York* **TYPOGRAPHIC SUPPLIER** *CTC Typographers Inc.*
STUDIO *Hershell George Graphics* **CLIENT** *The Juvenile Diabetes Foundation International* **PRINCIPAL TYPES** *Baskerville, Avant Garde Bold Condensed, and Baskerville Italic* **DIMENSIONS** *8½ × 11 in. (21.6 × 27.9 cm)*

BOOK
TYPOGRAPHY/DESIGN *Dick Mitchell, Dallas, Texas* **TYPOGRAPHIC SUPPLIER** *Southwestern Typographics, Inc.*
AGENCY *The Richards Group* **STUDIO** *Richards Brock Miller Mitchell & Associates* **CLIENT** *Lomas & Nettleton Financial Corporation*
PRINCIPAL TYPE *Palatino Italic* **DIMENSIONS** *10¼ × 13¼ in. (26 × 33.7 cm)*

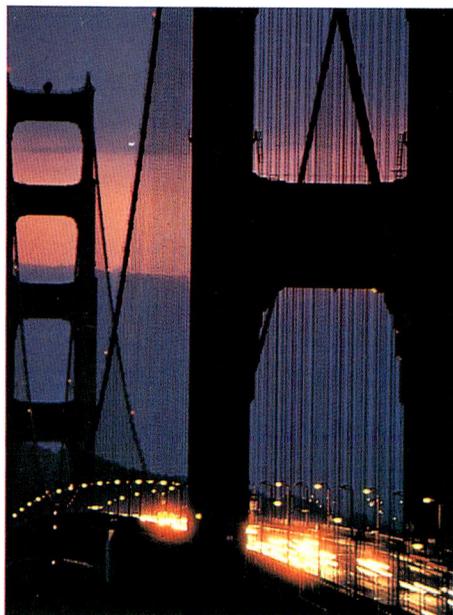

Griffin Real Estate Company Real Estate Brokerage and Commercial Leasing Services

"Providing successful real estate brokerage and leasing services is essentially a process of bridging gaps. We link buyer and seller, property and investor, tenants and the space they need, developers and the market."

BROCHURE
TYPOGRAPHY/DESIGN *Kevin B. Kuester and Tim Sauer, Minneapolis, Minnesota* **PRODUCTION** *Craig Schommer*
TYPOGRAPHIC SUPPLIER *Typeshooters* **STUDIO** *Madsen and Kuester, Inc.* **CLIENT** *The Griffin Companies* **PRINCIPAL TYPE** *Sabon*
DIMENSIONS *7½ × 11½ in. (19.1 × 29.2 cm)*

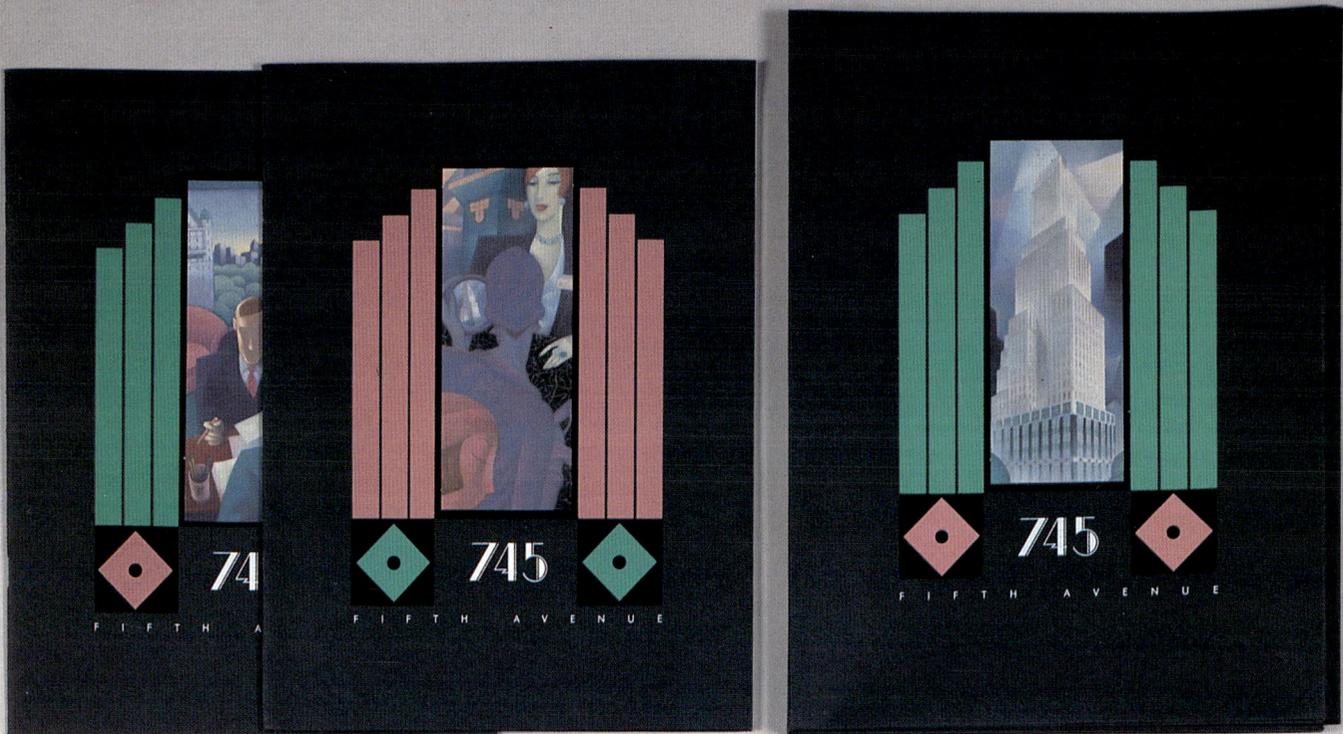

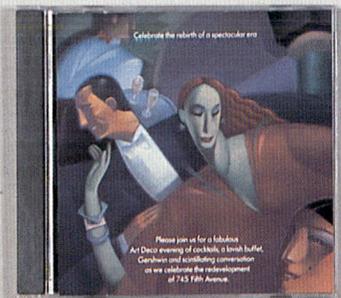

CAMPAIGN
TYPOGRAPHY/DESIGN *Diana Graham and Debra Thompson, New York, New York* **CALLIGRAPHER** *Serban Epure, New York, New York*
TYPOGRAPHIC SUPPLIER *JCH Graphics Ltd.* **AGENCY** *Diagram Design & Marketing Communications, Inc.* **CLIENT** *La Salle Partners*
PRINCIPAL TYPES *Handlettering and Futura Light* **DIMENSIONS** *Various*

POSTER
TYPOGRAPHY/DESIGN *Michael Mescall, Playa del Rey, California* **TYPOGRAPHIC SUPPLIER** *Composition Type*
AGENCY *Robert Miles Runyan & Associates* **CLIENT** *Travelers Insurance* **PRINCIPAL TYPE** *Univers*
DIMENSIONS *20 × 28 in. (50.8 × 71.1 cm)*

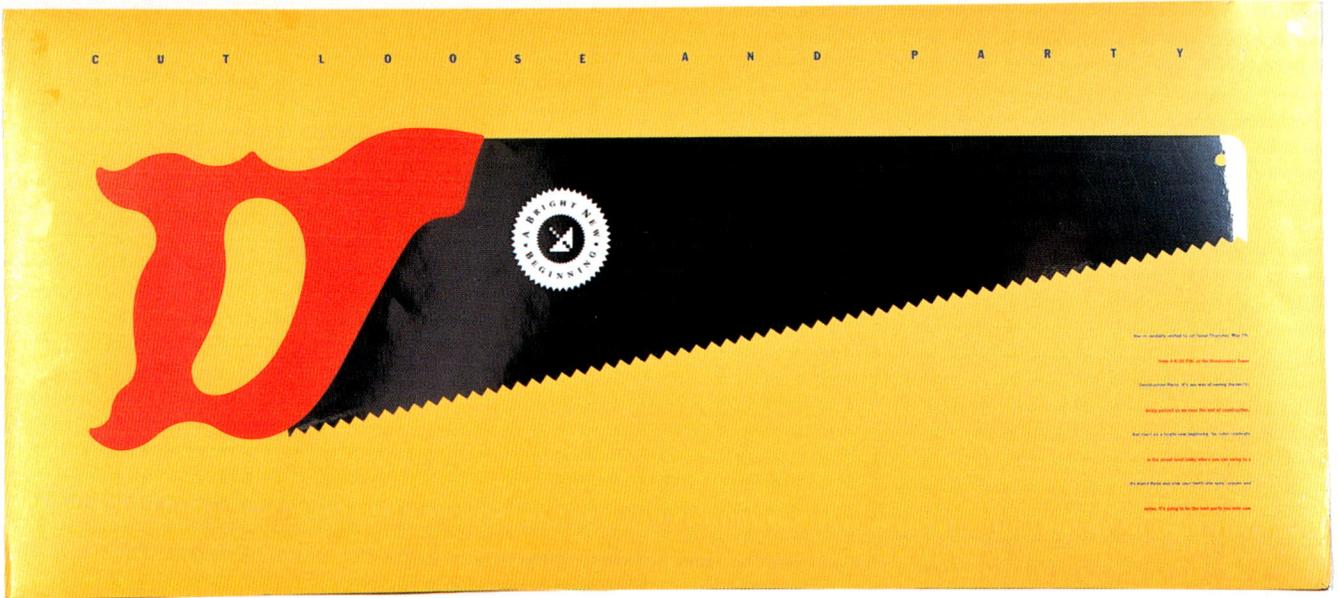

CUT LOOSE AND PARTY

POSTER
TYPOGRAPHY/DESIGN *Judy Dolim, Dallas, Texas* **TYPOGRAPHIC SUPPLIER** *Southwestern Typographics, Inc.*
STUDIO *Sibley/Peteet Design* **CLIENT** *LaSalle Partners* **PRINCIPAL TYPE** *Franklin Gothic Condensed*
DIMENSIONS *37 × 16 in. (94 × 40.6 cm)*

CAMPAIGN
TYPOGRAPHY/DESIGN *Jennifer Morla, San Francisco, California* **TYPOGRAPHIC SUPPLIER** *On-Line Typographers*
STUDIO *Morla Design, Inc.* **CLIENT** *Ghosts/San Francisco* **PRINCIPAL TYPES** *Futura, Univers, and Helvetica* **DIMENSIONS** *Various*

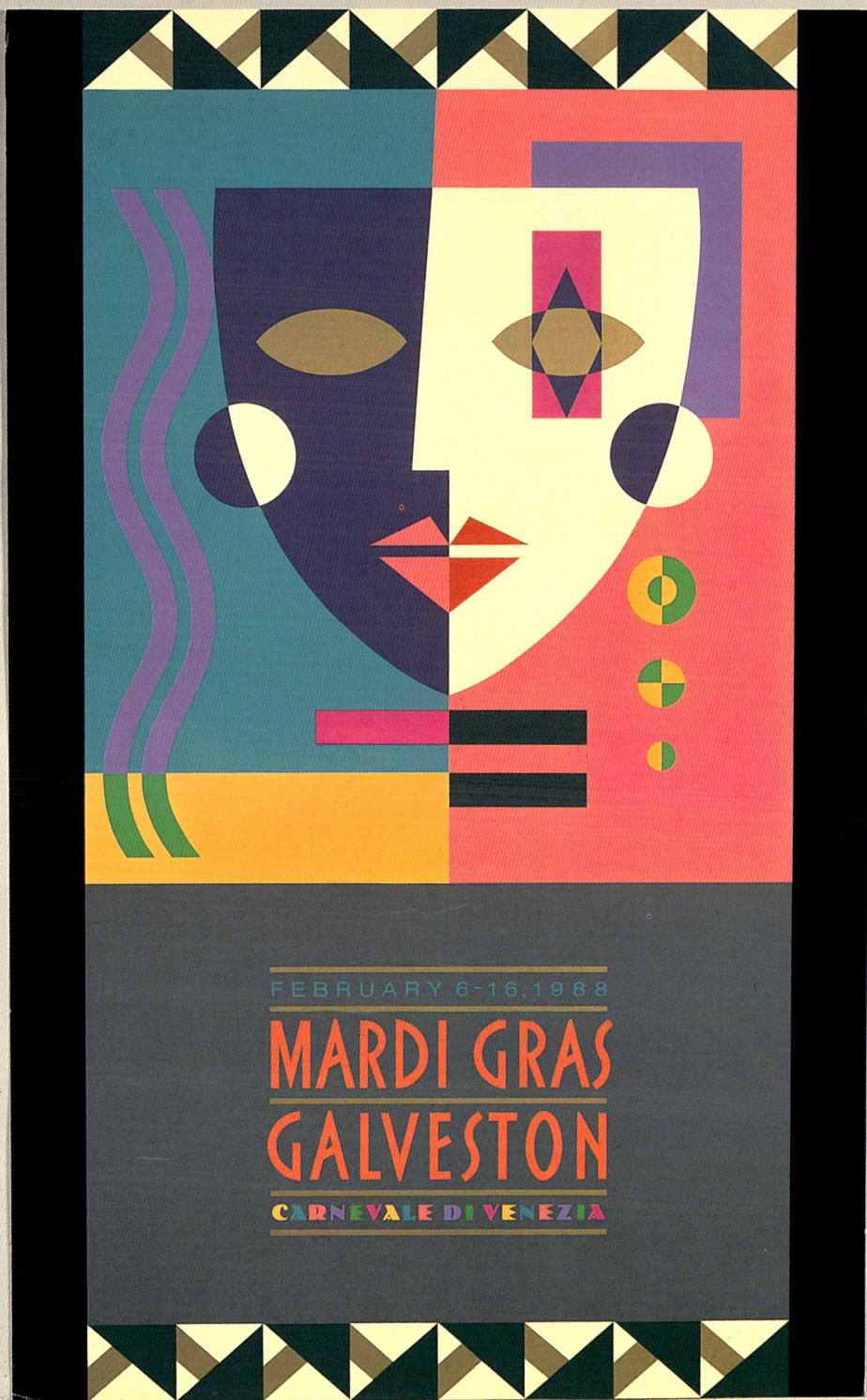

POSTER
TYPOGRAPHY/DESIGN *Don Sibley, Dallas, Texas* **LETTERERS** *Don Sibley and John Evans, Dallas, Texas* **STUDIO** *Sibley/Peteet Design*
CLIENT *Galveston Mardi Gras* **PRINCIPAL TYPES** *Handlettering and Dolmen Black* **DIMENSIONS** *21½ × 34 in. (54.6 × 86.6 cm)*

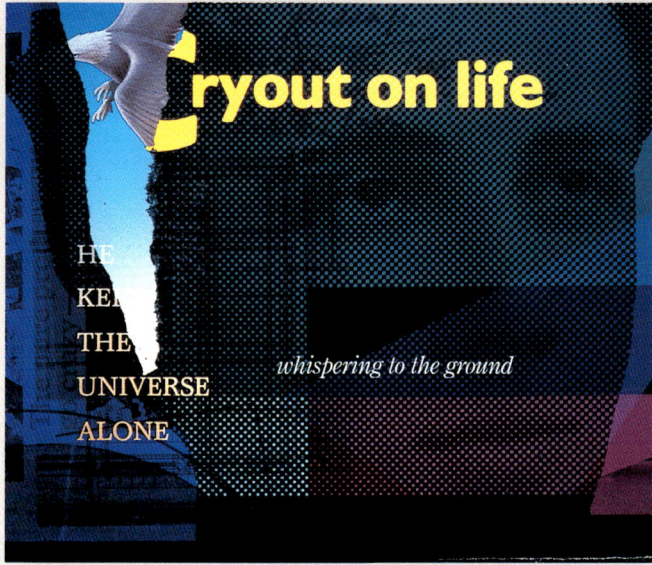

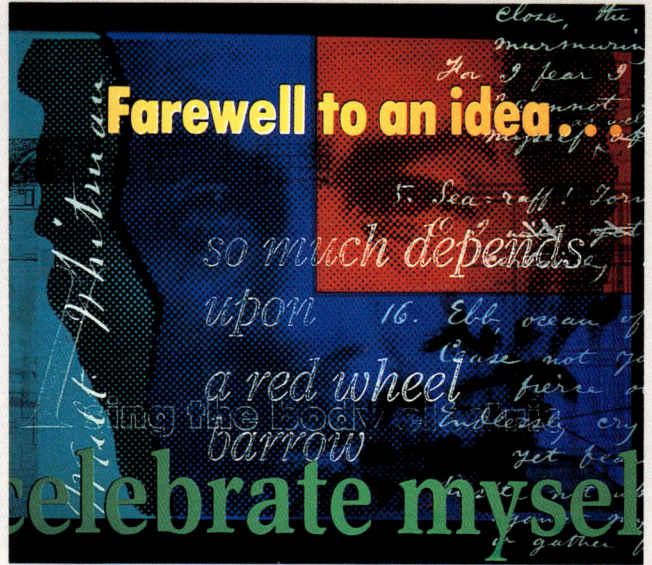

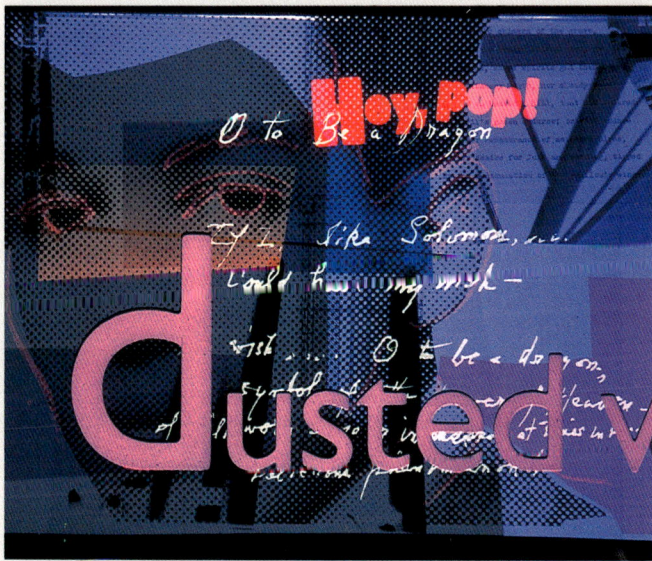

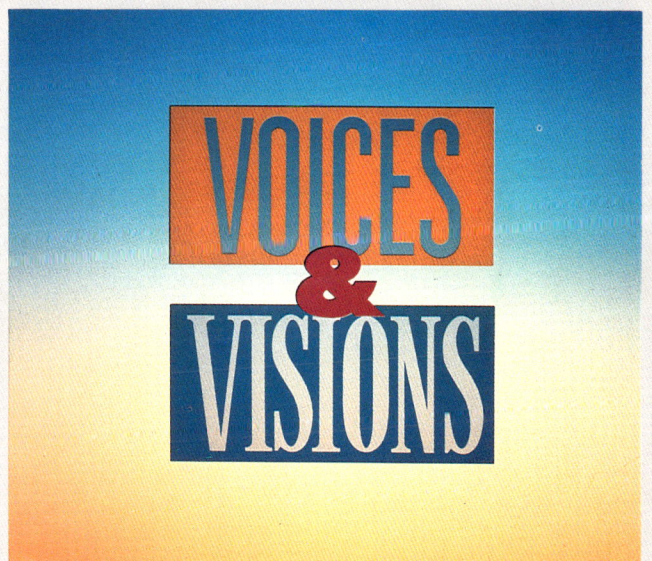

ryout on life

HE
KEP
THE
UNIVERSE
ALONE

whispering to the ground

Farewell to an idea....

so much depends,
upon 16. Ebb ocean
a red wheel
barrow

celebrate mysel

Hey, Pop!

O to Be a Dragon

dusted

VOICES
&
VISIONS

VIDEOTAPE
TYPOGRAPHY/DESIGN *Nancy Laurence, John Woo, and Roger Woo, New York, New York*
TYPOGRAPHIC SUPPLIER *Skeezo Typographers* **STUDIOS** *EYE Design and Woo Art International*
CLIENT *New York Center for Visual History* **PRINCIPAL TYPES** *Various and Handlettering*

THE COMPROMISE IS OVER...

BROCHURE
TYPOGRAPHY/DESIGN *David Brier, East Rutherford, New Jersey* **LETTERER** *David Brier*
TYPOGRAPHIC SUPPLIER *Dimensional Graphics* **STUDIO** *David Brier Design Works, Inc.* **CLIENT** *VNU Business Publications, Inc.*
PRINCIPAL TYPE *Helvetica Ultra Compressed* **DIMENSIONS** *11½ × 17½ in. (29.2 × 44.5 cm)*

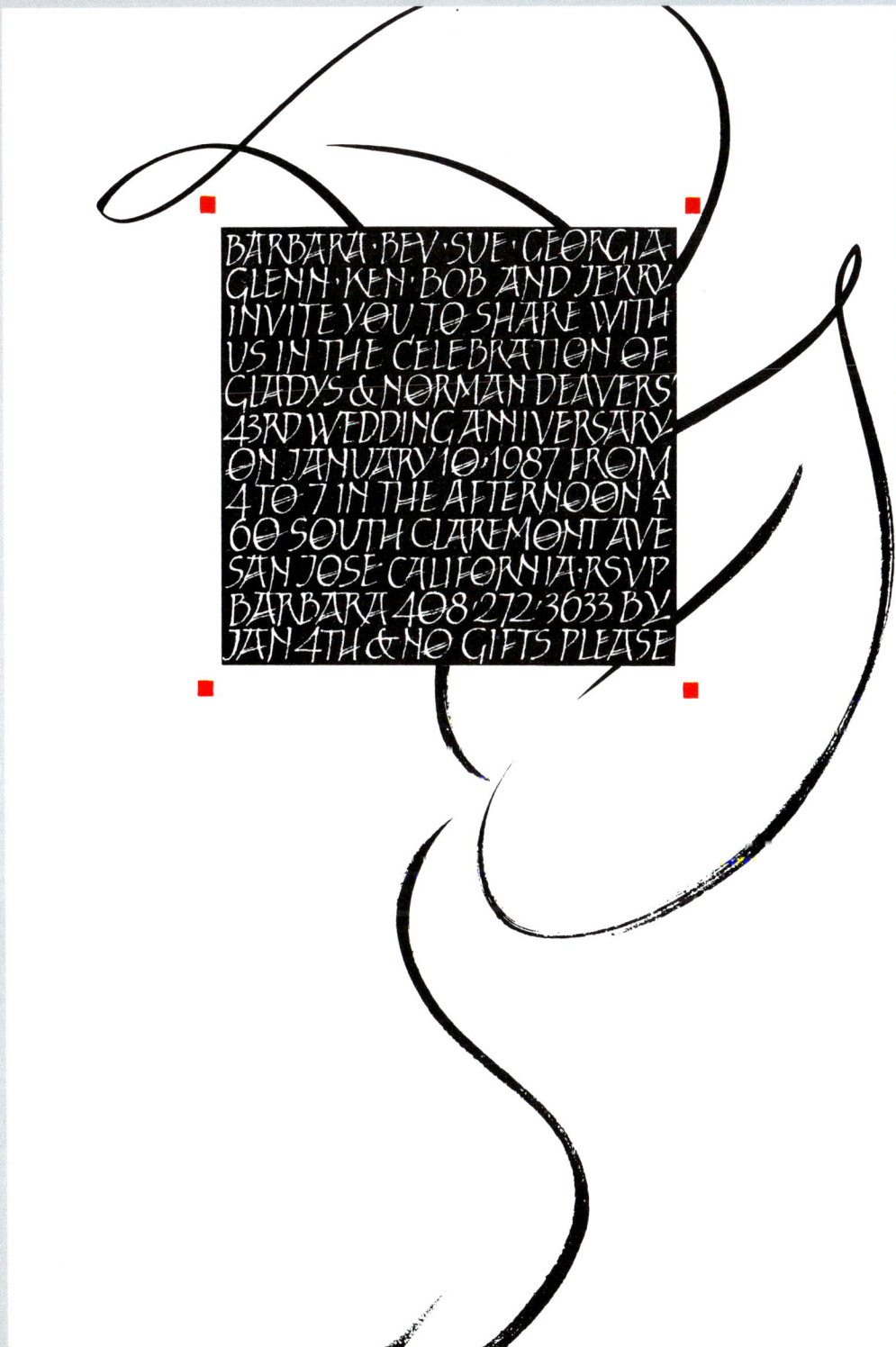

INVITATION
TYPOGRAPHY/DESIGN *Georgia Deaver, San Francisco, California* **CALLIGRAPHER** *Georgia Deaver*
STUDIO *Georgia Deaver Calligraphy and Handlettering* **DIMENSIONS** *5¼ × 7⅞ in. (13.3 × 20 cm)*
ERRATUM *This piece was selected last year for TDC 33, but inadvertently omitted from the annual Typography 8. It is thus included here.*

TYPE DIRECTORS CLUB

202

George Abrams '71
Mary Margaret Ahern '83
Leonard F. Bahr '62
Peter Bain '86
Don Baird '69
Colin Banks '88
Gladys Barton '83
Clarence Baylis '74
Félix Beltrán '88
Edward Benguiat '64
David Berlow '88
Peter Bertolami '69
Emil Blemann '75
Godfrey Biscardi '70
Roger Black '80
Sharon Blume '86
Janet Borrello '87
Art Boden '77
Karl Heinz Boelling '86
Friedrich Georg Boes '67
Garrett Boge '83
Ron Brancato '88
David Brier '81
Ed Brodsky '80
Kathie Brown '84
William Brown '84
Werner Brudi '66
Bernard Brussel-Smith* '47
Lisa Bucklin '87
Bill Bundzak '64
Aaron Burns '54
John Burton '85
Joseph Buscemi '82
Jason Calfo '88
Ronn Campisi '88
Daniel Canter '82
Tom Carnase '73
Matthew Carter '88
Ken Cato '88
Younghee Choi '86
Lawrence Chrapliwy '87
Alan Christie '77
Robert Cipriani '85
Travis Cliett '53
Mahlon A. Cline '48
Elaine Coburn '85

Tom Cocozza '76
Barbara Cohen '85
Ed Colker '83
Freeman Craw* '47
James Cross '61
Ray Cruz '75
David Cundy '85
Derek Dalton '82
Susan Darbyshire '87
Ismar David '58
Whedon Davis '67
Cosimo De Maglie '74
Robert Defrin '69
Ernst Dernehl '87
Claude Dieterich '84
Ralph Di Meglio '74
Lou Dorfsman '54
John Dreyfus* '68
Christopher Dubber '85
Curtis Dwyer '78
Rick Eiber '85
Lee Einzig '85
Penny Ellis '84
Bruce Elton '88
Eugene Ettenberg* '47
Leon Ettinger '84
Bob Farber '58
Sidney Feinberg* '49
Amanda Finn '87
Lawrence Finn '87
Blanche Fiorenza '82
Yvonne Fitzner '87
Holley Flagg '81
Norbert Florendo '84
Glenn Foss* '47
Dean Franklin '80
Carol Freed '87
Elizabeth Frenchman '83
F. Eugene Freyer '88
Adrian Frutiger** '67
Patrick Fultz '87
David Gatti '81
Alyce Nadine Geer '87
Stuart Germain '74
John Gibson '84
Lou Glassheim* '47

Howard Glener '77
Jeff Gold '84
Alan Gorelick '85
Edward Gottschall '52
Norman Graber '69
Diana Graham '85
Austin Grandjean '59
Kurt Haiman '82
Allan Haley '78
Edward A. Hamilton '83
Mark I. Handler '83
William Paul Harkins '83
Sherri Harnick '83
Horace Hart '67
Knut Hartmann '85
Geoffrey Hayes '86
Ronnie Hanolton '75
Fritz Hofrichter '80
Kevin Horvath '87
Gerard Huerta '85
Donald Jackson** '78
Jon Jicha '87
Allen Johnston '74
R. W. Jones '64
R. Randolph Karch '47
Louis Kelley '84
Michael O. Kelly '80
Scott Kelly '84
Alice Kenny '85
Tom Kerrigan '77
Zoltan Kiss '59
Robert Knecht '69
Tom Knights '85
Steve Kopec '74
Linda Kosarin '83
Gene Krackehl '75
Bernhard J. Kress '63
Walter M. Kryshak '84
Raymond Laccetti '87
James Laird '69
Guenter Gerhard Lange '83
Jean Larcher '81
Mo Lebowitz '61
Arthur B. Lee* '47
Judith Kazdym Leeds '83
Louis Lepis '84

Professor Olaf Leu '66
Jeffrey Level '88
Mark Lichtenstein '84
Clifton Line '51
Wally Littman '60
Sergio Liuzzi '85
John Howland Lord* '47
John Luke '78
Ed Malecki '59
Sol Malkoff '63
Frank Marchese '88
Marilyn Marcus '79
Michael J. Marino '87
Stanley Markocki '71
John S. Marmaras '78
Adolfo Martinez '86
Rogério Martins '85
Donna Marxer '85
James Mason '80
Les Mason '85
Jack Matera '73
John Matt '82
Frank Mayo '77
Egon Merker '87
Professor Frédéric Metz '85
Douglas Michalek '77
John Milligan '78
Michael Miranda '84
Oswaldo Miranda '78
Barbara Montgomery '78
Richard Moore '82
Ronald Morganstein '77
Minoru Morita '75
Raymond Morrone '88
Tobias Moss* '47
Richard Mullen '82
Keith Murgatroyd '78
Erik Murphy '85
Jerry King Musser '88
Louis A. Musto '65
Shireen Nathoo '87
R. Stanley Nelson '88
Alexander Nesbitt '50
Paschoal Fabra Neto '85
Robert Norton '88
Alexa Nosal '87

Jan Allan Nowak '85
Josanne Nowak '86
Jack Odette '77
Thomas D. Ohmer '77
Motoaki Okuizumi '78
Brian O'Neill '68
Gerard J. O'Neill* '47
Jane Opiat '84
Larry Ottino '88
Vincent Pacella '83
Zlata W. Paces '78
Bob Paganucci '85
Luther Parson '82
Charles Pasewark '81
Eugene Pattberg* '47
Alan Peckolick '86
B. Martin Pedersen '85
Robert Peters '86
Roy Podorson '77
Vittorio Prina '88
Richard Puder '85
David Quay '80
Elissa Querzé '83
Erwin Raith '67
Adeir Rampasso '85
Paul Rand** '86
Hermann Rapp '87
John Rea '82
Jo Anne Redwood '88
Bud Renshaw '83
Jack Robinson '64
Edward Rondthaler* '47
Robert M. Rose '77
Herbert M. Rosenthal '62
Tom Roth '85
Dirk Rowntree '86
Joseph E. Rubino '83
Erkki Ruuhinen '86
Gus Saelens '50
Howard Salberg '87
Bob Salpeter '68
David Saltman '66
John N. Schaedler '63
Jay Schechter '87
Paula Scher '88
Hermann J. Schlieper '87

Hermann Schmidt '83
Klaus Schmidt '59
Werner Schneider '87
Eileen Hedy Schultz '85
Eckehart Schumacher-Gebler '85
Robert Scott '84
Michael G. Scotto '82
David Seager '85
Gene Paul Seidman '87
William L. Sekuler* '47
Ellen Shapiro '85
Paul Shaw '87
Mark Simkins '86
Janet Slowik '84
George Sohn '86
Martin Solomon '61
Jan Solpera '85
Jeffrey Spear '83
Erik Spiekermann '88
Vic Spindler '73
Paul Standard** '86
Rolf Staudt '84
Walter Stanton '58
Mark Steele '87
Murray Steiner '82
Carole Steinman '88
Sumner Stone '88
William Streever '50
Hansjorg Stulle '87
Ken Sweeny '78
William Taubin '56
Jack George Tauss '75
Pat Taylor '85
Anthony J. Teano '62
Bradbury Thompson '58
David Tregigda '85
Susan B. Trowbridge '82
Lucile Tuttle-Smith '78
Edward Vadala '72
Roger van den Bergh '86
Jan Van Der Ploeg '52
Dorothy Wachtenheim '86
Jurek Wajdowicz '80
Robert Wakeman '85
Herschel Wartik '59
Julian Waters '86

Jessica Weber '88
Professor Kurt Weidemann '66
Ken White '82
Cameron Williams '82
John F. Williamson '85
Conny Winter '85
Hal Zamboni* '47
Professor Hermann Zapf** '52
Roy Zucca '69

**Honorary Member*
Charter Member

SUSTAINING MEMBERS
Ad Agencies/Headliners '55
Arrow Typographers '75
Cardinal Type Service, Inc. '82
Characters Typographic
 Services, Inc. '85
CT–Photogenic Graphics '86
Graphic Technology '88
The Graphic Word '87
International Typeface
 Corporation '80
Linotype Company '63
Pastore DePamphilis
 Rampone '76
Photo-Lettering, Inc. '75
Royal Composing Room '55
Techni-Process Lettering '74
Type Consortium Limited '87
The Type Shop '88
Typesetting Service
 Corporation '88
Typographic Designers '69
Typographic Directions
 Corporation '88
Typographic House '60
Typographic Images '86
TypoGraphic Innovations Inc. '72
TypoVision Plus '80

Members as of April 30, 1988

INDEX

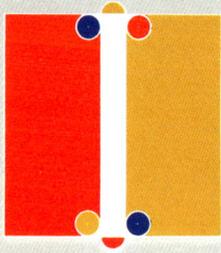

INDEX

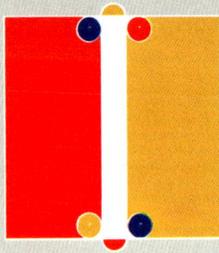

INDEX